# THE GREAT
# CHINESE ART HEIST

# THE GREAT CHINESE ART HEIST

Imperialism, Organized Crime, and
the Hidden Story of
China's Stolen Artistic Treasures

# RALPH PEZZULLO

PEGASUS CRIME
NEW YORK LONDON

THE GREAT CHINESE ART HEIST

Pegasus Crime is an imprint of
Pegasus Books, Ltd.
148 West 37th Street, 13th Floor
New York, NY 10018

Copyright © 2025 by Ralph Pezzullo

First Pegasus Books cloth edition July 2025

Interior design by Maria Fernandez

All rights reserved. No part of this book may be reproduced in whole or in part without written permission from the publisher, except by reviewers who may quote brief excerpts in connection with a review in a newspaper, magazine, or electronic publication; nor may any part of this book be reproduced, stored in a retrieval system, or transmitted in any form or by any means electronic, mechanical, photocopying, recording, or other, or used to train generative artificial intelligence (AI) technologies, without written permission from the publisher.

Library of Congress Cataloging-in-Publication Data is available.

ISBN: 978-1-63936-913-3

10 9 8 7 6 5 4 3 2 1

Printed in the United States of America
Distributed by Simon & Schuster
www.pegasusbooks.com

"Before you embark on a journey of revenge, dig two graves."
—Confucius

# Contents

| | |
|---|---|
| Introduction | ix |
| Chapter 1: Stockholm, 2010 | 1 |
| Chapter 2: The Old Summer Palace, Beijing | 8 |
| Chapter 3: The Opium Wars | 28 |
| Chapter 4: KODE Museum, Bergen, Norway | 43 |
| Chapter 5: The Century of Humiliation | 59 |
| Chapter 6: Château de Fontainebleau | 87 |
| Chapter 7: Empress Cixi | 108 |
| Chapter 8: The Triads | 124 |
| Chapter 9: Sun Yat-sen | 140 |
| Chapter 10: Repatriation | 157 |
| Chapter 11: The Chinese Civil War | 168 |
| Chapter 12: The Seventh Earl of Elgin | 182 |
| Chapter 13: Mao Zedong | 193 |
| Chapter 14: Antiquities Traffficking Unit | 214 |
| Chapter 15: Deng Xiaoping | 231 |
| Chapter 16: China Poly Group | 244 |
| Chapter 17: Unrestricted Warfare | 260 |
| Chapter 18: The Break-ins Continue | 274 |
| Notes | 279 |
| Acknowledgments | 293 |

# Introduction

HAVE YOU SEEN *The Italian Job* with Mark Wahlberg and Charlize Theron? Come to think of it, a better example is the heist scene in the movie *Black Panther*. Remember when Erik Stevens (aka Killmonger) played by Michael B. Jordan, "removes" a Wakandan artifact made of vibranium from a museum in London after claiming that it had been stolen from Africa by British colonizers?

The story I'm about to tell has similar elements—elaborately planned break-ins, diabolically clever diversion tactics, meticulously coordinated and timed operations, high-speed getaways on motorcycles and speedboats, and artworks valued in the hundreds of millions of dollars that had been previously looted by Western soldiers.

Except the events I'm about to describe didn't spring from the imagination of a Hollywood screenwriter. They actually happened, and are likely to occur again soon in a major museum in the United States or Europe. Even more intriguing, their motivation is rooted in a particularly heinous act that took place in the 19th century. And the thefts themselves raise serious questions about the hegemony of culture and art.

If that isn't enough, the heists also raise serious red flags (pardon the pun) about the brazen tactics of certain Chinese billionaires. Since

nothing of major significance happens in China without the knowledge and approval of the communist government of the People's Republic of China (PRC), art and law enforcement experts believe that Chinese officials are likely involved. Publicly stating this, however, is far from simple.

That's because there is also a real possibility that the PRC is hiding behind the cover of the state-run China Poly Group—an industrial giant that sells everything from gemstones to missiles and is connected to Chinese military intelligence.

Lurking in the shadows behind all of this and collaborating with the PRC are the Chinese triads—patriotic secret societies, which is a euphemism for criminal gangs that have seen a major resurgence in recent years. They were formed in the 19th century and are involved in all manner of international crime, delineating ranks according to numeric codes derived by Chinese numerology.

How does this all connect? I invite you to read on.

# 1
# Stockholm, 2010

> "Do not do to others what you do not want done to yourself."
>
> —Confucius

On a humid summer night in 2010, a forty-year-old filmmaker named Magnus (he asked that I not use his last name) and his wife were entertaining another couple at a popular downtown Stockholm restaurant. Ironically, for reasons that he would only discover years later, Magnus spent a good deal of the conversation telling his friends about a recent trip he had made to China where he planned to shoot scenes of an upcoming film.

"During dinner I was telling my friends about the forest of new office towers I had seen sprouting up all over Beijing," he told me. "I remarked on the contrast in the next postmodern architecture to that of the ancient Chinese that I had seen in places like the Forbidden City, Tiantan Park, and the Old Summer Palace. It seemed to me that China had kept itself hidden from the world for more than a century, and was now emerging like a giant dragon waking up from a long sleep. I predicted that China's impact on the global order would be equivalent

to that of the 17th and 18th centuries when Western Europe discovered and overran the New World."

It was well past 1:00 A.M. when, well sated with fine wine and food, my wife and I bid goodbye to our dinner companions. They had parked behind the restaurant. My wife and I went in the opposite direction. We exited out the front, turned at the first corner and were greeted by the mind-blowing sight of parked cars farther down the street in flames. I counted five, or maybe six of them. I thought for a moment that maybe we were looking at a film set. Except I didn't see crew members or cameras.

I immediately used my cell phone to summon the police and firefighters. They arrived, sirens blaring, minutes later.[1]

While policemen were pushing onlookers back and firefighters were rolling out hoses, several kilometers west on an island near the outskirts of the city, a small group of masked men entered the vast grounds of the Drottningholm Palace—the permanent residence of the King and Queen of Sweden.

Asleep in the palace at the time were King Carl XVI Gustaf, Queen Silvia, their children, and the King's sister, Princess Christina, who later claimed that the palace was also the home to friendly ghosts.

"There are small friends . . . ghosts," the princess told pSVT, the Swedish public broadcaster. "They're all very friendly, but you sometimes feel that you're not completely alone. It's really exciting. But you don't get scared."[2]

Filmmaker Magnus and his wife and daughter had visited this World Heritage site many times. Built in the 17th century and inspired by the Palace of Versailles outside of Paris, it is widely considered the finest royal residence in Northern Europe. Its manicured gardens, parks, fountains, and statues attract tens of thousands of visitors annually from every corner of the globe.

According to the Swedish police spokesperson Diana Sundin, "the visitors that morning didn't come for a stroll through the grounds or a boat-ride on one of the man-made lakes. Instead, they quickly made their way to the southern part of the complex and the Rococo-style Chinese Pavilion. They must have waited in the bushes and waited for the guards to pass, because they broke into the Pavilion exactly after a patrol passed the area."[3]

Designed as a tribute to Chinese art and design, this architectural gem of dragon heads and chinoiserie had been commissioned by King Adolf Frederick in 1763 and presented to his beloved Queen Louisa Ulrika as a present on her thirty-fourth birthday. A patroness of the arts, she had called it "the most beautiful building imaginable."

Chinese architecture had been very much in vogue among European royalty at the time the pavilion was built. Venetian explorer Marco Polo was the first European to remark on its unique aesthetic. At the end of the 13th century, he described a palace in the city of Khanbaliq (Peking) as, "the most extensive that has ever yet been known," whose beautiful chambers were "so admirably disposed that it seems impossible to suggest any improvement to the system of their arrangement."[4]

Nearly four hundred years later, French king Louis XIV commissioned the Trianon de Porcelaine at Versailles, which became the first major European building inspired by Chinese architecture. The self-proclaimed Sun King started a trend that continued with Polish king August the Strong who had his Dutch Palace in Dresden converted into a Chinese-themed one, substituting Chinese caryatids for Baroque pilasters and dressing the interior with Chinese furniture and artifacts. Other palaces followed: the Amalienburg in Munich, Le Trèfle in 1738 for the Polish king Stanislaus Lescynski, the Potsdam Chinese Tea House built for Frederick the Great, and the Chinese Pavilion at Drottningholm completed in 1769.

The last was arguably the most remarkable of these Chinese-themed royal pleasure palaces, exquisitely decorated with hand-painted paper and silk wall hangings, porcelain, lacquer screens, and other priceless decorative objects imported from China as well as Chinese-inspired Swedish Rococo furniture.

Swedish Police spokesperson Diane Sundin continued. "Several of these artifacts went missing the morning of August 6, 2010, when the three masked men forced their way into the elegant building, setting off the museum's alarm system, and destroying glass display cases with crowbars and hammers, and grabbing specific objects."[5]

Swedish National Police officers and palace guards raced across the palace grounds to the museum, but the criminals worked fast. They seemed to know exactly what they wanted. By the time the guards arrived, the thieves had fled. Later it was established that the masked men had entered at 2:00 A.M. and were out by 2:06 A.M. They left behind broken glass doors and shattered glass showcases.

With the help of a police dog, detectives found a moped that had been tossed in Lake Malaren, a few kilometers from the castle. They suspected that after fleeing the palace on foot, the thieves had mounted the waiting moped and sped to a nearby lake. There they were picked up by a white speedboat that took them through Stockholm's complex labyrinth of waterways to an unknown destination.

Swedish citizens greeted the news of the robbery with shock and anger. "What disappeared from the Chinese pavilion are a loss for Swedish cultural heritage," exclaimed royal curator Lars Ljungström.[6]

A popular Swedish radio host called the theft "an affront to Sweden and the Royal Family."[7]

The precious Chinese Pavilion had never been burgled before. Outraged Swedes like Magnus asked, "Who would do such a thing?"[8] It seemed as though the robbery had been meticulously planned.

Despite the lack of obvious clues, Swedish authorities remained optimistic that they would solve the case. They were armed with the knowledge that in the majority of art thefts, stolen items are eventually recovered. Thieves usually aren't prepared to market and sell high-profile "hot" works, which rarely yield more than five percent of their value.

Days after the robbery, the Swedish Royal Court announced that the pieces taken were considered priceless. They included a small Japanese lacquered box on a stand, a sculpture in green soapstone, a red lacquered chalice with a lid, a chalice carved from a rhinoceros horn, a small blackened, bronze teapot, and a plate made of musk wood. Several other objects were damaged during the break-in.

One item in particular held special cultural significance—a sculpture of soapstone in green tones from the end of the 17th century representing a mountain landscape with figures in two levels. The founder of Taoism and author of the *Tao Te Ching*, the legendary Lao Tzu is depicted on the upper level riding a deer.

Taoism is the belief that the universe and everything it encompasses follows a harmony, regardless of human influence, and the harmony is made up of goodness, integrity, and simplicity. This flow of harmony is called Tao, or "the way." In the eighty-one poetic verses that make up the *Tao Te Ching*, Lao Tzu outlined the Tao for individual lives as well as leaders and ways of governance.

The *Tao Te Ching* often repeats the importance of benevolence and respect. Passages frequently use symbolism to explain the natural harmony of existence. For example:

> Nothing in the world is softer or weaker than water, and yet for attacking things that are firm and hard, nothing is so effectual. Everyone knows that the soft overcomes the

hard, and gentleness conquers the strong, but few can carry it out in practice.[9]

How this sculpture of Lao Tzu riding a deer made its way into the Swedish Royal Collection is a fascinating story in itself. A century and a half earlier it stood among the prized Chinese cultural treasures housed in Beijing's Old Summer Palace, the main imperial residence of the Qianlong Emperor of the Qing dynasty.

Investigators later learned that it had been one of many ancient artifacts looted by French and British troops in 1860 when they overran and later burned the Old Summer Palace to the ground. The Lao Tzu piece was subsequently sold and traded through various European auction houses before it ended up in the collection of Swedish queen Ulrika.

How does the history of this precious artifact relate to the robbery at Drottningholm?

Swedish authorities didn't see the connection at first. Nor did they see the linkage between the break-in at the Drottningholm Palace on Lovöon Island and a Swedish merchant ship named the *East Indiaman Götheborg* that set sail for China some 270 years ago, heralding the beginning of Sino-Swedish cooperation. The *Götheborg* returned from China loaded with products such as silk, porcelain, and tea that the Swedes fell in love with. This cargo triggered a "China fever" throughout Sweden, which was evident from the construction of the Chinese Pavilion at the Drottningholm Palace.

Almost two centuries later, on May 9, 1950, Sweden became the first Western country to establish diplomatic ties with the People's Republic of China. Since then, Sweden supported the restoration of China's lawful seat at the United Nations, conducted friendly exchanges and cooperation with China in various fields and made positive contributions to China's economic development, reform, opening up, and

modernization. China had always regarded Sweden as a friend and an important trade partner. Sweden became one of the first Western countries to sign intergovernmental agreements on economic, trade, scientific, and technological cooperation with China.

The two countries were now each other's largest trading partners in Northern Europe and Asia. In 2010, bilateral trade surpassed $10 billion. China was also Sweden's largest trading partner outside of the European Union. In recent years, Chinese-Swedish cooperation under the Belt and Road Initiative had made positive progress, with the introduction of more direct China-Sweden flights and freight trains.

In the summer of 2010, Swedish investigators couldn't imagine how the break-in at the Chinese Pavilion at the Drottningholm Palace could challenge Sweden's friendly relationship with China.

But the more they looked into the sophisticated planning that went into the robbery and began to delve into history of the pieces taken, the more they saw a possible linkage between the looting of the Old Summer Palace outside of Beijing in 1860 and the heist at the Chinese Pavilion in 2010.

Just one year later, a series of similar thefts of Chinese artifacts took place at other major European museums. That's when this seemingly isolated case started to raise very troubling questions of global significance that continue to this day.

# 2
# The Old Summer Palace, Beijing

"No one will laugh long who deals much with opium; its pleasures even are of a grave and solemn complexion."
—Thomas De Quincey

Before it was ransacked, looted, and burned to the ground in 1860, the Old Summer Palace of the Qing emperors—aka Yuanmingyuan or Round Bright Garden—was known in Europe as the "Versailles of the East."

Victor Hugo, author of classic novels *Les Misérables* and *The Hunchback of Notre-Dame*, described it as a "miracle." He wrote:

> Build a dream with marble, jade, bronze, and porcelain, frame it with cedar wood, cover it with precious stones, drape it with silk, make it here a sanctuary, there a harem, elsewhere a citadel, put gods there, and monsters, varnish it, enamel it, gild it, paint it, have architects who are poets build the thousand and one dreams of the thousand and one nights, add gardens, basins, gushing water and foam, swans, ibis,

peacocks, suppose in a word a sort of dazzling cavern of human fantasy with the face of a temple and palace, such was this building.[1]

You can still feel the anguish in the words of James M'Ghee, chaplain to the British forces that sacked the Palace 160 years ago, when he said, "Whenever I think of beauty and taste, of skill and antiquity while I live, I shall see before my mind's eye some scene from those grounds, those palaces, and ever regret the stern but just necessity which laid them in ashes."[2]

Imagine how the Chinese people felt. To many of them living today the looting of the Old Summer Palace by French and British troops—the final, savage act of the Second Opium War—wasn't a "stern but just necessity" in the words of James M'Ghee, but a heart-wrenching moment of national shame. It marked the beginning of what historians refer to as "a century of humiliation" that ended with the establishment of the People's Republic of China by Mao Zedong in 1949.

Since Mao's ascendance to power, Chinese students have been taught that the Opium Wars are a testament to why China can never again let itself be weak, backward, and vulnerable to other countries.

"If you talk to many Chinese about the Opium War," wrote British historian Julia Lovell, "a phrase you will quickly hear is '*luo hou jiu yao ai da*,' which literally means that if you are backward, you will take a beating."[3]

Said China's current president Xi Jinping, "That page of Chinese history was one of humiliation and sorrow."[4]

Why are the Opium Wars a mere footnote in Western history, yet so significant to the Chinese people? The answer to this question seems to lie at the heart of Chinese pride and character, and a trade deficit that stymied Western European expansion at the beginning of the Industrial Revolution.

Dr. Greg M. Thomas is a professor of Art History at the University of Hong Kong. He has written extensively about the influences of ancient Chinese aesthetics on Western art. He explains events leading up to the Opium Wars and the impact of the wars on China this way:

> There are four important elements to this saga: silk, spectacular Chinese treasure ships, the first public investment trade companies, and opium. Woven together they tell a tale of infamy and revenge that continues into the present.[5]

Western fascination with Chinese culture dates all the way back to 207 B.C.E. and the establishment of the Silk Road; its primary purpose was to transport Chinese silk to the West, which dressed European royalty and the wealthy. It was also the route used to carry jade and other precious stones, porcelain, tea, and spices to Europe.

Despite its name, the Silk Road wasn't an actual road marked by stones and boundaries. Instead, it was a network of routes that extended 6,437 kilometers (4,000 miles) across some of the most inhospitable landscapes on the planet, including the Gobi Desert and the Pamir Mountains. With no one government to provide upkeep, the roads were typically in poor condition. Robbers were common. For protection, traders joined together in caravans with camels or other pack animals. And the road was dotted with inns called caravanserai to house traveling merchants.

Sometimes described as "roadside inns," caravanserai were safe havens, placed roughly forty kilometers apart (twenty-five miles) encircled with thick walls like those of a fort, where travelers could seek protection from bandits and harsh weather. Manned by porters and guards, visitors were directed through large ground-floor courtyards to stables for their camels, donkeys, and horses, and storerooms

for their goods. Upstairs were small, unfurnished rooms for sleeping. Meals were served downstairs around large fires.

Here, travelers from different cultures gathered. Christians, Jews, Muslims, and Buddhists, trading stories, merchandise, and ideas in a forerunner of globalization.

This is the same Silk Road that was traveled by Venetian merchant and seventeen-year-old explorer Marco Polo when he set off for China (then called Cathay by Europeans) with his father in 1271. It took father and son over three years before arriving at Kublai Khan's palace in Xanadu, Inner Mongolia, which at the time was the capital of the Mongol Empire that ruled China and most of Asia. Marco spent time at Khan's court and was sent on missions to parts of Asia never before visited by Europeans. Upon his return to Venice, Marco Polo wrote eloquently about his travels and the splendid art and architecture he discovered in China in his *Book of the Marvels of the World*.

In them, he described the most advanced economy on earth supported by a vigorous international trade with Ceylon, Indonesia, and other territories. One commercial city Marco Polo visited, the eastern port of Hangzhou (capital of Zhejiang province), he described as "the greatest city which may be found in the world," boasting one and a half million residents, making it fifteen times the size of his native Venice, and possessing a merchant class that traveled freely throughout the Far East and South Asia.

Some historians have accused Marco Polo of exaggeration. While there might be some truth to that, there's no question that by the end of the 13th century China was a commercial powerhouse with vigorous global ambitions that surpassed anything that the Europeans had ever seen. Meanwhile, countries like France, England, and Germany were still emerging from the social, economic, political, and cultural doldrums of the Middle Ages.

Chinese trade depended on ships that were mammoth in size with nine masts and four decks, capable of accommodating as many as one thousand passengers, as well as a massive amount of cargo. Some were reported to have been as long as 180 meters (600 feet) long and 55 meters (180 feet) wide, which was more than twice as long as the largest European ships of the time.

At the beginning of the 15th century Chinese emperor Zhu Di commissioned the building of hundreds of these spectacular ships to launch trade missions throughout Asia, South Asia, and the Middle East. One that set sail in 1414, commanded by court eunuch Zheng He, was a 317-ship mission to the port city of Hormuz on the Persian Gulf, in which the Chinese traded porcelains and silks for sapphires, rubies, oriental topaz, pearls, coral beads, amber, woolens, carpets, lions, leopards, and Arabian horses.

Zheng He is an interesting story. He was the great-great-great-grandson of Sayyid Ajjal Shams al-Din Omarin, who served in the administration of the Mongol Empire, which is considered the largest contiguous empire in world history. At its height the Mongol Empire stretched from the Sea of Japan to Eastern Europe. In the autumn of 1381, when the Ming army invaded and conquered Yunnan, in the final phase of the expulsion of Mongol-controlled Yuan dynasty from China, twelve-year-old Zheng He was captured, castrated, and placed in the service of the Prince of Yan, who later became the Emperor Zhu Di.

As an adult, Zheng He grew to almost seven feet tall and served as grand director and later as chief envoy (正使; zhèngshǐ) of massive expeditionary voyages sponsored by Emperor Zhu Di into Southeast Asia, India, Pakistan, Indonesia, the Middle East, and East and West Africa. Today, Zheng—a former slave and eunuch—is considered the greatest admiral in Chinese history.

Zheng He was also a highly skilled cartographer and military strategist. He wrote of his travels:

> We have traversed more than 100,000 *li* (approximately 34,000 English miles) of immense water spaces and have beheld in the ocean huge waves like mountains rising in the sky, and we have set eyes on barbarian regions far away hidden in a blue transparency of light vapors, while our sails, loftily unfurled like clouds day and night, continued their course (as rapidly) as a star, traversing those savage waves as if we were treading a public thoroughfare.[6]

By the early 15th century, China was superior to the West in technology, living standards, and global influence. But the death of Emperor Zhu Di in 1424 marked a dramatic turning point. In brief, an isolationist faction came to power in China, and the country started to develop a smug self-sufficiency, cultural and economic inwardness, a closed and centralized political system, and an anti-commercial culture. The highly educated Chinese elite decided they had little to learn from the West.

When a British trade mission—the Macartney Embassy—arrived in Beijing in 1793 bringing 600 cases of presents, including chronometers, telescopes, a planetarium, and chemical and metal products, Chinese officials rebuffed the foreigners, saying, "There is nothing we lack. We have never set much store on strange or ingenious objects, nor do we want any more of your country's manufactures."

While China receded inward, European countries began to burst with the curiosity and energy of the Renaissance. Countries like Portugal, Spain, the Netherlands, and England looked to expand their economic and political interests, and promote Christianity. Starting in the 16th century, Portuguese explorers and merchants led the way down

the coast of Africa and into the Indian Ocean. Mounting cannon on small caravel ships they muscled their way into the flourishing Asian trade system dominated by Arabs, Indians, Malays, and Chinese.

Much of the initial European expansion was driven by the demand for spices—particularly cinnamon, nutmeg, turmeric, black pepper, cumin, ginger, and cloves—among the wealthy and powerful classes of Europe.

In 1498, when Portuguese explorer Vasco da Gama made the first sea voyage from Europe to India, via the southernmost tip of Africa, the goal of his mission was to find a direct route to locations where spices were cheap and plentiful in order to cut out Arab middlemen. Likewise in 1492 when Christopher Columbus, sponsored by King Ferdinand and Queen Isabella of Spain, sailed west instead of east in search for a faster route to India, he was hoping to find spices. Instead, he discovered the New World, which led to its colonization and a whole new chapter in world history.

While spices had been consumed in Asia for centuries, in Europe they were becoming a new symbol of high social status. "Spices give the elites opportunity for extravagant display," said Marijke van der Veen, emeritus professor of archaeology at the University of Leicester. "And it emphasizes to everybody else that it is out of reach."[7]

And, despite their high cost, spices were used in great quantities. Sacks of them were required for royal banquets and weddings. In the 15th century, the household of the Duke of Buckingham in England went through two pounds (900 grams) of spice every day, mostly pepper and ginger.

Spain and Portugal spent much of the 16th century fighting over cloves, while England and the Dutch dueled over nutmeg in Indonesia.

One of the centers of the spice trade was the Moluccas, a group of islands in eastern Indonesia, which were discovered by Arab traders

in the 7th century. At the beginning of the 1600s, the tiny island of Pulau Run in the Moluccas became the world's most valuable real estate because of its preponderance of nutmeg trees.

In 1602, the Dutch East India Company (*Vereenigde Oost-Indische Compagnie* or VOC), was founded to exploit the spice trade in Indonesia. Sponsored by the Dutch government and backed by the Dutch military, it quickly established a monopoly in the trade of nutmeg and cloves, which allowed it to set prices and control supplies. The VOC was also granted the power to build forts, keep armies, and make treaties.

Capital was raised by selling bonds and stock to the general public, and the VOC was given an exclusive charter for twenty-one years.

In 1619, the VOC founded Batavia (modern Jakarta) in Java as the base for access to the spice islands of Southeast Asia. Five years later, it occupied Taiwan, where it developed the cultivation of rice and sugar, tried to convert the inhabitants to Christianity, and suppressed aspects of traditional culture that they found unpleasant, including public nakedness, forced abortions, and head hunting.

The VOC's main competition came from another joint-stock company known as the British East India Company (BEIC), which was granted a royal charter by Queen Elizabeth I in 1600. In practice both the VOC and BEIC were the world's first government-backed public companies charged with foreign direct investment. This was the dawn of modern capitalism, and these joint-stock companies became the precursors of modern international corporations.

Initially, both the VOC and BEIC cooperated in the trade in spices, which was largely confined to modern-day Indonesia. In 1620 the two companies began a partnership that lasted until February 27, 1623, when Gabriel Towerson, the chief merchant of the British East India Company in Amboyna, Indonesia, was beheaded along with nine other Englishmen, ten Japanese, and one Portuguese on orders of the

local Dutch governor, Herman van Speult. They had been charged with planning to kill van Speult and overwhelm the Dutch garrison of Fort Victoria.

Dubbed "the Amboyna Massacre" by the British press, it caused the English East India Company to move their trading posts from Indonesia to other areas in Asia. In exchange, the Netherlands gave the British a couple of colonies, including what is now known as the island of Manhattan.

Like its Dutch counterpart, the British East India Company grew quickly. Initially focused on negotiating trade deals with local powers along the coast of India, by the mid–17th century, it had established twenty-three "factories," or warehouses and living quarters for trading, along the Indian coast. Roughly 500 years later, the BEIC accounted for half the world's trade and controlled the majority of the Indian subcontinent either directly or via local puppet rulers, supported by a private army of 260,000 (which was twice the size of the British Army at the time).

During the late 17th century, seeking new markets and more trade, the British East India Company shifted its attention to China, shipping Bengal cotton from India and British silver to China in exchange for tea, silk, and porcelain.

The Chinese people had been drinking tea since 200 B.C.E., but it wasn't until the 1800s that black teas mixed with milk and sugar became a staple in Britain. Demand rose so quickly that by the end of the 19th century more than half of the 250,000 tons of tea produced in China was being exported to Europe.

Trade between China and Western countries was conducted according to the Canton System, whereby the southern Chinese city of Guangzhou (also known as Canton) was the only Chinese port open to trade with foreigners, and all trade had to take place through licensed merchants.

One such merchant was the son of a wealthy Scottish family named William Jardine. Formerly a ship surgeon for the BEIC, he partnered with fellow Scotsman James Matheson in 1828 and founded Jardine Matheson & Co. By 1841, Jardine Matheson commanded nineteen clipper ships—the largest international carriers of their day—as well as hundreds of smaller ships to conduct trade with China.

For many years, the BEIC and its associated traders like William Jardine and James Matheson ran a successful three-country trading operation, shipping Indian cotton and British silver to China, in exchange for Chinese tea and other Chinese goods. The problem with this arrangement was that the balance of trade tilted heavily in China's favor. UK consumers had developed a strong liking for Chinese tea and other goods like porcelain and silk. But Chinese consumers had no similar interest in anything produced in Britain. This forced the British government through the state-run EIC to use silver to pay for its expanding purchases of Chinese goods.

In the mid-1700s, the BEIC devised a way to alter this balance by exporting Indian-grown opium to China. Essentially, the BEIC became an international drug trafficker—a business strategy that proved phenomenally successful. Opium imported into China increased from about 200 chests (roughly 149 pounds) to 1,000 chests in 1767 and then to about 10,000 per year between 1820 and 1830. By 1838 the amount had grown to some 40,000 chests imported into China annually.

As tea flowed into London, the BEIC's investors grew rich and millions of Chinese wasted away in opium dens.

Derived from a milky latex from seedpods of the *Papaver somniferum* poppy, opium was as old as recorded history and referred to as "the herb of joy" on ancient Sumerian tablets inscribed around 5000 B.C.E. It had arrived in China sometime in the 6th century by Arab traders. But its use remained primarily medicinal until the 16th century when

the Chinese discovered it could be smoked for pleasure. Thereupon the practice spread quickly, and for many Chinese, rich and poor, opium smoking became an integral part of daily life governed by rules of social etiquette.

Australian journalist Richard Hughes in his book *Foreign Devil: Thirty Years of Reporting in the Far East* described a visit he made to an opium den in Canton and the process he observed:

> The brown sticky opium is cooked tenderly on the tip of a needle flame from the glass-chimneyed lamp, then inserted in the doorknob-shaped and sized bowl on the side of the bamboo stem. You rest your head on a blue porcelain "pillow," place your lips against the mouthpiece (not around it), tilt the bowl over the lamp flame, and cultivate a deep, easy, rhythmical inhalation . . . Once the fumes are inhaled, the smoker falls into a deep sleep, and wakes hours later feeling calm, subdued, and refreshed.[8]

By the early 19th century, the balance of trade had tilted so far in Great Britain's favor that the Chinese were now the ones paying for the deficit in silver. Simultaneously, increasing numbers of Chinese citizens were smoking Indian-grown British opium and suffering from symptoms of addiction. Some historians contend that by 1830 as many as 40 million men and women were addicted to the drug.

According to Alexander Hosie, the commercial attaché to the British legation at Peking, "There are about forty-two million people in Szechuan Province and I am well within the mark when I say that in the cities 50 percent of the males and 20 percent of females smoke opium, and that in the country the percentage is not less than 25 for men and 5 percent, for women."[9]

The effects of the drug were devastating. When a British traveler to the Chinese northern Shanxi Province asked an official how many of his village's inhabitants smoked opium, the official pointed to a twelve-year-old-boy and answered, "That boy doesn't."

A British scientist exploring the remote areas of Shanxi and other northern provinces in search of rare birds and animals recorded the following observations:

> Everywhere along the highroad and in the cities and villages of Shanxi you see the opium face. The opium-smoker, like the opium-eater, rapidly loses flesh when the habit has fixed itself on him. The color leaves his skin, and it becomes dry, like parchment. His eye loses whatever light and sparkle it may have had, and becomes dull and listless.
>
> With this face is usually associated a thin body and a languid gait. Opium gets such a powerful grip on a confirmed smoker that it is usually unsafe for him to give up the habit without medical aid. His appetite is taken away, his digestion is impaired, there is congestion of the various internal organs, and congestion of the lungs. Constipation and diarrhea result, with pain all over the body. By the time he has reached this stage, the smoker has become both physically and mentally weak and inactive.
>
> With his intellect deadened, his physical and moral sense impaired, he sinks into laziness, immorality, and debauchery. He has lost his power of resistance to disease, and becomes predisposed to colds, bronchitis, diarrhea, dysentery, and dyspepsia.[10]

James Bruce, eighth Earl of Elgin, described a visit to an opium den in 1857, after he was appointed high commissioner and plenipotentiary in China and the Far East to assist in the process of opening up China to Western trade.

> This morning I visited, in my walk, some of the horrid opium-shops, which we are supposed to do so much to encourage. They are wretched dark places, with little lanterns in which the smokers light their pipes, glimmering on the shelves made of boards, on which they recline and puff until they fall asleep. The opium looks like treacle, and the smokers are haggard and stupefied, except at the moment of inhaling, when an unnatural lightness sparkles from their eyes.[11]

Recognizing that opium had become a serious social and health problem, the Qing dynasty banned it and its importation in 1800. In 1813, it went a step further, outlawing the smoking of opium and imposing a punishment of beating offenders one hundred times.

The use of opium spread from the urban elites and middle class to rural workers throughout the country. By the time Japan invaded China in 1937, an estimated 10 percent of China's population—or 40 million people—were addicted to the drug.

British EIC traders were undeterred. They simply flouted China's opium ban through a black market of Indian opium growers and smugglers and ignored the devastating effect the powerful narcotic was having on the Chinese population. The EIC adopted the position that trade was good, no matter the consequences—an attitude reflected by historian Stephen R. Platt, who wrote in the *New York Times*, "when

left to its own devices, the Canton trade was a largely peaceful and profitable meeting of civilizations."[12]

This observation was characteristic of the mercenary and amoral nature of EIC policy. For them, it was convenient to ignore the human toll of their highly profitable drug trafficking operation, which they conveniently characterized as a peaceful meeting of civilizations. Commanding an army that was twice the size of the British army and responsible for more than half of Britain's trade, the rapacious EIC not only managed to hook China on opium, it forcibly annexed much of India, pressed many of their workers into slave labor, and extended the trade of African slaves to the West.

Whereas earlier British traders had perceived China as something of a mystery, seemingly unified and impenetrable, the EIC increasingly saw the country as weaker than previously imagined and possessing serious divisions. Chinese merchants, in their view, wanted free trade with the British, and the Chinese government stood in the way.

So, while Qing dynasty rulers were taking strong measures to end the opium trade, the British EIC was doing all it could to expand it. Britain's governor-general of India declared in 1830, "We are taking measures for extending the cultivation of the poppy, with a view to a large increase in the supply of opium." By 1835 EIC opium imports to China, instead of decreasing, increased to 17,257 chests valued in the tens of millions of British pounds.

The balance sheets of the EIC did not contain a column for the collateral damage caused by the illegal drug. Instead of recognizing opium's corrosive effects and switching to other goods, the EIC grew more aggressive, thus pitting themselves against the rulers of the Qing dynasty.

Several historians, including Jessica Harland-Jacobs and Simon Deschamps, have attributed the EIC traders' moral indifference to

the Chinese opium problem to the large numbers of Freemasons in their ranks.

French historian Simon Deschamps pointed out in his article "Merchant and Masonic Networks in Eighteenth-Century Colonial India" that "Masonic lodges often spread in the wake of British trading ventures" to India and Canton.[13] According to fellow historian Jessica Harland-Jacobs, "One of the great strengths of that originally British phenomenon (Freemasonry) was its exportability."[14]

More than merely entering a social fraternity, Freemasons swore an oath to a one world government of which they were the only citizens. Quoting from their own Grand Lodge Report, "For ourselves, we deny as Masons, that any civil government on earth has the right to divide or curtail Masonic jurisdiction. When once established, it can only be done by competent Masonic authority and in accordance with Masonic usage."

And: "Masonry is the living man, and all other forms of government mere convenient machines, made by a clever mechanic, for regulating the affairs of state . . . We know no government save our own."

"By the beginning of the nineteenth century," said historian Simon Deschamps, "Freemasonry formed an extensive imperial network, which facilitated the circulation of men, ideas, and information. Combined to the trust and cosmopolitan patterns that defined Masonic fraternalism, it facilitated the meeting of potential new trading partners hailing from all parts of the world."[15]

British historian Ronald Hyam in his book *Britain's Imperial Century* describes how Masonic lodges spread throughout India, Canton, and wherever the British traders landed and ran and managed the opium trade. Because Freemasons were loyal first and foremost to themselves and valued trade and profit over building mutually beneficial relationships with their trading partners, they enabled the EIC to build the first global narco-trafficking empire.

"At its peak, the English East India Company was by far the largest corporation of its kind," wrote Emily Erikson, a sociology professor at Yale University and author of *Between Monopoly and Free Trade: The East India Trading Company*. "It was also larger than several nations. It was essentially the de facto emperor of large portions of India, which was one of the most productive economies in the world at that point."[16]

The British government, which could have curbed the abuses of the EIC, benefited from it financially. Company power grew quickly by establishing monopolies on goods such as tea, spices, textiles, and opium in Asia. This provided valuable goods to English markets, allowing the government to collect taxes. It also allowed the EIC to control prices, manipulate politics, and exploit local farmers and workers who were forced to work for low wages under grueling conditions.

Additionally, the EIC served to expand the British Empire as the territories they conquered and controlled—including India, Burma, and later Hong Kong—became subjects of the British Crown, which also carried their own additional cash flow through tribute and taxation.

"The problem was, how would the East India Company rule these territories and by what principle?" asked Tirthankar Roy, a professor of economic history at the London School of Economics and author of *The East India Company: The World's Most Powerful Corporation*. "A company is not a state. A company ruling in the name of the Crown cannot happen without the Crown's consent. Sovereignty became a big problem. In whose name will the company devise laws?"[17]

The EIC answered to no higher authority, moral, spiritual, or otherwise, very much like current multinational corporations. As long as trade continued, EIC shareholders were making money, and the Board didn't interfere.

Because the EIC controlled the news coming from India and China to London (a letter took three months each way) the British public remained largely ignorant of human rights abuses of the EIC. Toward the end of the 19th century, British orator and parliamentarian Wilfred Lawson summed up British attitudes toward the East India Company and opium trade this way: "It came to this, that by hook or crook, money had to be had to fight Russia, or to steal rubies in Burma; and it had to be got by poisoning the Chinese, and then we thanked God that we were not as other nations."[18]

Samuel Merwin, writing at the end of the 19th century, expressed British attitudes this way:

> The notions which animated the English were . . . simple. Stripped of their quaint Occidental shell of religion and respectability and theories of personal liberty, they seem to boil down to about this that China was a great and undeveloped market and therefore the trading nations had a right to trade with her willy-nilly, and any effective attempt to stop this trade was, in some vague way, an infringement of their rights as trading nations. In maintaining this theory, it is necessary for us to forget that opium, though a "commodity," was an admittedly vicious and contraband commodity, to be used "for purposes of foreign commerce only."[19]

To the Chinese official mind, on the other hand, China was the greatest of nations, occupying something like five-sixths of the huge flat disc called the world. England, Holland, Spain, France, Portugal, and Japan were small islands crowded in between the edge of China and the rim of the disc. That these small nations should wish to trade with the Middle Kingdom and to bring tribute to the Son of Heaven, "was

not unnatural. But that the Son of Heaven" must admit them whether he liked or not, and as equals, was preposterous.

Boiled down it expressed the simple principle that China recognized no law of earth or heaven that could force her to admit foreign traders, foreign ministers, or foreign religions if she preferred to live by herself and mind her own business.

Certainly, there was plenty of arrogance and cultural insensitivity on both sides. But as Samuel Merwin wrote in his book *Drugging a Nation*, "That China has minded her own business and does mind her own business is, I think, indisputable."

The death of the son of Emperor Tao-kuang (Daoguag/Dàoguāng) from an opium overdose in the late 1830s led to renewed efforts to stamp out trade and consumption of the drug. Estimates of the number of Chinese addicts had swelled as high as fifty million. As a result, high-ranking mandarin and respected scholar Lin Tse-hu (Lin Zexu/ Lín Zéxú) was installed as special imperial commissioner in 1838 and was vested with extraordinary powers to tackle opium use and supply.

Lin Tse-hu wrote a letter to Queen Victoria in an attempt to appeal to her moral responsibility. It read in part:

> There appear among the crowds of barbarians both good persons and bad . . . there are those who smuggle opium to seduce the Chinese people and so cause the spread of Poison to all provinces. Such persons who care to profit themselves, and disregard their harms to others.[20]

He used the word "barbarians" to refer to British traders.

Unfortunately, the Queen never received Lin's letter because the British later claimed it was lost in transit. In March 1839, Lin demanded that foreign merchants in the port of Canton hand over all

of their opium and cease trading it. When they refused, Lin confiscated 20,283 chests of opium (worth around $200 million in today's money) already at Canton port and arrested merchants who engaged in the trade of opium to leave China. Seven thousand of those chests belonged to traders Jardine and Matheson. Lin disposed of the seized opium, which was hugely valuable, by having it mixed with water and lime in huge pits and then dumping the sludge into the Pearl River.

Jardine was travelling to Britain when he heard of the Chinese action. He immediately hurried to London where he was granted an audience with Lord Henry Palmerston, a fellow Freemason and the British foreign secretary. Jardine lobbied hard for British action and presented his ideas of the size of the force needed to enforce British demands.

In March 1840, Parliament took up the questions of whether or not to send a naval force to China to ensure Chinese repayment for the destroyed opium as well as opening additional ports to foreign trade. As debate closed, Lord Palmerston read a petition signed by British merchants in China. It read in part: "Unless measures of the government are followed up with firmness and energy, the trade with China can no longer be conducted with security to life or property, or with credit or advantage to the British nation."

In the end proponents of sending a naval force to China won by a vote of 271 to 261. Following strategies proposed by Jardine and armed with overwhelming technical superiority the British army prevailed. In October 1841, they captured the port of Chusan while losing only two men compared to China's loss of over a thousand.

A reporter for the *India Gazette*, a British publication, described the sack of Chusan: "A more complete pillage could not be conceived than took place. Every house was broken open, every drawer and box ransacked, the streets strewn with fragments of furniture, pictures,

tables, chairs, grain of all sorts—the whole set off by the dead or the living bodies of those who had been unable to leave the city from the wounds received from our merciless guns. . . . The plunder ceased only when there was nothing to take or destroy."[21]

Similar battles were also one-sided, prompting one British officer to comment, "The poor Chinese had two choices, either they must submit to be poisoned, or be massacred by the thousands, for supporting their own laws in their own land."[22]

Following the deaths of thousands more Chinese, the first Opium War ended on August 29, 1842, with the signing of the Treaty of Nanking (also spelled Nanjing). The treaty forced the Chinese government to pay $15 million to the British merchants, ceded the port of Hong Kong to the British, and opened the ports of Amoy, Foochow, Ningbo, and Shanghai to foreign trade.

Military historian Saul David summed the causes of the war this way: "If I had to say who holds the chief responsibility for the war then I'd have to say that the traders were to blame. And largest and most powerful amongst the traders was Jardine Matheson."[23]

# 3

# The Opium Wars

"For the Chinese people, the looting and burning of the Old Summer Palace is a shameful chapter in Chinese history."
—Professor Wei Zheng, University of Peking

Three years after the First Opium War, Sir George Staunton, speaking in the British House of Commons, said, "I never denied the fact that if there had been no opium smuggling there would have been no war."[1]

Historian Joel Black, in his book *National Bad Habits: Thomas De Quincey's Geography of Addiction*, took it a step further, writing, "It was Britain's insatiable tea habit, after all, that drove it to export Indian opium into China in the first place as a way of balancing its trade deficit with that nation."[2]

The Treaty of Nanking was augmented the following year by the Treaty of Bogue, granting British citizens in China extraterritorial rights, by which they were governed by their own consuls and were no longer subject to Chinese law. It also included a most-favored-national clause, guaranteeing to Britain all privileges that China might grant other powers.

This insured that British traders could not be arrested or attacked. Interestingly, neither treaty said anything about opium. The British, for their part, increased shipments of the drug to China. And still they pressed for more concessions, including the opening of all of China to their merchants, an ambassador to the emperor's court at Beijing, the legalization of the opium trade, and the exemption of their imports from tariffs.

The Qing government of newly installed Emperor Xianfeng had bigger problems than the two lopsided treaties, however. Starting in 1850 it was being challenged by a revolt of famine-stricken peasants, Christians, workers, and miners led by a religious fanatic who claimed to be the brother of Jesus Christ. Although some programs of the Taiping Rebels were widely supported, including their opposition to opium and prostitution, others clashed with widely held traditional values and Confucian beliefs of the Chinese people.

The resulting bitter conflict waged for more than a decade and consumed an estimated twenty million lives before the Qing government quelled the Christian rebellion in 1864. With the Qing dynasty's hold on the country becoming more and more tenuous, the British saw an opportunity to press their advantage. All that was needed to launch another war was a casus belli. That came in the form of what historians Justin and Stephanie Pollard in writing in *History Today* called "one of the most dubious reasons for ever starting a war"—known in history as the Arrow Incident.[3]

The *Arrow* was a lorcha—a type of sailing vessel with a junk rig, Cantonese-style batten sails, and a European-style hull. This design made it faster and able to carry more cargo than a traditional Chinese junk. She was owned by a Chinese man who had been a resident of Hong Kong for over ten years and had registered his ship with the colonial government.

On October 3, 1856, the *Arrow* entered the harbor of Canton whereupon one of the ship's navigators was recognized by another ship owner as one of the pirates who had attacked his ship a month earlier. He reported his suspicions to harbor authorities who dispatched a squad of marines to arrest twelve members of the *Arrow*'s fourteen-man crew. The Chinese marines said they didn't see any flag on the mast or any foreigner aboard.

The British captain of the *Arrow*, who was breakfasting with friends on another ship at the time, reported the incident to British consul Harry Parkes. Parkes subsequently filed a complaint with the imperial commissioner for foreign affairs Yeh Ming-chien (Ye Mingchen). It started, "I hasten to bring to your Excellency's attention an insult of grave character which calls for immediate reparation," and went on to claim that the *Arrow* had been flying British colors, which the Canton marines had "hauled down." Parkes contended that because the *Arrow* was flying the British flag, it was therefore a British vessel.[4]

Yeh Ming-chien disagreed, writing:

> It is an established regulation with the lorchas of your honorable nation, that when they come to anchor, they lower their colors and do not rehoist them until they again get underway. We have clear proof that when this lorcha was boarded her colors were not flying: how then could they have been taken down?[5]

This relatively minor incident spawned huge outrage in the British press, not so much over the seizure of the crew, but because the British captain alleged that the Chinese had torn down and trampled the British flag. But upon further investigation the tearing down of the British flag probably never happened and the *Arrow* was officially Chinese,

as its British registration had expired. So even if it had been flying a British flag, it was sailing under false colors. As for the crew, all of them were released—bar three, who were held on piracy charges related to the *Arrow*'s former career.

But none of this was going to hinder British prime minister and freemason Lord Palmerston who had been instrumental in launching the First Opium War and was keen to squeeze more trade concessions from China. He whipped up British outrage over the *Arrow* incident by declaring, "an insolent barbarian, wielding authority at Canton, has violated the British flag, broken the engagement of treaties, offered rewards for the heads of British subjects . . . and planned their destruction by murder and assassinations . . ."[6] This precipitated a debate in the House of Commons, a vote of no confidence and a new election.

The anti-Palmerston coalition lost what was called the "Chinese Election," and the British electorate affirmed an aggressive policy toward freeing overseas trade, including supporting Palmerston's tendency to send in troops where trade was threatened. Shortly after the vote, war preparations began.

First, the British contacted France, Russia, and the United States about forming an alliance. Russia and the US declined the offer and chose to send envoys to the Emperor's court at Peking instead. The French, however, were upset over the recent execution of French missionary August Chapdelaine by the Chinese. In February 1856, the French priest had been arrested in Guangxi, where foreigners were forbidden. In the suspicious and violent atmosphere of the Taiping Rebellion, he was executed for fomenting rebellion.

Months later, a terrorist attack was launched against foreigners living in Hong Kong when bread from the Cheong Ah-lum's bakery (which served the European community) was laced with arsenic. The plot failed because the dose was too high and simply induced vomiting.

Retribution was fierce. The French government, convinced that Britain would prevail in a second war with China, joined the British and formed a combined invasion force under the command of Admiral Michael Seymour of the Royal Navy and Lord Elgin. Commanding the French force was Marshall Gros. First, they attacked forts south of Canton on the Pearl River.

When imperial commissioner Yeh Ming-chien ordered his soldiers not to resist, the combined French-British forces occupied the city of Canton and started making arrests. Then they sailed north along the Hai River and seized the Taku Forts, which protected the northern port city of Tianjin and the imperial capital of Beijing.

During the summer of 1858, four separate treaties were signed between the Qing government and the United States, Russia, France, and Great Britain. The four Western powers were given the right to open diplomatic delegations in the formerly closed city of Beijing and ten additional Chinese port cities were open to Western trade. Christian missionaries were now permitted throughout China, and the opium trade was legalized. Additionally, the Qing government was forced to accept the payment of reparations to both France and Great Britain and bear the cost of the war.

American author and playwright Samuel Merwin summed up the war this way in his book *Drugging a Nation: The Story of China and the Opium Curse*:

> China had defied the laws of trade, and had learned her lesson. It had been a costly lesson, $24,000,000 in money, thousands of lives, the fixing on the race of a soul-blighting vice, the loss of some of her best seaports, more, the loss of her independence as a nation.[7]

Once the treaties were ratified, the forts at Taku, which protected the approaches to Beijing, were returned to the Qing government, and French and British troops were withdrawn. But the treaties were so one-sided and unpopular that shortly after agreeing to their terms, Emperor Xianfeng decided to renege and sent Mongolian general Sengge Rinchen to defend the newly returned Taku Forts.

The emperor should have anticipated the British response. It came in June 1859 when a British naval force commanded by Admiral Sir James Hope and carrying the Anglo-French envoys to Beijing approached the Taku Forts and demanded they be allowed to disembark the envoys and an armed escort to take them to Beijing. General Rinchen refused to allow the armed escort and ordered the British to land the envoys farther downstream. The British attempted to force their way past the forts on June 25, firing on the forts as they went by. Chinese cannon fire sank four British gunboats, and a US Navy steamer. Commodore Josiah Tattnall opened fire to help cover the British retreat, thus violating US neutrality. When asked why he intervened, Tattnall replied that "blood is thicker than water."

The British, meanwhile, retreated to Hong Kong—now under their control—where they proceeded to assemble a larger force. The following summer, the British and French returned to the mouth of the Hai River with 17,700 men sailing on 173 ships. Commanded by Lord Elgin and General Charles Cousin-Montauban they overwhelmed the Taku Forts on August 21 and occupied the city Tianjin. Then the combined Anglo-French army began moving inland toward the imperial capital of Beijing.

With the Anglo-French army drawing closer, Emperor Xianfeng called for peace talks. After four days of talks, the emperor's generals urged him to take one last stand. One advisor asked the emperor, "Will you cast away the inheritance of your ancestors like a damaged shoe? What would history say of Your Majesty for a thousand generations to come?"

Reversing course, Emperor Xianfeng authorized General Sengge Rinchen to take action. As a consequence, thirty-nine Anglo-French diplomats and their escorts were seized. They included British envoy Henry Loch, Consul Harry Parkes (from the *Arrow* incident), and the *Times* journalist Thomas William Bowlby.

Loch, Parkes, and their Sikh orderly were taken to the Peking Board of Punishments, where they were imprisoned in a ward with some first-class felons. The rest of the company, including Bowlby, were marched to the Old Summer Palace of Yuanmingyuan.

There they were tortured by applying wet ligatures to their limbs. As the cords dried, they tightened and produced pressure on their hands and feet so immense that they were "swollen to three times their proper size, and as black as ink," testified Bughel Sing, one of the few captives to survive. Also, dirt was forced down the prisoners' throats, food was withheld, beatings were regularly inflicted, and *lingchi* (or slow slicing, the infamous "death by a thousand cuts") was administered. Thomas William Bowlby withstood five days of this inhumane treatment before he died. Two other prisoners—Captain Brabazon of the Royal Artillery and Frenchman Abbé de Luc—were taken to the parapet of the bridge at Pah-li-chao, where they were beheaded and tossed into a ditch. Eventually thirteen of them died.

Other historians contend that this is a British and French retelling of history, and the torture of the diplomats didn't take place until after the total destruction of the Old Summer Palace.

Whatever the true story is, General Sengge Rinchen did attack the combined British-French invading near Zhangjiawan on September 18, but was repelled. As the British and French entered the Beijing suburbs, Rinchen made a final stand at Baliqiao.

Mustering over 30,000 men, the Chinese general launched ferocious frontal assaults on the Anglo-French positions only to be repulsed.

With the Chinese army destroyed and the British furious over the treatment of their envoys, Lord Elgin, Cousin-Montauban, and their forces entered Beijing on October 6.

The next morning, French soldiers broke through the gates of the 860-acre Summer Palace, abandoned days earlier by the Emperor Xianfeng and his court. French officers led by General de Montauban were struck by the magnificence of the many buildings. Among them was Lieutenant-Colonel Dupin who wrote the following:

> Words fail to depict the material and artistic treasures of these apartments . . . It was a vision from the *Thousand and One Nights*, such a fairytale that a delirious imagination couldn't dream of anything comparable to the palpable truth we had before us![8]

Much like Crystal Palace in London or the grounds of Versailles, the Yuanmingyuan in Beijing was an enormous complex roughly the size of New York City's Central Park, which housed an array of foreign and native Chinese objects, artwork, pleasure gardens, and architecture. Constructed from the 16th to the 18th century, it held over three thousand structures and served primarily as a summer resort for the Qianlong Emperor. Inside the imperial gardens were buildings, objects, and works of art from all over the world, including Europe, Asia, and distant regions within China—Mongolian and Tibetan temples, European palaces, and gardens drawn from Hangzhou and Suzhou.

Very few Europeans had actually seen it in person and most of what they had heard about it came from descriptions provided by Jesuit missionaries who visited the Chinese emperor's court. The most well-known of these was found in a letter written in 1745 by Jean Denis Attiret, who described a park filled with palaces, pavilions, teahouses,

temples, pagodas, and lakes filled with birds and magnificent boats. The emperor, Attiret explained, had selected forty locations from which "the gardens present itself in a particularly attractive fashion." Among them were buildings taken from around the world and China: temples from Mongolia and Tibet, a hamlet and river scene from Hunan, gardens from Hangzhou and Suzhou, and a set of European palaces.

Most remarkable in the words of Attiret was what he called "the beautiful disorder" and "anti-symmetry" that governed the layout and design. He waxed poetically about buildings of very different styles placed close together, paths that weren't straight, bridges across zigzagging lakes and doors that weren't square, but round, oval, or shaped in the form of birds, fish, or flowers. It sounded ridiculous, he admitted, "but seeing it in person you think differently and begin to admire the art with which this irregularity is put together." Walking through the gardens in its "admirable variety" gave the visitor an enchanting feeling, which transformed Yuanming Yuan from an imperial palace into a "pleasure ground."[9]

One of three main gardens in the Summer Palace, the Xiyanglou (meaning "Western-style building"), was located in the northern part of the Changchun Yuan (Garden of Eternal Spring). Covering an area of about seven hectares (or 17.3 acres) it featured palaces, gardens, and a maze that incorporated several popular European styles, most notably the *Le Nôtre* style popular in Europe at the time. Included was the Haiyan Tang, a hall built in a highly decorated French neoclassical style and with an entry embellished with a seashell-shaped fountain and two grand sweeping staircases.

In addition to displaying exceptional objects and architectural wonders from other countries, the Summer Palace also contained aspects of Chinese life that were inaccessible to the nobility. Much

like the Hameau de la Reine—Marie Antoinette's pretend village in Versailles—the gardens featured an artificial market town, comparable to the busiest commercial street in Beijing at the time. The market town was a place of leisure where the emperor could visit with his entourage, browsing shops and stalls staffed by eunuchs acting as shop owners and others playing the roles of beggars, thieves, sightseers, and minstrels. Another area of the gardens was reserved for a functioning farm complete with fields of vegetables, farm animals, and equipment.

The Summer Palace allowed the visitor to experience multiple aspects of the world in one place. And much like similar palaces in Europe, its abundance, variety, and beauty were meant to serve as a physical expression of the emperor's immense power.

Some British officers who visited it on the morning of October 7, 1860, however, were not impressed. "Everything upon which the eye could rest was pretty and well designed, each little object being a gem of its kind, but there was nothing imposing in the tout ensemble. Both in land-scape gardening and building, the Chinaman loses sight of grand or imposing effects, in his endeavors to load everything with ornament; he forgets the fine in his search after the curious," wrote Lt. Colonel Garnet Wolseley of the British Light Infantry.[10]

Yet, he went on to describe the Imperial throne as "a beautiful piece of workmanship, made of rosewood." It stood upon a raised platform eighteen inches above the other part of the hall, and was surrounded by an open-work balustrading, richly carved in representation of roses and other flowers. "Upon each side of the throne," Wolseley added, "stood a high pole screen decorated with blue enamel and pea-cocks' feathers, upon which small rubies and emeralds were strung."[11]

Lt. Colonel Wolseley was one of the last people to see the Summer Palace in its magnificent splendor. Because as British and French officers toured the imperial apartments, they started to select precious

objects to send back to their sovereigns. This set off a frenzy of looting by officers and soldiers alike.

Frenchman Armand Lucy, who witnessed the pillaging, described it like this:

> What a terrible scene of destruction presented itself! How disturbed now was the later quiescent state of the rooms, with their neat display of curiosities. Officers and men, English and French, were rushing about in a most unbecoming manner, each eager for the acquisition of valuables. Most of the Frenchmen were armed with clubs, and what they could not carry, they smashed to atoms.[12]

Soldiers and many officers ran from room to room "decked out in the most ridiculous-looking costumes they could find," wrote the aforementioned Garnet Wolseley. (See Garnet Wolseley's *Narrative of the War with China in 1860*.) "Officers and men seemed to have been seized by a temporary insanity. A furious thirst had taken hold of us." It was, Armand Lucy wrote, an "orgiastic rampage of looting."[13]

The avarice and disregard for the Chinese cultural treasures couldn't have been more blatant. Soldiers carried off sacks of gold and silver jewelry and objects, strings of pearls, watches, vases, pencil cases inlaid with diamonds, statues, porcelain, silk drapes and robes, and anything they could carry—an estimated 1.5 million artifacts in total!

The British, in their need to impose some kind of civil order on an act that could be best described as barbaric, set up a system whereby soldiers turned in their loot so the commissioners could auction it and divide the profits equally—one-third going to officers and two-thirds to the soldiers.

French officers, on the other hand, let their soldiers loot freely. Armand Lucy described soldiers leaving the palace with enormous sacks of goods, which they paid local peasants to carry for them when the armies moved out.

That might have been the end of the pillaging and destruction. But shortly after the Anglo-French force withdrew from the city of Beijing on October 8, British envoys Loch, Parkes, and six other members of their delegation were released from the Peking Board of Punishments. According to the overall commander of the Anglo-French force Lord Elgin, when he heard how the British diplomats under protection of the flag of truce had been brutally mistreated and murdered he was bent on seeking revenge.

First, he considered the destruction of the Forbidden City in Beijing as a means of humiliating the Qing dynasty. But the French envoys traveling with him pointed out that portions of the Forbidden City were over four centuries old, and destruction of the Summer Palace would be punishment enough.

The 8th Earl of Elgin wrote in his journals:

> Having, to the best of my judgment, considered the question in all its hearings, I came to the conclusion that the destruction of Yuanmingyuan was the least objectionable of the several courses open to me, unless I could have reconciled it to my sense of duty to suffer the crime which had been committed to pass practically unavenged. I had reason, moreover, to believe that it was an act which was calculated to produce a greater effect in China, and on the Emperor, than persons who look on from a distance may suppose.[14]

Envoy Harry Parkes, in a letter to his wife, wrote:

> But the difficulty was to know what punishment to inflict. Some advocated a heavy indemnity; others the burning of Peking; others the destruction of the Imperial Palace in the city. I think Lord Elgin came to the right decision in determining to raze to the ground all the palaces of Yuen Ming Yuen, the Emperor's Summer Palace, five miles outside Peking, where the Emperor and whole Court have lately spent two-thirds of their time, and where our poor countrymen were taken in the first instance and put to torture by direction of the Court itself.[15]

On October 18 Lord Elgin ordered 4,000 British troops to return to the Summer Palace, completely destroy it, and burn it to the ground. The destruction, Lord Elgin wrote later, was intended "to mark, by a solemn act of retribution, the horror and indignation . . . with which we were inspired by the perpetration of a great crime."

According to witnesses, the fire lasted for three days and nights. As the embers cooled and the smoke dispersed, the splendor and magnificence of the Old Summer Palace had disappeared. Days later, the emperor's brother signed the Convention of Peking, ratifying the Treaty of Tientsin and bringing the Second Opium War to an end.

"The destruction of the emperor's palace," concluded Lt. Colonel Wolseley, "was the strongest proof of our superior strength; it served to undeceive all Chinamen in their absurd conviction of their monarch's universal sovereignty."[16]

Over the next several days, libraries filled with rare books, palaces, temples, fountains, pavilions, and halls were sacked and reduced to ashes. It was an attack regarded as the single largest act of vandalism in China's modern history. In addition more than three hundred maids and eunuchs were torched to death while hiding from the foreigners. It was as if Hitler's armies before retreating from Paris had stripped the Louvre and Versailles of all their artistic treasures and then burned them to the ground and executed the staff in the process.

In the months that followed, thousands of items looted from the Summer Palace were put up for auction throughout London and Paris. By the 1870s some of the more valued pieces started to make their way into museums and royal collections across Europe. Over the years, Dr. Greg M. Thomas, professor of art history at the University of Hong Kong, has catalogued hundreds. A half-dozen entered the collection of the Chinese Pavilion at Drottningholm in Sweden. He knows this because they appear in the collection's inventory of 1878.

One of them was the aforementioned green soapstone sculpture of Lao Tzu. Also, among the pilfered items from the Old Summer Palace were several Pekinese dogs formerly owned by the Emperor, and extremely rare in Europe at the time. One particularly charming puppy, seized by British captain J. Hart Dunne, was presented to Queen Victoria. She named it Looty—in a naked display of imperial arrogance.

Looty went on to live a life of luxury at Windsor Palace until her death in 1872. Meanwhile, the Qing empire slowly disintegrated and China entered its self-named "century of humiliation."

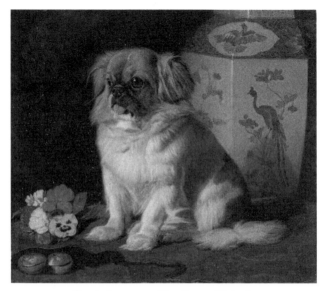

"Looty," so named by Queen Victoria

By 2010, however, that century was well over and the economic and political power of the two countries had reversed. China was in the midst of a manufacturing juggernaut that produced the second highest gross domestic product (GDP) in the world. At over six trillion dollars its GDP was roughly three times that of Great Britain, and twelve times the GDP of Sweden.

Their national pride growing, Chinese leaders made it clear that they wanted their looted treasures back. But would they resort to hiring professional thieves to break into European museums and snatch the pieces they wanted? That idea seemed wildly farfetched at the time of the Drottningham heist.

# 4
# KODE Museum, Bergen, Norway

"A thief is one who insists on sharing his victimhood."
—Criss Jami

A month after the break-in at the Chinese Pavilion at the Drottningholm Palace in Stockholm, Sweden, something eerily similar took place in Bergen, Norway, on that country's rugged southwestern coast. This time the target was the KODE Museum—a unique combination of art collections, Norwegian composers' houses, concert venues, and parks that house over 50,000 objects located on Bergen's picturesque central square.

That night, masked men eluded a very sophisticated security system by rappelling down from a glass ceiling into the prestigious KODE, three blocks from police headquarters. To the passing observer it might have seemed like the men were recreating a scene from the popular heist movie *The Italian Job* starring Mark Wahlberg. But once inside, the intruders broke through interior doors with sledgehammers and started grabbing Chinese vases, imperial shields, and other historic

objects. Security camera footage showed the thieves targeting specific pieces with a connection to Chinese history and leaving other equally valuable artworks behind. They were in and out in less than seven minutes, taking with them fifty-six valuable objects.

Bergen was known for many things: cobbled streets, fjords, picturesque wooden houses, rain (two hundred days of it a year), and the birthplace of composer Edvard Grieg, but art theft wasn't one of them. Its most notorious crime had been the discovery of someone who became known as the Isdal Woman in 1970—a still-unidentified half-burned woman who was found at the base of a hill outside Bergen. She possessed eight different passports and aliases, causing many investigators to speculate that she had been a spy.

Following the KODE break-in, Bergen residents were in shock. According to the *World Happiness Report*, Norway is the second safest country in the world after Finland, and Bergen is one of its safest cities.

Bergen police reported that the thieves had been professional, and the heist had been carefully planned and executed so as not to trip the museum's alarm.

So, who had done it? And why?

Because the stolen artifacts were well documented, authorities figured they would be hard to sell on the international market, so resale was likely not the goal. It seemed as though the items had been stolen for a specific buyer.

The KODE responded by publishing a series of photos on its website describing the stolen art and hoping someone would come forward with a clue. Some of the larger, more valuable pieces taken from the museum's China collection were up to 4,000 years old. The thieves had left them behind in favor of smaller items that were easier to handle and were believed to be easier to sell on the international market.

Despite an all-out effort over the next several weeks, Norwegian police failed to recover any of the stolen artwork. The artifacts seemed to have disappeared without a trace.

There were other things about this case that didn't add up. Why had the thieves targeted specific pieces? And why had they left other, more valuable artifacts behind?

Painstakingly tracking evidence—security camera footage, receipts for the sale of specific equipment, and rental car records—Norwegian investigators finally arrested six suspects after several weeks of investigation, all of whom were notorious criminals. But the suspects refused to share information about the individuals (or persons) who had hired them. Nor did they reveal anything about the location of the stolen artifacts.

Authorities concluded the six men were "mere foot soldiers" to others who had commissioned them to carry out the thefts.

"The thieves didn't think of this themselves," concluded one police official.

A KODE museum spokesperson offered this explanation: "We had objects that somebody wanted, and this person hired someone to take them."[1]

And given the expense that such a skillfully executed heist would have entailed, Norwegian law enforcement officials suspected that middlemen in Hong Kong and the powerful Chinese organized crime syndicate, the triads, were involved.

Then three years later, on January 5, 2013, thieves hit the KODE again, this time employing a tactic reminiscent of the one used at Drottningholm Palace. Just after 5:00 A.M. on a Saturday, a group of criminals set fire to two cars on the opposite side of town from the museum. After the police dispatched units to respond to the fire, two men wearing high-beam headlamps entered offices adjoining

the KODE and used crowbars to smash through a glass wall into the museum's China exhibit.

"The only thing missing (was) the theme song from *The Pink Panther*," reported the local newspaper *Morgenbladet* describing the scene of the break-in. Surveillance footage showed two thieves dressed in black and wearing headlamps climbing among ancient, fragile objects. In the semi-darkness, they picked their way to specific display cases, causing some urns to teeter, fall, and break. One thief slipped a hand behind the broken glass, retrieved centuries-old Ming and Qing porcelain vases, and handed them to his accomplice who carefully stashed them in a preprepared box padded with circular pockets.

Sirens echoing through Bergen's predawn streets, cops raced to the scene. When they arrived at the museum, they found shattered glass and porcelain, but no burglars. The thieves had fled approximately two minutes after they entered, taking with them twenty-five specific items, including jade and bronze statues, porcelain vases, and imperial seals, and leaving behind more valuable artworks.

Authorities were surprised again. "They were very exact," one police officer reported. "The entire operation was carefully planned."[2]

"The thieves operated quickly, effectively and professionally," announced Erlend Høyersten, director of the city's consortium of art museums. "It's entirely clear that they knew what they were after."[3]

Mr. Høyersten believed that the thieves had brought with them a "shopping list" of sorts and likely were hired to carry out the theft by clients keen on obtaining specific Chinese artifacts.

It was no surprise to director Høyersten why the KODE had been targeted again. Its Chinese collection is one of the largest of its kind in Europe, originally containing around 2,500 items that had been donated to the museum by Norwegian adventurer and general Johann

Wilhelm Normann Munthe, who died in 1935. Many of them, it turned out, had been looted by French and British troops from the Old Summer Palace outside Beijing.

General Johann Munthe, interesting enough, was a native of Bergen, Norway, and had attended the Bergen Military Academy. On the advice of his uncle, Iver Munthe Daae, who had worked in the Chinese Imperial Maritime Customs Service and returned to Norway with a large collection of Chinese art, Johann Munthe interrupted his military education to emigrate to China in 1886, shortly after the end of the Second Opium War. It was a time of great opportunity for Europeans living in China. Like his uncle, Johann Munthe started his career in the British-led Chinese Maritime Customs Service and ended it as the acting deputy commissioner of customs in the northeastern port city of Tientsin (Tianjin) on the Bohai Sea.

As a consequence of the Treaty of Nanking (1842), Treaty of Tianjin (1858), and the Beijing Convention (1860) that ended the Opium Wars, China was forced to open several ports along the coast and the Yangtzi River to foreign merchants. Foreign customs inspectors were appointed to collect taxes agreed to in the treaties—practice that was formalized and extended and became known as Chinese Maritime Customs Service (CMCS).

Technically the CMCS was part of the Chinese government, but it was run by foreigners, under the leadership of British inspector general Sir Robert Hart. Initially the role of the CMCS was limited to ensuring the accurate assessment of customs duties (taxes on imports and exports). But over time, it became involved in all sorts of activities including the maintenance of harbors and lighthouses, the payment of foreign loans, the preparation of a very wide range of published reports, and the provision of technical assistance to the Chinese government. Customs officials often were involved in diplomatic discussions and

served as informal intermediaries between Chinese officials and representatives of European counties.

Johan Wilhelm Normann Munthe from Bergen, Norway, benefited from the growing influence of the Chinese Maritime Customs Service. Still very much a soldier in appearance and bearing, he learned Mandarin Chinese and became a cavalry instructor in the Chinese army under General Yuan Shikai, who later advanced him to the rank of lieutenant general and put him in charge of a special gendarmerie of elite troops to ensure the security of the foreign legations.

Besides being a skilled cavalryman, General Munthe was also an admirer of Chinese art. He lived in China at a time when artifacts looted by the French and British were readily available through auction houses in Europe and Beijing. Toward the end of his life, he explained that shortly after marrying his wife, he started sending Chinese paintings, sculpture, and porcelain back to Norway "so that Norwegians could learn about China and its interesting and beautiful art." General Munthe eventually gifted over 2,500 Chinese works to the Vestlandske Kunstindustrimuseum (West Norway Museum of Decorative Art) in Bergen, making him one of Norway's greatest patrons of the arts.

In February 2013, shortly after being robbed a second time, the KODE hired former policeman Roald Eliassen to the position of KODE's director of security. A compact, brawny man, Eliassen said that after reading about the thefts in the newspaper, "I thought, 'How could this happen? Once, okay. Twice . . . well, that's not good.'"[4]

The citizens of Bergen were outraged. Herman Friele, former mayor of Bergen, after blaming museum security, said, "It's a shame that we haven't managed to take better care of this collection. . . . It's incomprehensible that we're so naive that we haven't learned from the first break-in. We almost deserved to be robbed again."[5]

A local newspaper, *Bergens Tidende*, had pointed out in an article written a month before the second robbery that the KODE still hadn't determined the value of the loss from the first break-in in 2010, and hadn't filed an insurance claim. Friele accused museum officials of being too passive and urged the museum's board of directors to demand improvements.

Months later, while authorities were investigating the second break-in, they got a big tip related to the first. They learned that a piece taken in the first KODE heist had made its way back to China and was on display at the Shanghai Airport.

Obviously, this was a major clue that should have invited immediate investigation. But these weren't normal times in Sino-Norwegian relations. Norwegian officials, afraid of further damaging relations with China, were hesitant to pursue the matter. Their hesitancy was based on two things: one, China's growing international economic might, and two, the 2010 Nobel Peace Prize, which had been awarded to jailed Chinese literary critic and philosopher Liu Xiaobo. According to the Norwegian Nobel Committee, Liu had been selected because of his "long and nonviolent struggle for fundamental human rights in China."

The Chinese government had reacted with fury, arguing that awarding the Peace Prize to a convicted criminal constituted serious interference in their political and legal affairs. And, to their minds, it wasn't the first time they had been insulted by the Nobel Committee. Twenty-one years earlier in 1989, shortly after the Tiananmen Square massacre, the Norwegian Nobel Peace Prize Committee awarded that year's prize to the Dalai Lama, who had long opposed Chinese control of Tibet.

After the latest affront by the Nobel Peace Prize committee, the Chinese government felt it was the Norwegians' responsibility to repair the relationship. Chinese Foreign Ministry spokesperson Hong Lei

characterized their position by quoting a Chinese proverb: "The one who tied the bell around the tiger's neck should be the one to untie it."

The dispute tilted in China's favor, because of the huge differences between the size and economic clout of the two countries. In 2012, China was Norway's third most important source of imports and ninth largest export market. Norway, on the other hand, was ranked as China's 65th most important trade partner.[6] And China at the beginning of the 21st century was just beginning to flex its economic might.

The proverbial bell around the tiger's neck that spokesperson Hong Lei had referred to was untied by Norway at the end of 2016, when it agreed to "do its best to avoid any future damage to bilateral relations." But, in early 2013, after the second KODE break-in, Norwegian officials were loath to risk angering the Chinese further by accusing their citizens of stealing artifacts from one of their museums—artifacts the Chinese could rightfully argue belonged to them.

Whether the people behind the thefts had deliberately taken advantage of the difficult time in Sino-Norwegian relations was hard to determine. Whether or not they did, Norwegian authorities decided to drop their investigation and accept that the stolen pieces were probably never coming back.

Kenneth Didriksen, the head of Norway's art-crime unit, explained the situation thusly: "If we say an item is in China, they say, 'Prove it,' And we don't want to insult anyone."[7]

Given the difficult state of geopolitical relations at the time, that position made practical sense for Norway. "The government in China doesn't think they're stolen objects," said Roald Eliassen. "They think they belong to them. They won't take it seriously, won't follow the trail. That's the biggest problem."[8]

Bjornar Sverdrup-Thygeson of the Norwegian Institute of International Affairs put it this way: "The relationship between China

and Norway thus showcases some of the broader issues faced by small states navigating a multipolar world where economic, political, and normative power is in increasing flux."[9]

Norway's museums weren't the only ones that were being broken into. On April 5, 2012, thieves chiseled through a three-foot-wide wall surrounding Durham University's Oriental Museum before crawling into the Malcolm MacDonald Gallery. In less than sixty seconds, they smashed two glass cabinets and made away with two Qing dynasty artifacts—a jade bowl with a Chinese poem inside that dated back to 1769 and a foot-high Dehua porcelain figurine of seven fairies in a boat. Only two of hundreds. The two pieces were valued to be worth $2.8 million. But as art experts pointed out, they would be practically impossible to sell through normal channels.

The university is the third largest in England located in the northern county seat of Durham—a city founded by Anglo-Saxon monks seeking a place safe from Viking raids to house the relics of St. Cuthbert. The stolen pieces had been selected from a ceramic collection of over 1,000 pieces, roughly half of which had been originally owned by politician, diplomat, and colonial administrator the Right Honorable Malcolm MacDonald. The son of Prime Minister Ramsay MacDonald, Malcolm served as a cabinet minister in the 1930s before diplomatic postings to Canada, Southeast Asia, India, and Africa. During the Cold War he became an informal envoy to Communist China.

In addition to being a prolific collector of Chinese ceramics, dating from the years 2,000 B.C.E. to 1940, MacDonald was also a dedicated ornithologist. He is famous for overseeing and introducing what became known as the MacDonald White Paper in 1939, which argued that since over 400,000 Jews had settled in the British Mandate of Palestine, the terms of the Balfour Declaration—announcing British

support for the establishment of a "national home for the Jewish people" in Palestine—had been met and an independent Jewish state should not be established.

Durham police were initially baffled by the museum theft, which had taken place on the night before Good Friday when the university was quiet. Although it appeared to have been carefully planned, they couldn't explain why the thieves had selected only the two objects, when after gaining entry to the museum they could have taken dozens.

They later learned that after making a successful getaway from the Oriental Museum, two professional burglars from Birmingham—Lee Wildman (35) and Adrian Stanton (32)—stopped to stash the stolen artifacts on waste ground on the outskirts of Durham near Remington Road. Two days later, when Wildman returned to the stash site, he couldn't find them. He was seen by witnesses digging in a wasteland and talking on his mobile phone in an agitated manner.

It turned out that Wildman was talking to his superiors, who weren't happy. For Detective Superintendent Adrian Green, this was the break in the case that uncovered a larger conspiracy. "We refer to that as 'panic day,'" he explained. "And we started to appreciate that there was probably a team above those burglars that was probably pulling the strings."[10]

The question, however, was "Who?" Who made up that "team above those burglars?" Who were the ones "pulling the strings?"

When one of the thieves, Lee Wildman, started to drive back to Birmingham, members of the Durham Constabulary forced his car off the road and placed him under arrest. Eight days later, a police search of the waste land uncovered the stolen artifacts under some hedge trimmings. Using the mobile phone recovered from Wildman's car, Detective Superintendent Green and his team of detectives traced the calls that Wildman had made back to a small town named Rathkeale in southwest Ireland.

This turned out to be a very significant clue.

Then a week after the Durham University's Oriental Museum robbery, thieves used a disc cutter to open a hole in a back wall at the Fitzwilliam Museum at Cambridge University and made off with eighteen ancient Chinese jade artifacts. Again, the raid seemed to have been professionally planned, and the thieves were in and out in a matter of minutes—very much like they had in Durham.

Initial estimates valued the art stolen—mainly jade, dating from the 16th and 17th century Ming and Qing dynasties—at between £5m and £40m, or $7.5m and $50m.

Various experts were consulted by police as part of the inquiry, including officers from the Metropolitan Police's Art and Antiques Unit and specialist art dealers.

One of those contacted was Roger Keverne, a London-based dealer who specialized in Chinese ceramics and works of art. He also worked on an inquiry into the theft of £1.8 million of Chinese art taken from Durham University's Oriental Museum on April 5.

"The point is they're almost worthless to the people who took them because everyone will know what they are and where they came from," Mr. Keverne explained. "Their only real value is in being back on display in the Fitzwilliam Museum where they belong."[11]

He said that very little in the art world was stolen to order, but believed it was possible that the items had been taken to China. "They could have gone there, but it would be very difficult to sell them openly," he speculated. "However, it is a very large country and things could disappear. On the black market, the pieces would be worth only a tiny amount of their real value."[12]

Dick Ellis, who headed the Metropolitan Police's Art and Antiques Unit for ten years, believed that the stolen art could have passed through a series of middlemen. "They then take the risk of being able

to sell the objects on, either using the Internet sale platforms, which are increasingly popular to sell arts and antiques, or using the large fairs which attract dealers from the continent," he said.[13]

The clue to solving both thefts in Durham and Cambridge turned out to be the small Irish village of Rathkeale found on Wildman's phone. Rathkeale is a town of only 1,441 inhabitants. Of those 1,441 at least half are members of Ireland's indigenous ethnic minority, the Travellers—a nomadic ethnic group with roots that are distinct from the settled Irish population. There are only 32,302 Travellers residing in all of Ireland according to the 2016 census. Many of them have lived on the margins of mainstream Irish society for centuries.

Though they're often described as "gypsies" because of their nomadic lifestyle, the Travellers are not related to the Romani. Instead, their origin is Irish and might track back to a group of people made homeless by the conquest of Oliver Cromwell in the 1650s. While they account for 0.7 percent of the country's population, they make up 10 percent of the general prison population. Like the Romani and other groups that live on the margins of society, they have a history of involvement in scams, grifts, crime, and shady business deals.

Crime journalist Eamon Dillon describes the Travellers in his book *Gypsy Empire*, as "willing to do business on any continent, moving quickly from one deal to the next, following the trail of euros, dollars, or pounds sterling."[14]

Detective Superintendent Adrian Green and his team of detectives learned that Lee Wildman and Adrian Stanton—the two thieves they had taken into custody for the Durham University's Oriental Museum heist—were not only Travellers, they were also members of a Traveller criminal gang named the Rathkeale Rovers.

Led by a successful antiques dealer named Sammy Buckshot, whose real name was Simon Quilligan, the Rovers were known for trading in

bogus goods, smuggled cigarettes, classic cars, tarmacking, and most bizarrely of all—rhino horn. (Tarmacking is applying a black tar-based surface to the top of a driveway or road.)

Over the years, the Irish newspaper *Sunday World* has tracked the Rathkeale Rover crimes—smuggling cigarettes from the UK to the Continent, tarmacking in Italy, Germany, France, South Africa, Chile, and Mexico, selling counterfeit electrical generators in Australia, and illegally trading rhino horns.

Detective Superintendent Adrian Green believed that it was the trade in stolen rhino horns that the Rovers engaged in with the powerful Chinese criminal gang the triads that got them involved in robbing and trafficking ancient Chinese artifacts. In both cases, the triads were looking to supply rich clients in China, and the Rathkeale Rovers provided the product.

For a time, the Rathkeale Rovers were so proficient in stealing rhino horns that law enforcement officials in Europe and the United States referred to them as "The Dead Zoo Gang."

According to Li Shih-chen's 1597 medical text *Pen Ts'ao Kang Mu*, ground-up rhino horn has been used in Chinese medicine for more than 2,000 years to treat fever, rheumatism, gout, and other disorders, including hangovers and food poisoning. It's also reputed to be an aphrodisiac.

While the international trade in rhino horns has been banned since 1977, the demand for rhino horn among elites in China, Vietnam, and other countries in Asia has grown. This led to an epidemic of poaching in wildlife sanctuaries and national parks spurred by the fact that a single rhino horn could fetch up to $60,000 or more per kilogram on the black market—more than gold, platinum, diamonds, or cocaine.

At the beginning of the 20th century, there were an estimated 500,000 rhinos remaining in Africa and Asia. By 1970, that number

had dropped to 70,000, and today, around 27,000 rhinos remain in the wild. Very few of them survive outside national parks and reserves due to persistent poaching.

African countries with the largest rhinoceros populations—South Africa, Tanzania, Zimbabwe, and Kenya—deployed lethal anti-poaching units like the Black Mambas, Team Lioness, and Akashinga to fight back. And so, thieves in Europe took to plundering rhino horns from natural history museums in Europe instead.

At 12:27 A.M. on Thursday, July 28, 2011, two men forced their way through a fire escape at the rear of the Ipswich Museum in the county of Suffolk northeast of London and made straight for a stuffed rhinoceros, which had been acquired by the museum in 1907 and was known to locals as Rosie the Rhino. After twisting off Rosie's eighteen-inch rhino horn, the thieves stopped to grab a black rhino skull displayed nearby, before leaving the museum four minutes later and jumping into a waiting car.

At first, museum officials couldn't explain why the thieves had chosen Rosie's horn and left behind the much more valuable gold burial masks of Titos Flavios Demetrios and other priceless artifacts. But investigators quickly linked the robbery to other recent thefts from museums in England, Portugal, Italy, Belgium, Sweden, and France.

In February a stuffed and mounted black rhino head was taken from Sworders Fine Art Auctioneers in Stansted Mounfitchet, Essex. On May 27 another mounted rhino head was stolen from the Educational Museum in Haslemere, Surrey, which boasts one of the largest natural collections in the UK. In June, thieves stole a rhino head from a museum in Liège, Belgium. That same month they made off with a black rhino head from 1827 hanging in the Royal Belgian Institute of Natural Sciences in Brussels.

According to the UK Metropolitan Police, twenty similar thefts took place in museums throughout Europe over the next six months. Patrick Byrne, Europe's head of organized crime units, declared, "We are not dealing with petty criminals." Detective Constable Ian Lawson, from the Metropolitan Police's art and antiques unit, believed that the robberies where all the work of one gang, which used similar methods to steal both rhino horns and ancient Chinese artifacts.[15]

Then in April 2012, Rathkeale Rovers Lee Wildman and Adrian Stanton were arrested in Durham and the gang's criminal scheme started to unravel. Fellow Rovers Jereiah and Michael O'Brien were caught flying almost $700,000 dollars' worth of rhino horns into Shannon, Ireland, from Portugal. Their cousin Richard 'Kerry' O'Brien Jr. was already in police custody in Denver, Colorado, for illegally trading rhino horn. He joined Richard Sheridan and a half-dozen other Rathkeale Rovers who were jailed in the United States for trafficking stolen rhino horns.

Fourteen members of the Rathkeale Rover gang were eventually arrested for the Durham and Cambridge Museum robberies, including Wildman, Stanton, Kerry and Danny "Turkey" O'Brien, cousin Richard Sheridan, and London-based Chi Chong Donald Wong. Wong was the outlier as the others were all Irish Travellers. Authorities believed that he was the one with the links to Hong Kong and the Chinese triads. Wong refused to talk and was sentenced to five years and six months in jail.

The other Rovers were charged with conspiracy to steal Chinese antiques and rhino horn and received prison sentences ranging from fifteen months to six years and eight months (the maximum penalty for the charge is seven years). Their total haul was valued at up to £57m.

In court, Judge Christopher Prince told defendants Wildman and Stanton they had shown "crass ineptitude" in being unable to find the

two items they had stolen from the Oriental Museum at Durham. "Thank heavens you could not, because they may have been lost," he continued. "The financial value of artifacts such as these is perhaps the very least important factor. These items have got a historical, cultural, and artistic value that is quite simply immeasurable."[16]

All of the defendants showed no remorse and tried to play down their roles in the burglary. They gave no indication why they had selected the artifacts they did or who might have commissioned the crime.

Speaking specifically of the Durham break-in Judge Prince said, "Although this burglary was carried out according to a prepared plan, there were elements toward the end of it that reduced the plan to complete farce."[17]

Although the ceramics taken from the Oriental Museum at Durham had been recovered, the eighteen pieces of jade taken from the Fitzwilliam in Cambridge were not. Detective Superintendent Adrian Green, who led the investigation, believes that they probably ended up in China. Green told *The Art Newspaper* that he believed an ornately carved jade Ming brush-washing bowl may have been stolen to order for a specific collector. He also suspected that the Rathkeale Rovers gang were behind the robberies of the KODE Museum in Bergen, Norway.

Even with the more than a dozen Rathkeale Rovers gang members in custody, Green warned museums to remain vigilant and said, they "must keep on top of the game." Even without large security budgets, he said they needed to take prudent measures to reduce the chances of being hit.

Months later, thieves struck again.

# 5

# The Century of Humiliation

"It has always been a mystery to me how people can respect themselves when they humiliate others."
—Mahatma Gandhi

Until recently, the average Chinese person did not seem to care about the over 1.67 million artifacts of their cultural heritage that were held in two hundred-plus museums across forty-seven countries. Instead, they viewed them as relics of feudal oppression and reminders of what their textbooks had called "a century of shame and humiliation."

Over one hundred years of humiliation, 1839–1949. It's a period of history that has informed all aspects of Chinese political and cultural life since. In fact, the injuries inflicted on China are considered so important and their effects so profound that they are charted in an official Chinese Communist Party (CCP) *Dictionary of National Humiliation* that is four centimeters thick. It's read widely and studied in China today.

The trauma and lessons of the Century of Humiliation are ingrained deeply into the Chinese consciousness. For evidence, one need look no

further than the popularity of these recent hit Chinese TV series: *The Great Revival*, *The Conquest*, and *The Rebirth of a King*, as well as the prize-winning Chinese movie, *Hero* (2002) directed by Zhang Yimou. All are based in part on the story of King Goujian. The central theme of these popular movies and TV series is the same: China can only be strong and resist foreign domination through national unity.

The history of King Goujian, who ruled the Kingdom of Yue, or present-day Zhejiang (on the eastern coastal province of China) from 496–465 B.C.E. is largely unknown to most Western scholars.

Professor Paul A. Cohen—currently professor of History emeritus at Harvard University's Fairbank Center for Chinese Studies—has been teaching Chinese History for thirty-five years. Back in 2009, he started to notice an interesting phenomenon. Wherever he looked in Chinese culture and media—in opera, school textbooks, graphic novels, and other forms of popular entertainment—he kept encountering the story of a king who lived more than 2,500 years ago: King Goujian.[1]

Goujian (496–465 B.C.E.) was a descendant of the Miao people of southern China. In the 23rd year of Emperor Jing of the Zhou dynasty, Goujian ascended the throne as the King of the Yue State.

In the first year of Goujian's reign, Helu, the King of the Wu State, invaded the Yue State. Goujian deployed his army in Xieli (today's Jiaxing) to resist the invading army. Goujian's army defeated the Wu invaders and the King of the Wu was hurt by an arrow. On his deathbed, Helu told his son Fuchai, "Never forget Yue."

After ascending the throne, Fuchai trained his army for revenge. In May 492 B.C.E., Goujian was soundly defeated. Barely surviving, Goujian was further humiliated by being forced to eat excrement, and he, his wife, and first minister Fan Li would spend three years as servants to King Fuchai of Wu chopping wood, cleaning toilets, and taking care of horses.

Because they showed no resentment, Goujian, his wife, and first minister were released and granted amnesty. In 490 B.C.E., King Goujian arrived home and resumed his rule, appointing skilled politicians as advisors to help build up the kingdom and working to weaken the State of Wu internally through bribes. He also relinquished all kingly riches, and instead ate food suited for peasants, as well as forced himself to taste bile, in order to remember his humiliations while serving under the State of Wu. The Chinese idiom, *wòxīn-chángdǎn* (sleeping on sticks and tasting gall), refers to Goujian's humiliation and perseverance.

For years, King Goujian did everything possible to unite his people. He enriched his kingdom, lightened punishments for violations of laws, reduced taxes, encouraged people to give birth to more children, and built up his army. He also adopted his prime minister's advice to build a small square city and build a larger square city later as a civic works endeavor to boost wealth and social cohesion. As a result of these endeavors, his subjects became rich and Yue society more stable. The nation under his leadership called to avenge the Wu State.

In 482 B.C.E., King Fuchai of the Wu State met in Huangchi with his counterparts from northern states, leaving his crown prince at home to guard the state. King Goujian seized on this opportunity to make his move. With the help of 40,000 soldiers, including 6,000 bodyguards, he defeated the Wu army, captured the crown prince, seized the capital, and burned the Guxi palace to the ground.

King Fuchai, safe in Huangchi, asked for an armistice. Believing he was not powerful enough to conquer the entire Wu State, Goujian agreed to withdraw. Five years later, he launched another revenging war on Wu. The two states battled three times at a place called Lize, and King Goujian's army defeated Fuchai's every time. But Goujian didn't want to acquire Wu territory.

He waited three more years, when he started another war and besieged the capital of Wu for three years. Fuchai asked for a peace treaty. This time King Goujian refused. Fuchai, realizing he was defeated, committed suicide. Finally in 473 B.C.E., Goujian annexed the state of Wu, and the Yue state ruled over the Wu for the next 240 years.

King Goujian attributed his victory to *wòxīn-chángdǎn* (臥薪嚐膽, "sleeping on sticks and tasting gall")—metaphors for humiliation and perseverance.

Since the ascension of Mao in 1949 at the end of the Chinese Civil War, *wòxīn-chángdǎn* has become a rally cry for the Chinese people. It is meant to remove the stigma of defeat and humiliation from the late Qing period onward. This call to action has been used by republicans, communists, and capitalists alike to convince the Chinese people that in order to avert a constant threat of dismemberment and disgrace, the country has to stay unified at all costs.

It has also become an approach or strategy of how to deal with the United States and the West. And the influence of *wòxīn-chángdǎn* (臥薪嚐膽) on the Chinese cultural consciousness cannot be understated.

Another China expert, Alison A. Kaufman, in her testimony before the US-China Economic and Security Review Commission, reiterated this theme: "Anyone who spends time reading Chinese newspapers or official speeches, or talking at length with PRC (People's Republic of China) nationals will eventually encounter the Century of Humiliation. This tale of loss and redemption, in which modern China was forged out of a crucible of suffering and shame at the hands of foreign powers, has become part of the PRC's founding narrative, in the same way that colonial Americans chafing under British taxation and their subsequent battle for independence is part of ours."[2]

So, what exactly was the Century of Humiliation? What does it have to do with the wave of thefts of Chinese artifacts from museums in Europe that began in 2010? And how does it continue to impact China's policies toward Western powers including the United States?

Most historians mark the beginning of the Century of Humiliation with the British invasion of China in 1839 at the start of the First Opium War. Before that China had never been invaded or seriously challenged by any outside power.

For centuries the Ming and Qing emperors reigned over what was known as the Middle Kingdom, which consisted of all of East Asia. And the Chinese people lived in relative peace. They and their rulers had limited contact with any civilization outside of Asia. In their few contacts with Westerners, Chinese rulers made it clear that they expected Westerners to treat them with the same respect and deference they had received from peoples on their periphery.

According to a report by the Council on Foreign Relations:

> For more than two millennia, monarchs who ruled China proper saw their country as one of the dominant actors in the world. The concept of zhongguo—the Middle Kingdom, as China calls itself—is not simply geographic. It implies that China is the cultural, political, and economic center of the world. This Sino-centrist worldview has in many ways shaped China's outlook on global governance—the rules, norms, and institutions that regulate international cooperation. The decline and collapse of imperial China in the 1800s and early 1900s, however, diminished Chinese influence on the global stage for more than a century.[3]

For over two thousand years, beginning with the Qin dynasty (221–206 B.C.E.), the monarchs who ruled China invoked a "Mandate of Heaven" to legitimize their own rule and rhetorically assert their own centrality to global order, even though they never built a global empire themselves.

The Mandate of Heaven was an ancient Chinese philosophical concept that originated during the Zhou dynasty (1046–256 B.C.E.)—the time of Goujian, King of Yue. The Mandate—*tianming*—determined whether an emperor of China was sufficiently virtuous to rule. Unlike the European "divine right of kings," there was a degree of responsibility involved for the ruler. If he did not fulfill his obligations as emperor, then he lost the Mandate and thus, the right to be emperor.

The Mandate consisted of four principles:

> Heaven grants the emperor the right to rule,
> Since there is only one Heaven, there can only be one emperor at any given time,
> The emperor's virtue determines his right to rule, and,
> No one dynasty has a permanent right to rule.

If the emperor and his government failed to govern responsibly, mistreated the people or abused their power, their authority to rule could be withdrawn. Some signs that Heaven had withdrawn its royal mandate included natural disasters such as floods, droughts, famines, or pandemics.

Interestingly, peasant rebellions were also construed as evidence that the emperor had lost the support of Heaven, as explained by Chinese scholar Pro-Ching Yip:

> As a matter of historical fact, all peasant uprisings and changes of dynasty were staged and carried out in the

name of the will of heaven. It transpires that tianming means 'destiny, i.e., orders or instructions from heaven' and geming 'revolution' [both imply] the transferring of orders or instructions from heaven, taking the mandate from one ruler to give it to another. The ancient Chinese believed that intervention from heaven in terms of the heavenly mandate might take various forms. If heaven was angry, there could be floods, droughts and other natural disasters which would immediately affect the livelihood of an agricultural society. A supernatural being was believed to be behind all these doings and undoings.

The Chinese emperors and their ministers and advisors never imagined anything as powerful, predatory, and contemptuous as the British East India Company, backed by the British military, Parliament, and Crown. And they were unprepared.

How could they have been? With very minimal contact with the West, the Chinese mandarins, their advisors and scholars, and lastly their Chinese subjects, had no understanding of the rapacious spirit and quest for knowledge, territory, and power that was growing in Europe. Born of advances in technology—particularly in mapmaking, ship design, and weapons—Westerners yearned for wealth in the form of gold and silver, and power in the form of territory and control.

Explorer Sir Samuel Baker explained the source of British aggression in 1855: "There is in the hearts of all [Englishmen] a germ of freedom which longs to break through the barriers that confine us to our own shores. . . . This innate spirit of action is the wellspring of the power of England."[4]

The British came to the East "with a magic sense of superiority," wrote author Ronald Hyam in his book *Britain's Imperial Century*,

"by projecting the idea of their own unquestionable omniscience and effortless superiority."

"For young men, life in Victorian England might seem intolerably dull," Hyam continued. "To go overseas offered a chance to make money, to see something of the world, to engage in some exotic sexual activity, or hunting, shooting, fishing, meanwhile."[5]

In the resulting clash of cultures, Western powers like the UK and France regarded trade between countries as a natural human function and assumed the right to trade with whoever they pleased. Chinese influencers did not share that view. They were perhaps too insular and pleased with themselves. From their perspective, the West had very little to offer to make their lives better.

Additionally, the mandarins who ruled China regarded commerce as an activity undertaken by people of a low and unrefined nature. And they could cite many examples of such behavior by merchants—be they Chinese or Westerners—to support their opinion.

The Chinese view of the individual's role in society was fundamentally different from that of Europeans and was highly influenced by the teachings of the philosopher Confucius. Also, his ideas reinforced the concept of the Mandate of Heaven.

Confucius wrote, "To put the world in right order, we first must put the nation in order. To put the nation in order, we first must put the family in order. To put the family in order, we first must cultivate our personal life. We must first set our hearts right."

Confucius was a teacher, historian, and philosopher whose ideas became intrinsically entwined with the national identity of China. Born 551 B.C.E. near Qufu in eastern China, into a family that might have been aristocratic, he studied music, mathematics, the classics, and history.

He believed that education and reflection led to virtue, and that those who aspired to command others must cultivate discipline and

moral authority in themselves. And espoused learning "for the sake of the self."

Confucius stressed the importance of social rituals (*li*), and humaneness (*ren*)—sometimes translated as love or kindness. *Ren* to his mind was not any one virtue, but the source of all virtues and key to developing a good moral character, which could then affect the world around that person by achieving "cosmic harmony." He believed that people are essentially good yet may have strayed from the appropriate forms of conduct.

The role of education, Confucius said, was to help foster the growth of virtuous character and put people on the right path.

In *Analects*, 2:4, he wrote, "At fifteen, I set my heart on learning. At thirty, I was firmly established. At forty, I had no more doubts. At fifty, I knew the will of heaven. At sixty, I was ready to listen to it. At seventy, I could follow my heart's desire without transgressing what was right."

Confucius was largely unknown in his own time. When he died in 479 B.C.E., he left behind a following of around three thousand students, who devoted themselves to preparing and propagating their master's precepts. His students were so successful that by the second century B.C.E. Confucius's teachings were enthusiastically adopted as Chinese state ideology by the Han dynasty. His *Analects* would go on to guide governments and individuals for millennia, informing and influencing Chinese history and civilization.

Interestingly, Confucius and Lao Tzu—the two masters of Chinese philosophy—were contemporaries. Classic Chinese historian Sima Qian (c. 145–86 B.C.E.) recorded their one encounter, in his biographical sketch of Lao Tzu. It took place when Confucius was fifty-one and about twenty years older. Confucius had still had not "heard the Tao," Sima Qian wrote. He traveled south to Pei and called on Lao Tzu and asked him about the virtues of benevolence and righteousness.

According to Sima Qian, this was Lao Tzu's answer:

> You speak of men who have long decayed together with their bones. Nothing but their words has survived. When a Gentleman is in tune with the times, he rides a carriage; when he is out of tune, he makes his way disheveled as he is. I have heard that just as the best merchant keeps his stores hidden so that he appears to possess nothing, so the True Gentleman conceals his abundant Inner Power beneath an appearance of foolishness. Rid yourself of Pride and Desire, put aside your fancy manner and your lustful ways. They will bring you nothing but harm. That is all I have to say.[6]

Sima Qian continues:

> After he had taken his leave of Lao Tzu, Confucius said to his disciples: "Birds fly; fishes swim; animals run. These things I know. Whatsoever runs can be trapped; whatsoever swims can be caught in a net; whatsoever flies can be brought down with an arrow. But a Dragon riding the clouds into the Heavens—that is quite beyond my comprehension! Today I have seen Lao Tzu. He is like a Dragon!
>
> Lao Tzu cultivated the Tao and the Inner Power. He advocated the hermit's life, a life lived in obscurity. He lived in Zhou for a long time, but when he saw that the Zhou dynasty was in a state of decline, he departed. When he reached the Pass, the Keeper of the Pass Yin Xi said to him: "You sir are about to retire into seclusion, I beseech you to write a book for me!" So Lao Tzu wrote a book in

> two parts, treating of the Tao and the Power, in a little over five thousand words. And then he went on his way . . . No one was able to tell who he really was, no one knew where he went to in the end . . . He was a recluse.[7]

According to legend, Lao Tzu, after his encounter with Confucius, composed the *Tao Te Ching* in a single session before retiring into the western wilderness. The result was a book consisting of over five thousand Chinese characters, divided into two parts. In some sects of Taoism, Chinese Buddhism, Confucianism, and Chinese folk religion, Lao Tzu then became an immortal hermit.

The *Tao Te Ching* describes the Tao (or Dao, which roughly translated means *Virtue*) as the source and ideal of all existence: it is unseen, but not transcendent, immensely powerful yet supremely humble. The Tao is the root of all things. People have desires and free will, and thus are able to alter their own nature. Many act "unnaturally," upsetting the natural balance of the Tao. The intent of *Tao Te Ching* is to lead those who study it to a return to their natural state, in harmony with Tao. In Taoism, language and conventional wisdom are critically assessed as inherently biased and artificial.

Here's one passage:

> Nothing in the world is softer or weaker than water, and yet for attacking things that are firm and hard, nothing is so effectual. Everyone knows that the soft overcomes the hard, and gentleness conquers the strong, but few can carry it out in practice.[8]

Both Confucius and Lao Tzu were spiritual truth seekers and contemporaries. Much like Socrates in the West, Confucius was concerned

with the goal of developing good citizens. While Lao Tzu's *Tao Te Ching* addresses inner, spiritual cultivation.

Both men have had a profound effect on China. And both Confucianism and Taoism have become pillars of Chinese culture and religion, although in different ways. Confucianism, with its rites, rituals, ceremonies, and prescribed hierarchies, became the outline or physical construction of Chinese society. On the other hand, Taoism emphasized the spirituality, harmony, and duality present in nature and existence, especially as it grew to encompass more religious aspects during the Imperial Era.

British and French traders of the seventeenth and eighteenth centuries, who were in search of power and wealth, had little interest in the rich and ancient Chinese culture or the virtue of Confucian thought or Taoist belief. What they found instead, in the words of James Bruce, the Eighth Earl of Elgin—British high commissioner in China and the man who ordered the sacking of the Old Summer Palace—was "a dense population, timorous and pauperized." He confessed, "There is certainly not much to regret in the old civilization which we are thus scattering to the winds."[9]

The Chinese people were so different in their culture and behavior that the Europeans found it hard to treat them as human beings. James Bruce openly admits this in his *Journals*:

> It is a terrible business, however, this living among inferior races. I have seldom from man or woman since I came to the East heard a sentence which was reconcilable with the hypothesis that Christianity had ever come into the world. Detestation, contempt, ferocity, vengeance, whether Chinamen or Indians be the object. There are some three or four hundred servants in this house. When one first passes

by their *salaaming* one feels a little awkward. But the feeling soon wears off, and one moves among them with perfect indifference, treating them, not as dogs, because in that case one would whistle to them and pat them, but as machines with which one can have no communion or sympathy.[10]

Reducing the Chinese to a "timorous and pauperized" people with strange beliefs and customs and a history and culture they didn't understand or have any interest in, the humiliation of China began. It started in earnest in 1839 when British warships arrived on the south China coast and fought their way through a blockade on the Pearl River (Zhu Jiang). With the Chinese military concentrated on coastal defense, once the British had pierced the hardened perimeter, the heart of China was vulnerable.

Imagine for a minute the leader of a country banning the importation of a highly addictive drug like opium because of the devastating effects it was having on his country's population, with a foreign commercial interest backed by that government's army and navy, waging a war and forcing that country to not only allow in more of the destructive narcotic, but also to make it easier for the foreigners to do so.

That's essentially what happened in the aftermath of the lopsided First Opium War, during which sixty-nine British soldiers and sailors lost their lives, compared to approximately 18,000 Chinese soldiers. According to the terms of the Treaty of Nanking, the Daoguang Emperor of China was forced to open up five more trading posts to the British and cede the coastal island of Hong Kong for a period of ninety-nine years.

It's as if today we allowed the Mexican Sinaloa Cartel to open legal distribution centers for cocaine and methamphetamine in Dallas, Houston, and San Diego.

Known to the Chinese as "the first unequal treaty," the Treaty of Nanking also granted British citizens extraterritorial rights to live in the cities of Amoy, Guangzhou, Fuzhou, Ningbo, and Shanghai "without molestation or restraint" and install British consular officers at each port to negotiate directly with local officials. Additionally, the treaty required the Qing government to release all British prisoners of war to pay war reparations totaling 21 million silver dollars over the following three years.

Having effectively opened China to their commercial agents, the British feared that other nations would form more advantageous agreements with China and usurp Britain's position. In the 1843 Supplement Treaty of Bogue they added the following stipulation: "Should the Emperor be pleased to grant additional privileges or immunities to other foreign countries, the same would automatically be extended to and enjoyed by British subjects."

Known as the "most favored nation principle," this simple device shaped all trade treaties with China—that eventually included more than twenty countries, including the Free State of Congo and Peru—for the next hundred years.

Given their treatment, it's no surprise that many Chinese felt ambivalent about foreigners living permanently in their country.[11] They saw it as a sign of political and military weakness.

The forced opening of Chinese ports to Western trade resulted in more opium imported into China, creating more addiction and increased revenue for British merchants. When Chinese officials dragged their feet in implementing certain provisions of the Treaty of Nanking because of popular displeasure, Great Britain and France sent their warships to China one more time and again quashed and humiliated the Chinese army and navy. A second treaty, the Treaty of Tientsin, was signed in 1858 opening more Chinese ports to Western

trade, allowing Christian missionary activity in China and legalizing the import of opium.

The following illustration drawn by Honoré Daumier depicts a French soldier shoving opium down the throat of a powerless Chinese. It ran in newspapers and magazines throughout Europe in 1859, months before the looting of the Old Summer Palace, and is meant to satirize European treatment of the Chinese.

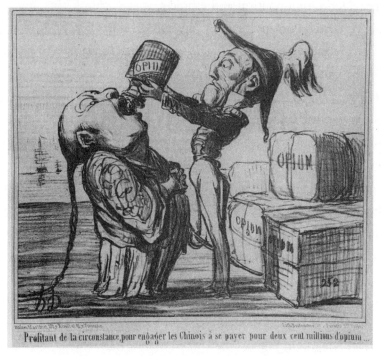

Honoré Daumier illustration, 1859

Clearly, some Europeans were disturbed by the rapaciousness of their countries' commercial interests in China. But they weren't strong enough politically to stop them.

China was still the greatest country on the planet in terms of area (9.6 million square kilometers) and population (460 million in 1860).

But the trade treaties they had been forced to sign, with their territorial losses, indemnities, and erosion of sovereignty served as a blow to their prestige. They might have still boasted a third of the world's population, but China's army and navy were no match for the better equipped, led, and trained militaries of Great Britain and France.

The Qing dynasty and the Middle Kingdom—once the supreme power of East Asia—now appeared to be a nothing more than a paper tiger. Opposition political and ethnic groups within China, and the country's neighbors, particularly Japan, took note.

At the same time, the Western powers of Great Britain, France, Russia, and the United States quickly extended their influence and institutionalized their control. Small towns along the south coast of China that had previously been closed to Western trade—like Hong Kong and Shanghai—soon became thriving international ports and commercial centers under British control. Foreign-born traders, entrepreneurs, and business owners known as *tai-pan* lived a very comfortable life in a self-governing strip of prime waterfront real estate with their own shops, restaurants, recreational facilities, parks, churches, police, and local government. For the most part, these enclaves remained off-limits to natives.

Typical of them was the Bund in Shanghai along the Huangpu River, which housed numerous banks and trading houses from the United Kingdom, France, the United States, Italy, Russia, Germany, Japan, the Netherlands, and Belgium, as well as the consulates of Russia and Britain. The Shanghai Club—the principal men's club for British residents of Shanghai—was famous not only for its size and opulence but also for its 111-foot Long Bar. There, they celebrated their wealth and power. Playwright Noël Coward once remarked that the mahogany bar at the Shanghai Club was so long that when he laid his cheek on it, he could see the curvature of the earth.

Membership was restricted to male whites of a certain class. Everything was subject to military or masonic order. Even one's position at the Long Bar was subject to strict hierarchy—the prime Bund-facing end was reserved for *tai-pan* and bank managers and the social scale descended as one moved down the length of the bar.

To British writer George Orwell, who as a young man served as an imperial police officer in neighboring Burma, the club was "the spiritual citadel, the real seat of British power," and its chief purpose was to keep Britons from going native. That explained the clubs' resistance to the admission of non-Europeans.[12]

"To keep up our prestige," Orwell remarked with a degree of sarcasm, "we white men must stick together."[13]

Later in his highly impactful career, Orwell wrote a controversial essay called "*Shooting an Elephant*," first published in the literary magazine *New Writing* in 1936.

The essay describes the experience of the English narrator—Orwell himself—who is called upon to shoot an aggressive elephant while working as a police officer in Burma, which was then a British colony. Because the locals expect him to do the job, he does so against his better judgment. But his anguish is increased by the elephant's slow and painful death. The story is regarded as a metaphor for colonialism as a whole.

In the essay, he wrote:

> I perceived in this moment that when the white man turns tyrant it is his own freedom that he destroys. He becomes a sort of hollow, posing dummy, the conventionalized figure of a sahib. For it is the condition of his rule that he shall spend his life in trying to impress the "natives," and so in every crisis he has got to do what the "natives" expect of

him. He wears a mask, and his face grows to fit it. I had got to shoot the elephant. I had committed myself to doing it when I sent for the rifle. A sahib has got to act like a sahib; he has got to appear resolute, to know his own mind and do definite things. To come all that way, rifle in hand, with two thousand people marching at my heels, and then to trail feebly away, having done nothing—no, that was impossible. The crowd would laugh at me. And my whole life, every white man's life in the East, was one long struggle not to be laughed at.[14]

Perhaps nothing better describes the necessity of the Bund or the British club.

Deciding not to broaden their dominion of China past the coastal enclaves, from which they could enrich themselves from trade, primarily in opium, the British were heavily dependent on their own imported inventions to keep up morale. "The club, the Anglican churches, railway reception rooms, mock-Tudor taverns, masonic lodges, the golf course, the racecourse," observed Ronald Hyam, "they all played their part." And "snobbery, pretentiousness and self-conscious social graduation and class distinctions" flourished everywhere.

Facing the Huangpu River opposite the public gardens on the Bund esplanade sat the grand Shanghai Masonic Hall. "It was such an influential society that the site was specially approved by the British Consulate," said Tongji University professor Qian Zonghao.[15]

If the British club was, in the words of George Orwell, the "real seat of British power," the Masonic Hall was its dark hidden center, where the ideals of power, money, and control were enshrined and promoted. And its members pledged loyalty to one another over any other authority, including the British government, Anglican Church,

or the Crown. In the words of the Eleventh Earl of Elgin (the grandson of James Bruce), freemasonry was "perhaps the most profound feature, socially of the 19th century era," wherever the British went to fight and trade.[16]

Also located in the Bund were the offices of the Chinese Maritime Customs Service (CMCS). Its role was to collect duties on goods arriving in or leaving China. Aside from some junk trade to neighboring countries, all imports and exports were handled by foreigners. As trade grew, the demands on the CMCS increased. Under the leadership of Sir Robert Hart, the CMCS took on responsibility for lighthouses, river maintenance, and postal services. In 1907, the IMC employed approximately 1,400 foreign staff—including Europeans, Americans, and Japanese—and over 12,000 Chinese workers. In most treaty ports like Shanghai the customs staff formed the largest group within the foreign population and ranked socially with the consular and diplomatic service.

In 1900, journalist H. C. Whittlesey visited the Bund and observed the following about the lives of the European members of the CMCS: "They live in the foreign concession, and the tendency is to keep largely by themselves, and to maintain in China the same family customs that they had observed at home. The social side of life is particularly prominent with frequent dinner parties, picnic and luncheon and other social functions."[17]

"At four o'clock business closes for the day, and it is a part of the established order to turn to some form of diversion or healthful exercise. The ladies serve tea and toast, and make duty visits between the hours of four and seven, while the men, disregarding the heat of the climate, practice their favorite athletic sports of riding, boating, cricket, football, and tennis."[18]

Under Sir Robert Hart's administration customs revenue rose from $6,000,000 in 1860 to over $20,000,000 in 1899. According to

Whittlesey, Sir Robert was "the most important man in China" and the CMCS "China's financial mainstay," allowing the Qing government to meet its financial obligations to foreign traders and European governments promptly and in full.

In addition to its role of collecting money, the CMCS, whose management according to Whittlesey was "entirely in the hands of foreigners," compiled and printed statistics regarding China's trade in tea, silk, and opium, which were the "yellow books of China and provide(d) an accurate account of the country's resources."[19]

Sir Robert Hart and the British-run CMCS were, in effect, the financial managers of all Chinese trade revenue. His appreciation of Chinese culture and his ability to see things from the Chinese perspective—which was unusual among the British living in China—meant that he became a trusted and influential figure, valued by the Empress Dowager Cixi, Chinese government, and foreign ministers alike, who often sought his advice. Hart encouraged China to open embassies abroad, cofounded a foreign language school that became part of the University of Beijing, and established the Chinese postal service.

His effectiveness was aided, in part, by his ability to speak Chinese. As one reporter pointed out, "having a Chinese concubine probably helped."

Opium addiction grew and trade boomed. In 1865, one British trading house alone shipped opium worth £300,000. In 1918, the British-led Hong Kong government made a record $8.5 million from the sales and trade of opium in Hong Kong alone.

Deeply involved in the drug trade with offices in Shanghai and Hong Kong was the aforementioned Jardine Matheson—founded by Scotsmen William Jardine and James Matheson—which, by the end of the 19th century, has transformed itself in one of the world's first

international corporations. Today, Jardine Matheson is still the largest private employer in Hong Kong and a worldwide company with holdings in automobiles, insurance, real estate, hotels, and hygiene products. As of 2021 Jardine Matheson—which is currently controlled by the Keswick family, who are descendants of cofounder William Jardine's older sister, Jean Johnstone—boasts assets totaling $92 billion and employs over 400,000 people and has branches and subsidiaries all over the world.

In order to handle the tremendous amount of money generated from opium sales by companies like Jardine Matheson, a fellow Scotsman named Thomas Sutherland, who was employed by the Peninsular and Oriental Steam Navigation Company in Hong Kong, saw the need to start a local bank. In March 1865 he established the first one in Hong Kong and opened another one a month later in Shanghai, naming his enterprise the Hong Kong Shanghai Banking Corporation (HSBC).

Members of the banking cooperative included American, German, Scandinavian, and Parsee Indian merchant houses, as well as representatives from the Bombay-based David Sassoon & Company, Hong Kong-based Dent & Company, American firm Russell & Company, and Jardine Matheson. With the founding of the HSBC, a whole system of legalized drug dealing and money laundering was put into place. In effect, drug trafficking was given a corporate veneer of respectability that remains today.

Working for Russell & Company at the time was the grandfather of future US president Franklin Delano Roosevelt, Warren Delano Jr. Much like William Jardine and James Matheson did, Warren Delano Jr. and his friend John Perkins Cushing established an offshore base in the 1850s—an anchored floating warehouse—where Russell & Company ships would offload their opium contraband before continuing up the Pearl River to Canton.

"Almost without exception," wrote historian Jacques M. Downs, "Americans involved in opium during the last quarter century of the old China trade went home with fortunes after only a few years in the trade."[20]

The opportunity wasn't open to anyone. "To succeed in Guangzhou, a young American needed an education, as well as family connections to secure for him not just a clerkship in a good firm but also access to capital, which usually came... from relatives," wrote Amitav Ghosh in *The Nation*.[21]

The names of the young Americans involved in the Chinese opium trade reads like a list of the Northeastern upper crust: Astor, Cabot, Peabody, Brown, Archer, Hathaway, Webster, Delano, Coolidge, Forbes, Russell, Perkins, Bryant, and so on. Many of them had been educated at elite schools like the Boston Latin School, Milton Academy, Phillips Academy Andover, and Phillips Exeter Academy, and many went to universities like Harvard, Yale, the University of Pennsylvania, and Brown.

Jacques M. Downs noted that the American opium traders made up an East Coast commercial aristocracy, with members "linked by ties of blood, marriage, religion, business, friendship, and politics." "[T]o go to a spot as remote as Canton took some planning, some connections," and the firms there, "being generally less central to the family interest, were staffed by cousins, nephews, former apprentices, and friends."[22]

As the opium trade boomed, HSBC grew. Its red and white house flag, which later became the bank's logo, was based on the Scottish flag, which is the angular cross that Saint Andrew—the patron saint of Scotland—was crucified upon.

"The three most important people in Hong Kong," according to historian David Kynaston, "were the British governor as appointed by the British government, the head of the Jockey Club for the horse racing, and the third was the chairman of HSBC."[23]

Author Thomas Manuel of *Opium Inc.* called the British opium trade "a story of immense pain for many and huge privileges for a few." Thanks to corporations like HSBC, Hong Kong became an imperial narco-state.[24]

Today, HSBC is the largest corporation in the world in terms of assets (as of 6/30/23, $1.74 trillion, while Citigroup reported $1.63 trillion). Nearly 22 percent of its earnings are from operations in Hong Kong, where it was headquartered until 1991. If HSBC were a country, it would be the fifth largest world economic power.

Despite its size and veneer of corporate respectability, HSBC hasn't forgotten its roots in the opium trade. Over the years it has created a unique network to move dirty money around the world. From tax evasion to money laundering for the mafia and manipulation of currency, "this bank had done everything bad that a bank can possibly do," said John Christensen of the Tax Justice Network. As recently as 2012, HSBC nearly lost its license to operate in the US because it was caught laundering money of Mexican and Colombian drug cartels. One billion euros of cocaine money passed through its Mexico City subsidiary before being recycled into the US economy.

Richard Elias, former deputy federal prosecutor, explained, "Affiliates of drug cartels were walking into branches with hundreds of thousands, sometimes millions of dollars in Mexico and literally putting it through the teller window, sometimes in boxes that we specially designed to fit through the teller window. And HSBC employees took it, deposited it, gave the person a receipt and never reported and never stopped it. It happened systematically over the course of a decade. Once a person walked in with three million in cash and HSBC bank employees spent over a day counting it."[25]

While British, French, Russian, and US traders were enriching themselves at China's expense, the Chinese people and their government

were being met with more and more humiliation. Following China's defeat in the Second Opium War, it entered a period of internal unrest and political turmoil. It also faced a series of other defeats at the hands of foreign powers. The first of these came in 1894 with the first Sino-Japanese War, which marked the emergence of modernized Japan as a world power and the decline of China's dominance in East Asia.

For centuries China had enjoyed a measure of control over neighboring tributary states to include Joseon Korea, Vietnam, and Japan. Then in 1853, US Commodore Matthew Perry steamed into Edo Bay (Tokyo Bay) and demanded that the Tokugawa shoguns—a military government that had ruled Japan since 1608, allow foreign powers access to trade. Japan's political elites, realizing that the United States and other countries were ahead in terms of military technology, felt the looming threat of Western imperialism. Seeing how the Qing dynasty in China had been brought to its knees by the British fourteen years earlier, members of Japan's elites sought to modernize the country under the control of a strong central leader.

The resulting Satsuma Rebellion of 1877 ended the era of samurai, and replaced it with a government with more contemporary Western values and modernized military. Meanwhile, China, though weakened, still considered itself the preeminent power in the region with dominion over the peninsula of Korea.

Sensing an opportunity to expand Japan's sphere of influence, Japan's Emperor Meiji declared war in China in 1894. The resulting First Sino-Japanese War was primarily fought at sea—pitting the much larger but antiquated Chinese navy against the smaller, but more modern Japanese navy. Japan prevailed in one battle after another. In 1895, with Japanese forces approaching Beijing, the Qing government sued for peace.

The result was the Treaty of Shimonoseki, signed by Qing China and Meiji Japan on April 17, 1895. In it, China agreed to relinquish

all claims of influence over Korea, which became a Japanese protectorate, and granted Japan control of Taiwan, the Penghu Islands, and the Liaodong Peninsula. It also opened additional ports in China to Japanese trading vessels, and paid war reparations of 200 million taels of silver.

This was another humiliating blow to the Qing rulers, as they themselves were conquering Manchus from the North who had ruled China for more than a century. The devastating Opium Wars, defeat by Japan, out of control inflation, floods, famine, and other calamities that befell China at the end of the 19th century, convinced the Chinese (who were majority Han) people that the alien ruling Manchu Qing dynasty had lost the Mandate of Heaven and needed to be overthrown.

The Mandate of Heaven—which was a core concept of Confucian political philosophy was explained by writer Mencius 孟子 in the 3rd century B.C.E.:

> The people are of supreme importance; the altars of soil and grain come next; last comes the ruler. That is why he who gains the confidence of the multitudinous people will be Emperor . . . When a local lord endangers the altars of soil and grain, he should be replaced. When the sacrificial animals are sleek, the offerings are clean and the sacrifices are observed at due times, and yet floods and droughts come [by the agency of heaven], then the altars should be replaced.[26]

Unlike the European "Divine right of kings," the Mandate of Heaven did not confer an unconditional right to rule. Instead, a ruler's performance had to be just and effective, and the people retained a right to rebel.

All of this shame, humility, suffering, and frustration formed a fertile breeding ground for revolt. In November 1897 a gang of armed men burst into a Catholic mission in the county of Juye in the poor coastal province of Shandong and murdered two German priests. In response, the German government sent two gunboats to the Shandong coast and bullied the Qing government into approving a German sphere of influence in the province. As more German missionaries arrived in Shandong, a secret society called the Fists of Righteous Harmony (Yihetuan) organized a revolt among the local peasants, whose aim was to "drive out the foreign devils." Their members practiced a form of kung fu resembling Western boxing (which is why they were called "Boxers"). Some attempted to perfect a mystical skill called "iron shirt," which involved toughening and tensing the body to withstand blows and, even, make them impervious to bullets.

Initially the leaders of the Qing dynasty tried to put down the Boxers. But hoping the Boxers might drive foreigners from China, the Empress Dowager Cixi gave them her cautious support, declaring in 1900:

> For the past thirty years [the foreigners] have taken advantage of our country's benevolence and generosity, as well as our whole-hearted conciliation to give free rein to their unscrupulous ambitions. They have oppressed our state, encroached upon our territory, trampled upon our people and exacted our wealth. Every concession made by the Court has caused them, day by day, to rely more upon violence until they shrink from nothing. In small matters they oppress peaceful people; in large matters, they insult what is divine and holy. All the people of our country are so full of anger and grievances that every one of us desires to take vengeance.[27]

Imperial edicts in January and April 1900 legalized the formation of civilian militias, providing a green light to Boxer recruiting. The Qing also filtered money to Boxer leaders to help support training and purchase better arms and equipment. The Boxers reciprocated by adopting the catchphrase "Revive the Qing! Destroy the foreigner!"

By the spring of 1900, thousands of Boxer rebels armed with sticks and swords were marching across northeastern China and approaching Beijing. A mood of panic swept through the diplomats and officials from nine countries gathered in a fortified compound in the capital and protected by a garrison of 400 troops. After German ambassador Clemens von Ketteler flogged a man who appeared to be a Boxer, he was stopped on the street and shot dead at point blank range.

"Situation becoming serious," US ambassador Edwin H. Conger cabled Washington. "The whole country is swarming with hungry, discontented, hopeless idlers."[28] British minister to China Claude Maxwell MacDonald requested that foreign soldiers be dispatched to Beijing immediately to defend the legations.

Gunboats rushed to China, while foreigners huddled within the compound, armed only with rifles and one single cannon. They remained under siege for almost two months (a situation later depicted in the movie *55 Days at Peking* starring Charlton Heston, Ava Gardner, and David Niven). Just as their supplies were running out, the foreigners were rescued by 20,000 troops from the so-called Eight Nation Alliance (Britain, France, Germany, Austria-Hungary, Italy, Russia, Japan, and the United States). They entered Beijing on August 14, 1900, relieved the legations, and drove the Boxers from the city.

Then in a scene reminiscent of the Second Opium War, the Forbidden City was raided at least twice and stripped of priceless artifacts. Among the looted items were gowns belonging to Dowager Empress Cixi and also ceramics and paintings from her personal collection.

Captured Boxers were beaten, raped, and executed in public. The worst offenders seemed to be German soldiers, who were spurred on by a July 1900 speech given by their monarch, Kaiser Wilhelm II:

> Should you encounter the enemy, he will be defeated. No quarter shall be given. Prisoners will not be taken. Whoever falls into your hands is forfeited. Just as a thousand years ago the Huns made a name for themselves under Attila . . . may the name German be stamped by you in such a way that no Chinese will ever again dare to look cross-eyed at a German.[29]

The sixty-five-year-old Dowager Empress Cixi was forced to don a disguise and flee the Forbidden City in another act of humiliation.

In the movie *55 Days at Peking*, the character of the Empress Dowager declares to the senior officer at the British Embassy (played by David Niven), "The Boxer bandits will be dealt with, but the anger of the Chinese people cannot be quieted so easily. . . . Foreign warships occupy our harbors, foreign armies occupy our forts, foreign merchants administer our banks, foreign gods disturb the spirit of our ancestors. Is it surprising that our people are aroused?"

# 6

# Château de Fontainebleau

"Revenge is an act of passion; vengeance of injustice. Injuries are revenged; crimes are avenged."
—Samuel Johnson

More than a century after the Boxer Rebellion in China, the museum break-ins in Europe didn't end with the arrests of the Rathkeale Rovers, those Irish social outcasts who had most likely never set foot in a Bund or a proper British club.

Instead, the suspicious pattern of robberies was only getting started. A third target was the Chinese Museum in the world-famous Château de Fontainebleau 50 kilometers (c. 31 miles) southwest of Paris.

This was the second time in three years that thieves broke into a royal European residence. As dramatic as the 2012 break-in at the Drottningholm Palace had been, the robbery at Château de Fontainebleau was even more audacious. After all, the Château de Fontainebleau was one of the most famous monuments in France and a popular site for tourists worldwide. The château had been the residence of French monarchs from Louis VII, who lived there in 1137,

to Napoleon III. Napoleon Bonaparte called it a "true home of kings, house of centuries."

Like the Drottningholm Palace in Sweden, the Château de Fontainebleau is a UNESCO World Heritage Site celebrated for its rich architectural framework as well as its exceptional collections of paintings, sculptures, and art objects, ranging from the 6th to the 19th century.

Surrounded by a vast park and adjacent to the lush forest of Fontainebleau, the palace displays elements of medieval, Renaissance, and classical styles due to the many additions commissioned over the years by monarchs and their wives. Both in its architecture and interior decorations it represents the meeting of Italian art and the French tradition.

In 1520 Francis I, king of France and patron of Leonardo da Vinci, commissioned architect Gilles Le Breton to build a new palace on the site of the original medieval castle in the Renaissance style. In his will, he expressed his desire to "create in Fontainebleau a new Rome" in which Italian artists could express their talent and influence French art.

At Fontainebleau he created a brilliant and scholarly court where poets, musicians, and learned men mingled with rough noblemen and beautiful ladies. Typical of Francis's chivalrous gallantry was his comment, "A court without women is a year without spring and a spring without roses."

His love of artists and their creative output gave birth to the École de Fontainebleau, which refers to two periods during the late French Renaissance of artistic production centered on the royal palace. They were crucial in forming Northern Mannerism, and represent the first major production of Italian Mannerist art in France.

Mannerism encompassed a variety of approaches influenced by, and reacting to, the harmonious ideals associated with artists such as

Leonardo da Vinci, Raphael, Vasari, and early Michelangelo. While High Renaissance art emphasized proportion, balance, and ideal beauty, Mannerism exaggerated such qualities, often resulting in compositions that were asymmetrical or unnaturally elegant. Examples include Michelangelo's murals on the ceiling of the Sistine Chapel and the paintings of Caravaggio and El Greco.

The Sun King, King Louis XIV (1638–1715), though forever associated with the Palace of Versailles, actually spent more time at Fontainebleau than any other monarch. He liked to hunt there every year at the end of summer and the beginning of autumn. He made few changes to the exterior of the château, but did build a new apartment for his companion and second wife Madame de Maintenon. He also liked to entertain foreign guests at the château, including Queen Christina of Sweden. On November 10, 1657, shortly after she had abdicated the crown, she was a guest in the château. Suspecting that her Master of the Horse and reputed lover Marchese Gian Rinaldo Monaldeschi had betrayed her, she ordered her servants to chase him through the halls of the château and stab him to death.

During the French Revolution that began in 1789, the château itself was spared significant damage because of its distance from the turbulence in Paris. But gangs of looters did strip out windows, mirrors, and lead roofing, and emptied the château of its furniture. All that remained inside the château were two consoles in the Council Chamber, as well as the canopy crown and the headboard of the queen's bed.

Fontainebleau was largely abandoned until First Consul Napoleon Bonaparte chose it as the site of the distinguished military school—École Spéciale Militaire—in May 1802.

Two years later, Napoleon was enthusiastically declared Emperor of the French by the Senate at the age of thirty-five. He chose Fontainebleau as the place to house Pope Pius VII and his entourage,

who were traveling to Paris from Rome to crown him emperor. Accompanied by the architect Pierre-François-Léonard Fontaine, Napoleon toured Fontainebleau, pointing out needed renovations. He declared, "We will make something of this ruin."

Plasterers, painters, and carpenters worked around the clock while artisans in Paris upholstered chairs, wove rugs, and sewed curtains. In only nineteen days they refurbished forty state apartments and two hundred suites, and conveyed all new furniture from Paris to Fontainebleau.

On November 25, 1804, Napoleon was coronated emperor by the pope in a lavish ceremony at the Notre-Dame Cathedral in Paris. The palace returned to its former glory. The new emperor was so impressed with the restored glory of Fontainebleau that he had the ceremony repeated two days later at the château. On that occasion the new emperor declared:

> I swear to maintain the integrity of the territory of the Republic, to respect and enforce respect for the Concordat and freedom of religion, equality of rights, political and civil liberty, the irrevocability of the sale of national lands; not to raise any tax except in virtue of the law; to maintain the institution of Legion of Honor and to govern in the sole interest, happiness, and glory of the French people.[1]

After that Fontainebleau, which Napoleon called the "rightful house of kings" became his and Empress Josephine's primary residence and he set out to refurbish the palace to his tastes. What had been the grand Francis I Gallery became the Emperor's Gallery, and was decorated with busts of ancient or contemporary illustrious political leaders from

Alexander the Great to George Washington, and its terrace was carefully restored to how it was in the 16th century.

The King's bedroom was transformed into a throne room. And the state apartment was moved to the first floor of the palace and adapted to the modern bourgeois lifestyle, to which the People's Emperor aspired.

An avid reader and scholar, Napoleon had his private library set up in the Petits Appartements for private use, as well as an adjacent topographical cabinet in which he could consult large maps as he plotted his conquest of Europe.

Because Napoleon became so occupied with military campaigns, his visits to Fontainebleau grew more infrequent. But he was there on November 15, 1810, when the chapel of the château was used for the baptism of his nephew, the future Napoleon III, with the emperor serving as his godfather, and Napoleon's second wife, the Empress Marie-Louise, as his godmother. His marriage to his first wife, Josephine, had been annulled by this time because of her inability to provide him with a male heir.

Between the hours of 2:00 and 3:00 on the morning of July 6, 1809, French troops under the orders of Napoleon scaled the walls of the gardens of the Quirinal Palace in Rome and penetrated into the part of the palace occupied by papal servants. After an hour of violent skirmishes with the Swiss Guards, they arrested Pope Pius VII, and spirited him away in the night to Savona, near Genoa, and then through a difficult journey through the Alps to Fontainebleau, where the pontiff was held captive in the former Queen-Mother's apartment. He would remain imprisoned there for the next two years.

The kidnapping was the climax of the combative relationship between the global leader of the Catholic Church and the brash emperor, fighting over control of Europe.

On January 25, 1813, Emperor Napoleon I secured a concordat from Pius VII, a "series of articles to serve as a basis for a definitive arrangement" between the two rulers. Pius VII was only released from his golden jail at Château de Fontainebleau the following year, on January 23, 1814, when France was invaded by the allied powers, and the Empire was being shaken to its core.

During his disastrous French Campaign of 1814, Napoleon's army held out against the allies of the Sixth Coalition—Austria, Prussia, Russia, and other states in Germany—but was ultimately overpowered. On the 30th of March, Paris capitulated. Upon hearing the news, Napoleon fled to Fontainebleau. The historic château would serve as the stage for the fall of his regime.

Napoleon spent the last days of his reign at Fontainebleau, before abdicating on April 4, 1814. In his memoirs, written in exile on the island of Saint Helena, he wrote of Fontainebleau: "Perhaps it was not a rigorously architectural palace, but it was certainly a place of residence well thought out and perfectly suitable. It was certainly the most comfortable and happily situated palace in Europe."

His nephew, Louis Napoleon Bonaparte (better known as Napoleon III, elected France's first president in 1848 and elevated to emperor of France in 1854), resumed the custom of long stays at Fontainebleau, particularly during the summer. Many of the historic rooms, such as the Gallery of Deer, were restored to something like their original appearance, while the private apartments were redecorated to suit his tastes of those of his strong-willed wife, Empress Eugénie.

Napoleon III was the emperor of France when France and England sent a military expedition to China in what became known as the Second Opium War. And he was the leader of France when Yuanmingyuan (the Old Summer Palace) was looted and burned to the ground.

He obviously didn't heed the advice of his uncle, who famously had said, "Let China sleep. For when she wakes, the world will tremble." Perhaps he was prophesying the sack of the Old Summer Palace.

One French soldier who witnessed the event tried to put into words the material significance of the event in a letter to his father:

> I take up the pen, my good father, but do I know that I am going to tell you? I am amazed, stunned, stunned by what I saw. The Arabian Nights are for me a perfectly truthful thing now. I walked for almost two days on more than 30 million francs of silks, jewels, porcelain, bronzes, sculptures, treasures in short! I don't think we've seen anything like this since the barbarians sacked Rome.[2]

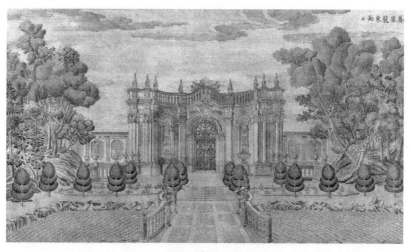

Yuanmingyuan

Contemporary poet Wang Shangchen tried to capture the emotional impact of the destruction of the palace in his poem "Song of Yearning":

*Barbaric destruction of symbolic retribution—the razing of the Yuanming Yuan.*
*Hot Indian deserts exhale poisonous miasma,*
*roast worms of sandy gold;*
*Black crows tear flesh from the bones of corpses,*
*peck at the fat, dripping blood;*
*Blood red poppies spring up, for all this,*
*they make a paste of yearning.*
*Greenish smoke arises when paste is pounded to pieces,*
*it drains gold and money out of the country.*
*The vitality of a neighborhood disappears daily;*
*the celestial mists become the sky of yearning . . .*[3]

Following the sack of the Old Summer Palace, French officers presented a large cache of treasures from the palace to Napoleon III and Empress Eugénie. Initially displayed at the Tuileries Palace in Paris, they were moved to Fontainebleau in 1863. Treasures from the Yuanmingyuan—many dating from the Qianlong period (1736–1795) including jades, cloisonné, lacquer, textiles, and objects in gold as well as bronze—filled a suite of three rooms at Fontainebleau, which Empress Eugénie turned into the Musée Chinois (Chinese Museum).

Located on the ground floor of the Gros Pavillon near the pond, the rooms that made up the Musée Chinois were among the last decorated within the château while it was still an imperial residence. In 1867, the Empress Eugénie—a woman known for her championing of authoritarian and clerical policies—had the rooms remade to display her personal collection of Asian art, which included gifts given to her and her husband by a delegation sent by the King of Siam in 1861 and crates of loot taken from the Old Summer Palace and sent to her by

General Charles Cousin-Montauban. The first shipment arrived in February 1861. The entire collection numbered some 800 objects, with 300 coming from the sack of the Old Summer Palace.

After the sack of the Yuanmingyuan, French officers presented a large cache of treasures to Napoleon III and his empress Eugénie. Initially displayed at the Tuileries Palace, they were moved to Fontainebleau Castle near Paris in 1863. Some 400 treasures from the Yuanmingyuan—many dating from the Qianlong period (1736 to 1795), including jades, cloisonné, lacquer, textiles, and objects in gold as well as bronze—filled a suite of three rooms at Fontainebleau called the Musée Chinois (Chinese Museum), where they remain to the present day.

"The gifts given at that time constitute the embryo of the imperial collection," said Jean-François Hébert, director of the Château de Fontainebleau. He specified that the collection grew quickly due to the contribution of works from the Mobilier National of the French Ministry of Culture, acquisitions made on the Paris antiques market, and further shipments from the French expeditionary force that sacked the Old Summer Palace in Beijing.

The objects displayed in the antechamber include two royal litters or palanquins: one designed to carry a king and the other—complete with curtains—to transport a queen. Inside the two salons of the museum—which was recently renamed Empress Eugénie's Chinese Museum—some walls are covered with lacquered wood panels in black and gold, taken from 17th century Chinese screens. In the corners stand tall matching wooden cases to display antique porcelain vases. Other objects on display include a Tibetan stupa, or hemispheric structure, containing a brass Buddha taken from the Summer Palace; and a royal crown given to Napoleon III by the King of Siam.

Blue and gold cloisonné chimera

The Chinese rooms house the Empress's original collection of jades, gold coins, cloisonné, lacquer, and textiles. One of the most striking displays at Fontainebleau is a set of five ritual vessels of blue and gold cloisonné. They are pictured in the museum catalog resting on a set of five red lacquered stools against a background of French chandeliers. Also pictured is the above blue and gold cloisonné "chimera" (a mythical animal with a lion's body and dragon's head) and an elegantly embossed pair of bronze bells—both of which were taken from the Old Summer Palace.

Empress Eugénie—who was the daughter of Spanish nobility and known as a style icon of her time—never intended for the Chinese rooms to be a museum or public exhibition space. She had the rooms decorated by palace architect Alexis Paccard—who had also worked on the Louvre—to be used as a private space where she could entertain guests and friends. That's why the drawing room included a billiard table and a mechanical piano.

The whole suite was inaugurated by the empress on the 14th of June 1863, with a grand party attended by the crème of French society.

Over a hundred and fifty years later, shortly before 6:00 A.M. on Sunday, March 1, 2015, thieves pried through the garden doors and entered what was then called the Musée Chinois. The museum was one of the most secure areas of the entire château and armed with alarms and security cameras. "It was a space," said museum president Jean-François Hébert, "that was often closed to the public, very intimate, very atypical, with its large screens lacquered with gold."[4]

The thieves then shattered the glass of three display cases. They seemed to know exactly what they wanted. Working fast, they stole fifteen Chinese artifacts in a mere seven minutes. The objects stolen were called "priceless," according to French authorities.

Before the thieves left, they sprayed everything with a fire extinguisher to remove any trace of fingerprints. And they had fled the

grounds of Fontainebleau by the time the police and security personnel arrived.

Among the items they took with them were twenty gold coins from China and the kingdom of Siam, and also a crown of the King of Siam given to Emperor Napoleon III during the king's official visit to France in 1861, an enamel piece that dates from the reign of Emperor Qianlong in the 17th century, and a Tibetan mandala.

Because of the theft and the damage it caused, officials closed the museum until it could be repaired.

Jean-François Hébert, who ran the Fontainebleau castle, called the break-in a "very big shock and trauma."

"We think they [the thieves] were very determined, knew exactly what they were looking for and worked in a very professional manner," added Hébert. "The objects they took were among the most beautiful pieces in the museum," he was quoted as saying on the BBC.[5]

French culture minister Fleur Pellerin said in a statement, "The police forces, and in particular the Central Office for the Fight against Trafficking in Cultural Property (OCBC), the Ministry of Culture and Communication and the Château de Fontainebleau are doing everything possible to ensure that these objects, which are perfectly identified, find their place in the national collections as quickly as possible."

As in past thefts of ancient Chinese artifacts, the thieves seemed to snatch items from a list, ignoring paintings and furniture that were considered more valuable. They included some of the masterworks of Renaissance Europe, including Joos van Cleve's life-sized painting of François I, *Two Ladies Bathing* from the first quarter of the 17th century, and masterpieces by French masters Jean-Auguste Dominique Ingres and Pierre-Auguste Pichon. Also spared were a gallery of portraits of members of Napoleon's family, medals, and decorations, several

costumes worn during Napoleon's coronation as Emperor, a gold leaf from the crown he wore during the coronation, and a large collection of souvenirs from his military campaigns.

"The museum was robbed, and Chinese objects were taken. The investigation makes us think that they just wanted to steal only Chinese objects," explained one French inspector.[6]

In a letter to a friend written on November 21, 1861, French novelist Victor Hugo seemed to predict the robbery at Musée Chinois.

> One day two bandits entered the Summer Palace. One plundered, the other burned. Victory can be a thieving woman, or so it seems. The devastation of the Summer Palace was accomplished by the two victors acting jointly. Mixed up in all this is the name of Elgin, which inevitably calls to mind the Parthenon. What was done to the Parthenon was done to the Summer Palace, more thoroughly and better, so that nothing of it should be left. All the treasures of all our cathedrals put together could not equal this formidable and splendid museum of the Orient. It contained not only masterpieces of art, but masses of jewelry. What a great exploit, what a windfall! One of the two victors filled his pockets; when the other saw this he filled his coffers. And back they came to Europe, arm in arm, laughing away. Such is the story of the two bandits.
>
> We Europeans are the civilized ones, and for us the Chinese are the barbarians. This is what civilization has done to barbarism.
>
> Before history, one of the two bandits will be called France; the other will be called England. But I protest, and I thank you for giving me the opportunity! The crimes of

those who lead are not the fault of those who are led; Governments are sometimes bandits, peoples never.

The French empire has pocketed half of this victory, and today with a kind of proprietorial naivety it displays the splendid bric-a-brac of the Summer Palace. I hope that a day will come when France, delivered and cleansed, will return this booty to despoiled China.[7]

To Victor Hugo's mind an act of retribution was almost inevitable. Given the earlier thefts of Chinese artifacts from museums in Sweden, Great Britain, and Norway, it certainly seemed to fit a pattern. In all of the break-ins the objects taken were almost exclusively objects that had been looted from the Old Summer Palace.

If France officials saw the Fontainebleau robbery as part of a pattern, they weren't saying. Nor did they mention the fact that only weeks before the break-in at the Musée Chinois a delegation of Chinese officials and collectors had visited the Fontainebleau to tour their Chinese collection and to discuss the return of artifacts looted from Yuanmingyuan.

One of the members of the Chinese delegation was billionaire, real estate tycoon, and poet Huang Nubo.

"For many years," said journalist Alex W. Palmer (who wrote the article in *GQ* that inspired this book), "the Chinese have been talking about their desire to reclaim this art . . . saying, 'you should return this stuff.' But it got really serious in about 2009 when the government started sending out what it called 'treasure hunting teams' to museums across the West, like the Metropolitan in New York, and then to some of these European museums that ended up getting burgled."[8]

These treasure-hunting teams often included representatives from Chinese state media and Beijing museum employees led by an

archivist from something called the China Poly Group, which had cataloged over a million looted Chinese artifacts in every corner of the world. When one such team arrived at the Metropolitan Museum of Art in New York City in December 2009, they arrived with a film crew.

James C. Y. Watt, head of the museum's Asian art collection, didn't know what to expect and braced for a confrontation. As the delegation toured the Asia galleries, they asked questions about the provenance of the objects on display. Arriving at a display of ancient Chinese jade, they requested documentation to show that the pieces had been legally acquired. They were particularly interested in anything that had been looted from the Old Summer Palace.

Mr. Watt pointed out that most of the palace relics displayed at his museum and others were actually privately owned by collectors, including a number in Hong Kong, Taiwan, and mainland China.

Announcing that they were satisfied, the treasure-hunting team smiled for a group photo and drove off. It turned out the group's visit was part of a twenty-day tour of US museums that was sponsored by a Chinese liquor company. And it wasn't carefully organized. A visit to Nelson-Atkins Museum of Art in Kansas City, Missouri, had to be canceled after the group realized the museum was not located in the Northeast.

If the efforts of these treasure-hunting teams were confused and disjointed, the message was singular and clear: We want our artifacts back.

Zhang Yongnian, director of China's lost cultural relics recovery program, explained: "We want to retrieve the lost artworks, because they belong to this country and its culture. They originated in China, and China is where they should be, forever. Their cultural value can be appreciated by the world, but they should be preserved in their home countries."[9]

In Zhang's opinion all the relics that were lost through illegal or immoral means should be returned to their rightful owners, whether they were lost during wartime or not.

His opinion was echoed by one of China's most well-known cultural experts, Li Xueqin. "I think we should show the world just how determined we are to regain our relics as we have lost so many throughout history. We need them to preserve our traditional culture and so future generations can marvel at their beauty. We should therefore do everything in our power to get them back."[10]

What did that mean? The answer to many observers was: By any means necessary.

In the words of James Ratcliffe, director of recoveries and general counsel at the Art Loss Register, which is the largest private database of stolen and looted art, "In China in particular you have a combination of significant wealth and the desire for looted art to return home. There is also a widely held view that these pieces are not legitimately held in the West so there is nothing wrong acquiring them if they have been stolen from a Western museum."[11]

One of the means of recovery Chinese officials used with increasing frequency was to pressure collectors who were putting up looted artworks for sale.

A case in point are a collection of twelve bronze zodiac heads that were part of a water clock fountain or clepsydra—a type of fountain that tells time—located in front of the Haiyantang Palace of the Xiyang Lou (Western-style mansions) area of the Old Summer Palace in Beijing.

Every two hours water poured from a different bronze head, as time was traditionally measured in twelve two-hour periods.

Coincidentally, some architects have observed that the Haiyantang palace might have been inspired by the Château de Fontainebleau outside of Paris.

Bronze rat fountain head

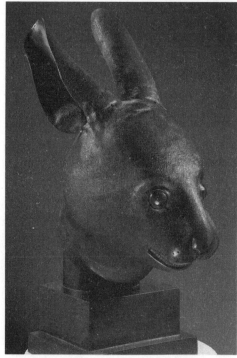

Bronze rabbit fountain head

The bronze heads were the creations of a Milanese Jesuit, Brother Giuseppe Castiglione, a young painter who trained in the Milanese style. After becoming a missionary, he traveled to China in 1715, where he became enamored of Chinese painting and worked under the Chinese name Lang Shih-ning. The Emperor Quianlong supported and encouraged Castiglione, who developed a syncretic style that blended both Chinese and Western artistic traditions. Interesting that artworks made by an Italian became the objects of a dispute over Chinese national heritage.

But that's exactly what happened in March 2009, when the sculptures were scheduled to be auctioned in Paris, along with the rest of the art collection that belonged to the late high-fashion designer Yves Saint Laurent and his partner Pierre Bergé. The sale price was estimated by Christie's—which was running the auction—to be in the vicinity of $20–$24 million.

Mr. Bergé was selling the whole of the collection he and Saint Laurent amassed in order to fund AIDS research. The entire sale was expected to raise as much as $375 million.

The bronze animal heads aroused strong emotions in China due in part because of a popular 25-episode, 24-part Chinese television series that aired in 2005 called *Palace Artist*, which was based on the life of Giuseppe Castiglione. The character of Castiglione was played by popular Canadian actor Mark Rowswell—a celebrity in China known by his stage name Dashan.

Meanwhile, a group of over eighty Chinese lawyers were planning to petition a Paris judge to suspend the auction, which was scheduled to be held at the Grand Palais. "If we can delay the auction, we can sit down and negotiate a reasonable price," said Liu Yang who headed the volunteer legal team.

Regarding the upcoming auction of the bronze rabbit and rat heads, Foreign Ministry spokesperson Jiang Yu stated the government's

position: "China has incontrovertible ownership of these objects, which should be returned."[12]

The Chinese government refused to buy the bronze heads directly, on the grounds that it would legalize theft. "If your belongings are stolen and you see them in the market the next day you do not buy them back. You call the police," said Chinese cultural relics scholar Xie Chensheng.[13]

But authorities were not averse to wealthy benefactors purchasing precious cultural items on behalf of the nation.

Nine years earlier, China Poly Group, the state-owned weapons and real estate conglomerate, had bought the monkey, tiger, and ox heads at auction in Hong Kong, after official protests had failed to stop the sale.

Then in 2003, Stanley Ho, a billionaire casino kingpin from Macau whose daughter Pansy Ho has been accused by the State of New Jersey of links to the Chinese triads, bought the boar and horse, and donated them to the Poly Group's art museum. The horse head had reportedly been purchased from a Taiwanese businessman for US$8.84 million.

Five heads are still missing, and many experts fear they may no longer exist.

The sale of the bronze heads became even more fraught with controversy when owner Pierre Bergé offered to bring the heads in person to China in exchange for a pledge by the Chinese government to honor human rights in Tibet.[14] Bergé said that to his mind the European looting of the Old Summer Palace in 1860 and the Chinese destruction of Tibetan culture were parallel events.

"All that I ask," Bergé said, "is that China respects human rights, gives Tibet its freedom, and agrees to the return of the Dalai Lama." M. Bergé's statement was angrily dismissed by Beijing as "ridiculous."[15]

The Chinese government decided not to send an official request to intervene in the auction, held at Christie's in Paris, but an independent

team of Chinese lawyers did try to stop the sale. Their claim was rejected by a French court before the auction began. The buyer of the two bronze heads, which sold for 15.7 million euros (£13.9 million or $17.5 million) each, was Chinese collector Cai Mingchao.

In another twist, Mingchao then dramatically announced that he was refusing to pay for the bronze heads and called this "a patriotic act."

The China National Treasures Fund, to which Mr. Cai was an adviser, said it backed the plan to sabotage the auction. "The fund faced great pressure and risks by bidding for the two sculptures, but this was an extraordinary method taken in an extraordinary situation, which successfully stopped the auction," said Niu Xianfeng, its deputy head.[16]

The fund was a patriotic association of collectors, historians, and prominent figures, which works closely with the government.

But Christie's said the rules were simple—buyers who failed to pay up within a week did not receive the goods.

In a statement, it added: "We are aware of today's news reports. As a matter of policy, we do not comment on the identity of our consignors or buyers, nor do we comment or speculate on the next steps that we might take in this instance."[17]

Mr. Bergé, who had raised 373 million euros from the auction—a world record for a private collection—said he would be happy to keep the bronzes if necessary.

"I'll keep them at my place," he said. "We will continue to live together in my home."[18]

The dispute ended amicably on June 28, 2013, when the family of French billionaire and art collector François Pinault bought the bronze heads from Mr. Bergé for 14.9 million euros ($18.3 million or £14.5 million) each and personally returned them to China.

"By returning these two marvels to China, my family is loyal to its commitment to preserving national heritage and artistic creation," said

his son François-Henri Pinault, chief executive of luxury and retail group Kering, at a ceremony held at China's National Museum alongside Tiananmen Square. "We always have the desire to accompany our enterprises with gestures and actions not necessarily economic or financial, but environmental or in the artistic domain."[19]

The brand portfolio of Kering, which until March of 2013 was known as PPR, included Gucci, Stella McCartney, Balenciaga, and none other than St. Laurent Paris. The Pinault family also controlled the famed Château Latour vineyard in Bordeaux, the French magazine *Le Point*, and Swiss economic newspaper *L'Agefi*.

Pinault's father, François Pinault, and Chinese vice premier Liu Yandong attended the official handover of the small bronze busts in front of an audience of international reporters.

"This gesture is an expression of deep friendship with the Chinese people," announced Chinese vice minister of culture Li Xiaojie.[20]

While preserving and restoring art were motivations for the Pinault family, their philanthropy also likely benefited the company's ventures into the huge Chinese market. Just four months earlier, in December 2012, Kering had made its first acquisition in China—a majority stake in fine jeweler Qeelin.

Their business strategy bore fruit in July 2019 when Kering signed a comprehensive agreement with one of China's biggest real estate developers, the Hang Lung Group, to open fourteen new boutiques for five brands, including Gucci, in six cities throughout the country.

"This agreement with Hang Lung gives us access to the entire spectrum of Chinese luxury shopping," announced Kering's real estate director Sergi Villar, "from the traditional luxury consumer to the emerging affluent shopper."[21]

# 7

# Empress Cixi

"Now they (the foreign powers) have started the aggression, and the extinction of our nation is imminent. If we just fold our arms and yield to them, I would have no face to see our ancestors after death."
—Empress Cixi

Just like the Chinese lawyers and members of the China National Treasures Fund, who fought the auction of the two bronze heads belonging to the estate of designer Yves St. Laurent in March 2009, more than a century earlier the Empress Dowager Cixi (1835–1908) did what she could to fight for the dignity of China.

Whether you're an admirer of Cixi or not, it's impossible not to talk about the fall of the Qing dynasty without telling the story of a woman who remains one of the most controversial figures in Chinese history. In the minds of some historians Cixi was a narcissistic "dragon lady" who would stop at nothing (including poisoning members of her own immediate family) to retain power. To others, Cixi was a victim of circumstances who tried to preserve the dignity of the Qing Empire and China in the face of voracious foreign interests.

What's certain is that Empress Dowager Cixi's legacy continues to be the subject of debate in the West and in China. It's a debate that has been made difficult because of two things: the very closed and secretive world of the Qing court during the latter decades of the 19th century, and two Western journalists who claimed to have special access to that court at that time and wrote influential books and articles that cast Cixi in a particularly negative light.

The journalists in question were Sir Edmund Backhouse, 2nd Baronet of England, and J.O.P. Bland, who wrote at the beginning of the 20th century. In their writing they characterized Empress Dowager Cixi as "cruel and unstable," "a dragon lady," and "a greedy tyrant."

Their two major works *Annals and Memoirs of the Court of Peking* (1914) and *China Under the Empress Dowager* (1910), were pivotal in shaping Western perceptions of the Qing court under Cixi. Even though Backhouse was accused of forgery by another *Times* correspondent, Dr. George Ernest Morrison, for his heavy reliance in *China Under the Empress Dowager* on the diary of a high court official named Ching Shan, this source later proved to be a fabrication.

The accusations against Backhouse were never fully substantiated during his lifetime and didn't seem to dim the popularity of his books. In them he and Bland offered a description of Empress Dowager that perfectly matched Western prejudices. After all, she represented the conservative element of the Qing government that was determined to resist Western (and British) aggression where, to her mind, it violated the dignity of China.

Time and more research have revealed Edmund Backhouse and J.O.P Bland to be thinly veiled propagandists who cast Cixi in the role of cruel and immoral tyrant—something we know isn't unusual where the interests of two nations clash and the journalists in question represent the interests of one side.

But truth tends to reveal itself over time. When more current scholars started to examine Bland's and Backhouse's sources and claims, many of them were proven without merit. Backhouse was the source of most of the information in the books on Cixi and the Qing, and Bland served as the writer. Among Sir Edmund Backhouse's claims (or boasts) was that he had affairs with Oscar Wilde, French poet Paul Verlaine, and the Empress Dowager herself, which lasted until her death in 1908.

In his sexual memoir, *Décadence Mandchoue*, the openly gay Backhouse, who pronounced his name *Bacchus*, claimed he met the aging empress after he returned looted artifacts to her palace. He wrote that after doing so he was called in for a private audience with the empress, during which he was washed and perfumed by eunuchs and called up to the sixty-nine-year-old Empress's bedchambers to perform sexual acts on her like a slave girl in a harem.

> She allowed me to fondle her breasts which were those of a young married woman; her skin was exquisitely scented with the violet to which I have made allusion; her whole body, small and shapely, was redolent with *la joie de vivre*; her shapely buttocks pearly and large were presented to my admiring contemplation: I felt for her a real libidinous passion such as no woman has ever inspired in my pervert homosexual mind before nor since.[1]

When Sir Edmund wasn't frolicking with the "Old Buddha," as she was affectionately known, he was coupling with just about any young, attractive eunuch in her service. Sex with eunuchs—and with catamites in the "bathhouses" of Peking (now Beijing)—was Backhouse's preferred form of eroticism. This is where he met the love of his life, whom he dubbed Cassia Flower.

When the empress called, however, Backhouse was dutifully present, even if a powerful aphrodisiac was required to get him through prolonged nights requiring three to four orgasms with his insatiable, near-septuagenarian royal partner. This exacting sexual schedule continued until shortly before Cixi's death, at seventy-three, in 1908—or so his memoirs attest.

Backhouse also contends that Cixi did not die of natural causes. No, she was murdered—with three brutal, point-blank shots to the abdomen—by none other than Yuan Shikai, one of the eight regional viceroys during her reign who was later to become second president of the Republic of China.

He got this scoop from Cixi's chief eunuch, Li Lianying, who happened to be Backhouse's best friend and gave him his personal diaries detailing all his years of service to the empress. Unfortunately, those diaries and any of the other corroborating papers were lost, according to Backhouse.

Most of his claims are dismissed today as bunk. British historian and Regius Professor of Modern History at the University of Oxford Hugh Trevor-Roper—also a former MI6 officer and an expert in clandestine affairs—found that not only was Backhouse's claim of being seduced by Cixi most likely untrue, he doubted that the British author had ever met her.[2]

In his biography of Backhouse, *The Hermit of Peking* (1976), Professor Trevor-Roper dismissed most of what Backhouse said about the Qing court as nonsense and exposed virtually all of it as fraud. He deemed the books Backhouse wrote with Bland "worthless historic documents."

As for his bawdy memoir, *Décadence Mandchoue*, Trevor-Roper wrote: "No verve in writing can redeem their pathological obscenity."[3]

In addition, Trevor-Roper pointed out that despite Backhouse's superficial appearance of affection for the Chinese, much of what he

wrote about China confirmed Western "yellow peril" stereotypes, which might have explained their popularity when they were published. Backhouse variously depicted the Chinese as pathologically dishonest, sexually perverted, morally corrupt, and generally devious and treacherous. In Backhouse's view, Chinese civilization was deeply sick and decadent.

So was British civilization in his opinion. In *Décadence Mandchoue*, Backhouse claimed that the wives and daughters of British diplomats in Beijing trained their dogs and tamed foxes to perform oral sex on them, which he cited as evidence of British "decadence," and later used to explain why he was supporting the fascist governments of Germany and Japan in the Second World War.

Trevor-Roper, by the way, would later be implicated in a hoax of his own. In 1983, in his capacity as independent director of the *Sunday Times*, he authenticated what were called the *Hitler Diaries* (*Hitler-Tagebücher*)—a series of sixty volumes of journals purportedly written by Adolf Hitler, but forged by Konrad Kujau. The diaries were purchased in 1983 for 9.3 million Deutsche Marks (£2.3 million or $3.7 million) by the West German news magazine *Stern* and later sold for serialization. At the press conference to announce the publication, Trevor-Roper announced that on reflection he had changed his mind as other historians had raised questions concerning their validity. Rigorous forensic analysis, which had not been performed previously, quickly confirmed that the diaries were fakes.

Getting back to the man who was largely responsible for fixing the initial view of Empress Dowager Cixi in the Western consciousness, Professor Trevor-Roper wasn't the only historian to arrive at a negative opinion of Sir Edmund Backhouse. British historian Robert Bickers, known for his articles on China and British colonialism in the *Oxford Dictionary of National Biography*, said that Backhouse was a "fraudster."

He continued: "May indeed in his memoirs have been the chronicler of, for example, male brothel life in late-imperial Peking, and there may be many small truths in those manuscripts that fill out the picture of his life, but we know now that not a word he ever said or wrote can be trusted."[4]

Of Backhouse's coauthor J.O.P. Bland, Bickers said, "he had some talent as a writer and fashioned them (Backhouse's insights into the Qing court) into readable manuscripts."[5]

What do contemporary Chinese scholars make of Backhouse and Bland? Noted Chinese historian Lo Hui-min (1925–2006) put them both in the category of "China-watchers." As Lo Hui-min explained in one of his lectures, "The derogatory overtones that came to be associated with the term 'China-watcher' may, however, also be due to a certain resentment felt by some at what they consider to be the undeserved influence exercised by these observers, an influence often quite disproportionate to their knowledge and understanding of their subject."[6]

Having achieved prominence through advancing a false narrative of Empress Dowager Cixi and the Qing court jointly with Sir Edmund Backhouse, J.O.P. Bland became one of the most frequently quoted sources on modern Chinese history. For the next thirty-five years, in historian Lo Hui-min's words, "he went on turning out plausible half-truths, building up his reputation as a relentless campaigner against China."[7]

Bland's sympathies clearly lay with British mercantile interests in China. In 1906, he took up a leadership position with the British and Chinese Corporation (BCC), formed largely by Jardine Matheson and by the HSBC. He became its Peking-based agent conducting railway loan negotiations with the same Chinese government that he characterized as "the sick man of Asia."

Concluded Lo Hui-min, "His (Bland's) followers and less gifted imitators since have merely traced and retraced the same old steps in

an intellectual vicious circle, endeavoring to get a glimpse of the China from which they draw further and further away, lost in the mists of the very myth they help to perpetuate."[8]

At the end of the 20th century, more contemporary Western writers like Sterling Seagrave tried to correct the established view of Empress Dowager Cixi. In her 1996 biography of Cixi entitled *Dragon Lady*, Seagrave characterized her as "a spirited and beautiful young woman trapped in a losing proposition. . . . A figurehead empress who lost three emperors to conspiracy; a frightened matriarch whose reputation was destroyed as she presided over the decline of a bankrupt dynasty."

A more balanced and nuanced portrait of the Empress Dowager started to emerge. Professor Sue F. Chung of the University of Nevada in her book *Much Maligned Empress Dowager* described her as a victim of circumstances—a woman stuck between the Manchu nobility wanting to maintain Manchu dominance and remove Western influences from China at all cost, and more moderate influences trying to cope with China's problems in a more realistic way. The Empress Dowager, she argued, did not crave power but simply acted to balance these influences and protect the dynasty as best she could.

Chinese author Jung Chang depicted a woman who was unusually wise for her age and time. In her view, Empress Dowager Cixi is one of the most important women in Chinese history, ruling the empire from behind a yellow silk screen for nearly half a century (1861–1908) and being responsible for bringing the "medieval empire into the modern age." Under Cixi's rule, China built its first railroads (including the important Beijing-Canton railroad line), installed telegraphs, introduced electricity, steamboats, modern mining, and newspapers, established the state bank, and promoted freedom of religion.

The constitutional system Cixi initiated, Chang wrote in her 2014 biography, included modern laws—commercial, civil, criminal, and

judicial, and the establishment of law schools. In the early 20th century, she allowed women to appear in public, abolished foot binding, lifted the ban on Han-Manchu intermarriage, and decreed that girls should be educated.

At the same time, Chang described in detail how, after not feeling sufficiently revered, Empress Cixi issued a decree that all her advisors would have to kneel in her presence—although she ended the practice later in her reign. When a palace eunuch made a remark that offended her, she had him strangled to death. When she discovered a plan to assassinate her, she not only had the plotters beheaded, but also two innocent bystanders to avoid having the case turn public.

Empress Dowager Cixi was born Yehe Nara Xingzhen on November 29, 1835, according to Imperial court records. In 1851, she joined Emperor Xianfeng's harem at the age of sixteen and became known as Concubine Yi. What today might sound like a demeaning role for a young woman was considered an honor in 19th-century China.

Concubine Yi was not a great beauty, nor did she have a formal education. But she possessed poise, grace, intuitive intelligence, and an interest in state affairs, which she got from her father.

American artist Katharine Carl, who later painted her, described her as possessing: "A high nose . . . an upper lip of great firmness, a rather large but beautiful mouth with mobile, red lips, which, when parted over her firm white teeth, gave her smile a rare charm; a strong chin, but not of exaggerated firmness and with no marks of obstinacy."[9]

Although not a favorite of the Xianfeng Emperor, who had one empress, two consorts, and about eleven concubines in his harem, Concubine Yi bore him a son named Zaichun, born on April 27, 1856. Her newfound status as the mother of the Emperor's only son earned her the title Cixi, meaning "empress of the western palace,"

which placed her second only to Empress Ci'an among the women in Xianfeng's harem.

That same year, the Second Opium War broke out. That conflict, which saw Western troops lock horns with Chinese troops over trade disputes and access to China's ports, placed a huge strain on the Xianfeng Emperor, whose Summer Palace was burned to the ground by French and British soldiers. As a result of the defeat and the loss of territories, the emperor, who had been born prematurely and had always suffered from bad health, fell into a severe depression, which led to his death at the age of thirty.

The year 1861 was critical for China and the Qing dynasty. Defeat and uncertainty hung over the entire imperial kingdom. In an attempt to salvage the Qing dynasty, several regional governors proposed a series of reforms to bolster the military and give people in the provinces more control over local affairs. Known as the self-strengthening movement and championed by the Chinese scholar and official Feng Guifen, it sought to reform old Confucian ways and introduce Western technology as a way to resist the challenges from foreigners. Or, in Feng Guifen's own words, to "use the barbarians' superior techniques to control the barbarians."[10]

Xianfeng's death seemed to coincide with Cixi's own political awakening. At the age of twenty-one and with a decade of exposure to the imperial court, she also started to see the need for reform and opening to the outside world. Making China strong, she wrote, "is the only way to ensure that foreign countries will not start a conflict against us . . . or look down on us."[11]

In 1861, Cixi's five-year-old son and Xianfeng's only male heir became the Emperor Tongzhi, and Cixi ascended to the rank of Empress Dowager. According to tradition, she also became a regent ruler until her son turned seventeen.

Beset by revolt from within and incursion from without, the dynasty's system of governance was gravely stressed during the second half of the 19th century. Traditional Confucian political culture held it unacceptable for a woman to rule, so Cixi was forced not only to sit behind a screen during imperial audiences but to govern indirectly in the name of young male heirs. She was, as one courtier derisively put it, like "a hen crowing in the morning, which is bound to herald a disastrous day." Only able to pick her way forward gingerly, as if "through a minefield." She was, nonetheless, able to put her understandable anger at Western arrogance aside and appreciate, as she put it, the West's "ability to make their countries rich and strong."[12] In Jung Chang's view, Cixi became a strategically astute and successful reformer, despite all her shortcomings and obstacles.

After her son came of age, she did turn the throne over to him. But the young Emperor Tongzhi was not interested in political leadership, and instead led a dissolute life, frequenting prostitutes of both sexes and clashing with his ministers and uncles—Prince Gong and Prince Chung.

In 1875, the emperor died at the age of fourteen after a bout of smallpox. Others claimed the cause was syphilis. What is certain is that Tongzhi left no heir. But at the time of Emperor Tongzhi's death, his first-ranking concubine, Arute, was pregnant. Arute and her unborn child died during the debate over succession.

The Western press was quick to cast aspersions. The *New York Times* reported that the circumstances of Arute's death "aroused general suspicion." Some members of the imperial court claimed that Arute committed suicide. According to court records she died after a long illness. Others pointed out that if Arute was murdered, Cixi wasn't necessarily responsible, as the late emperor had five brothers, princes of the imperial court, who had their own rivalries and ambitions for controlling the throne indirectly.

Together Empress Dowager Cixi and Empress Dowager Ci'an—the empress consort of the Xianfeng Emperor—were left to solve the problem of succession. They did so by installing Cixi's four-year-old nephew and adopted son Zaitian, who was named the Guangxu Emperor on August 14, 1871.

By the last quarter of the 1800s, Cixi had become the most powerful individual in China. Although she officially retired from public life when her adopted son came of age and remained in her summer residences and traveled little, she continued to preside over the seething caldron of dynasty intrigue and act as a watchdog for Qing conservatism, Manchu values, and neo-Confucianism. She did not like political and social change and resisted it where she could.

It was only when she felt that her adopted son was bending over too far to accommodate foreign interests that Cixi engineered another coup and returned to power. She continued to rule, according to Chang, with an impressive aplomb and authority that belied the prejudice so many foreigners continued to harbor against her.

She believed as inspector general of Chinese maritime customs, Sir Robert Hart, did when he said, "It is not China that is falling to pieces: it is the powers that are pulling her to pieces."[13]

Swayed by resentment against foreign pressure, Cixi decided to ally the dynasty with the anti-Christian, anti-foreign cult the Boxers. Although the Boxer Rebellion was not her fault, her support of it turned out to be most disastrous of all her failures.

In 1901, after China's overwhelming defeat by foreign forces the Qing government was forced to sign the Boxer Protocol. In yet more humiliation, China agreed to pay reparations of one silver *tael* for each head of population—the equivalent of roughly $340 million. In addition, anti-foreign groups were banned, military restrictions were imposed, and foreign troops were permanently garrisoned in Beijing.

Ten Qing government officials believed to have supported or encouraged the Boxers were executed, and the Qing government was forced to issue a formal apology for the murder of the German ambassador and to erect a commemorative arch at the site of his death.

French caricature of Empress Cixi

A year later, Empress Dowager Cixi was allowed to return to her royal residence in the Forbidden City in Beijing. In the past Cixi had largely supported the conservative faction of the Chinese government that was strongly attached to tradition. Now, the Empress Dowager Cixi saw the need for herself and her government to become less antagonistic toward the West and its allies. She started showering the foreign dignitaries with gifts including prize Pekingese dogs, which were previously kept only in the Forbidden City, as a sign of her commitment to improving ties with the outside world. And she introduced a series of reforms that went a long way in making China more open. Some of her most notable reforms were in the education system and legal code.

Sarah Pike Conger, writer and wife of US diplomat Edwin H. Conger, was one of the few Western women to meet Empress Cixi, which she did in December 1898. Later she and Conger were interviewed by world renowned geologist Bailey Willis about their impressions of the Dowager Empress.

"Do you think the Empress is sincere in her profession of friendship?" I (Willis) asked.

"If you could meet her and she should take your hand and look in your eye and speak to you as she has to me, you would think her sincere," was the answer.

"A man's first impression of a woman as deep as the Empress is not worth much," I said.

"I would rather trust a woman's intuition of the woman."

"What does that tell you?"

"I cannot think otherwise than that she is sincere."[14]

As part of her effort to reach out to the West in friendship, Cixi broke tradition and posed for an official portrait. Once displayed, the portrait would allow the world to see her true likeness instead of basing her appearance upon the unflattering caricatures and rumors spread about her. Upon meeting the Empress, American artist Katharine Carl was surprised. Empress Cixi wasn't the woman she had expected. She didn't appear harsh or wicked, but instead had a soothing presence and was one of the most pleasant women she'd ever met.

But Carl encountered other problems.

I was obliged to follow, in every detail, centuries-old conventions. There could be no shadows and very little perspective, and everything must be painted in such full light

as to lose all relief and picturesque effect. When I saw I must represent Her Majesty in such a conventional way as to make her unusually attractive personality banal, I was no longer filled with the ardent enthusiasm for my work with which I had begun it, and I had many a heartache and much inward rebellion before I settled on the inevitable.[15]

Carl ended up painting four portraits of the empress, one to be hung in the entrance hall to the palace to be seen by international guests, another designated for her chambers, which was subsequently lost, a third to be kept in the palace as an official record, and a fourth in her full court attire with a background suggesting the imperial court. The work would undertake the task of mending Qing China's international image at the St. Louis World's Fair.[16]

On May 4, 1904, the portrait traveled from Beijing to St. Louis for the exposition. The work wound up in the American section instead of the Chinese one. At first some thought it hung there because it was the work of an American artist, Katharine Carl. But the real reason turned out to be more interesting: Cixi herself ordered the portrait to appear there, as it was the American audience and their perception of her and Qing China that she wanted to impact. Her strategy seemed to pay off, because the event drew an estimated 20 million visits and the Cixi portrait was said to attract "throngs of visitors at all times."[17]

"Cixi was afraid of foreigners," Professor Chang said in an interview, "but she managed to modernize the Chinese government and build consensus. She did this by finding people in the court who would work with her and managed to improve education for girls, outlaw foot binding, and take steps toward instituting a parliamentary government."[18]

Many historians still consider her reign despotic. In their view, the original opinion still held that Empress Dowager Cixi was a power-mad woman who poisoned most of her family. They attribute the fall of the Qing dynasty and Imperial China to her inability to understand the challenges posed to traditional China by the modern world. But other viewpoints have evolved to consider her an intelligent survivor who learned to navigate Qing politics and rode the wave of very troubled times.

About six years into Cixi's reforms, on November 14, 1908, the Guangxu Emperor passed away at the age of thirty-seven. The cause of death was said to be acute arsenic poisoning. This was confirmed by forensic tests conducted in 2008 and 2019, which revealed that the level of arsenic in the emperor's remains was 2,400 times higher than that of ordinary people. Forensic scientists concluded that the poison could only have been administered in a high dose at one time.[19]

That same day—November 14, 1908—the throne was passed to the Guangxu Emperor's two-year-old nephew Puyi. The night before, the infant had been taken from his family home by eunuchs and rushed to the Forbidden City to meet Empress Dowager Cixi.

He later wrote:

> I still have a dim recollection of this meeting, the shock of which left a deep impression on my memory. I remember suddenly finding myself surrounded by strangers, while before me was hung a drab curtain through which I could see an emaciated and terrifying hideous face. This was Cixi. It is said that I burst out into loud howls at the sight and started to tremble uncontrollably. Cixi told someone to give me some sweets, but I threw them on the floor and yelled "I want nanny, I want nanny," to her great displeasure. "What a naughty child," she said. "Take him away to play."[20]

Puyi was crowned the Xuantong Emperor on November 15, 1908, and the next day Empress Dowager Cixi died at the age of seventy-two.

The crippled imperial dynasty clung to power for three more years, but it became increasingly clear that the Xuantong Emperor was not fit to fulfill the Mandate of Heaven. Signs that a particular ruler had lost the mandate included peasant uprisings, invasions by foreign troops, drought, famine, floods, and earthquakes—all of which had occurred in the preceding decades.

Revolutionaries, upset over government corruption, the encroachment of foreign countries into China, and resentment over Manchu rule over Han Chinese, finally overthrew the Qing dynasty in 1911. What became known as Xinhai Revolution ended more than 2,000 years of dynastic rule in China and ushered in the Republican Era of 1911 to 1949.

Six-year-old Puyi, the Last Emperor, formally abdicated the throne on Feb. 12, 1912. Seventy-five years later in 1987, Italian director Bernardo Bertolucci made a movie based on Puyi's life. Starring actors John Lone, Joan Chen, and Peter O'Toole, it was the first Western feature film authorized by the People's Republic of China to film in the Forbidden City. At the 60th Academy Awards, *The Last Emperor* swept all nine of the Oscars for which it was nominated, including Best Picture, Best Director, and Best Adapted Screenplay.

Critic Roger Ebert wrote in his review, "The ironic joke was that he was emperor of nothing, for there was no power to go with his title, and throughout the movie he is seen as a pawn and victim, acted upon, exploited for the purposes of others, valued for what he wasn't rather than for what he was."[21]

One could argue that Emperor Puyi was the perfect representation of China at the time—a victim, acted upon and exploited for the purposes of others.

# 8

# The Triads

"Pearls don't lie on the seashore. If you want one, you must dive for it."

—Chinese proverb

The break-ins continued...

At 1:20 in the morning, Tuesday, April 17, 2018, masked burglars smashed through a first-floor window to gain access to the Museum of East Asian Art in Bath, England. The thieves broke several display cabinets and grabbed a number of jade and gold artifacts before escaping in a dark-colored SUV. Local police, who reached the scene within minutes of receiving an alert, said the burglary appeared to be well planned and swift.

Located in a restored Georgian townhouse on Bennett Street just a few blocks from the King's Circus—a historic ring of stone townhouses designed by architect John Wood, the Elder, in 1754—the Museum of East Asian Art bills itself as the only UK museum dedicated to the arts and cultures of eastern and southeastern Asia. It opened in 1993 and features thousands of objects from the region. Some of its Chinese art dates from 5000 B.C.E.

The city of Bath, in the valley of the River Avon, is a living museum only ninety-seven miles west of London. Named after the baths the Romans built in 60 C.E., it is the only UK city that's been designated as a UNESCO World Heritage Site. It was the home to Jane Austen, Thomas Gainsborough, and other famous British artists.

In its center lies the Museum of East Asian Art. "We have one of the most comprehensive jade collections in the UK and some of the finest bamboo carvings in Europe. We have lively and innovative exhibits which give visitors a wonderful insight into the art, craftsmanship, and cultures of China, Japan, Korea, and Southeast Asia," said museum curator Nicole Chiang.

Among the forty-eight artifacts taken by burglars was a jade monkey holding a peach, from the early Ming dynasty; jade mandarin ducks with lotus flowers, from the Qing dynasty; and a set of fourteen gold plaques from the early Ming dynasty.

A police spokesman commented that "due to the items stolen and the speed of the burglary we suspect this to be a targeted attack with the artifacts possibly stolen to order."[1]

Nicole Chiang said in a statement: "We are deeply shocked and saddened by the burglary as we are preparing for our 25th anniversary celebrations. Not only do the stolen objects have significant historical and cultural value, they also hold irreplaceable emotional value for our founder."[2]

Over the last several years a rash of other robberies of ancient Chinese artifacts have taken place at auction houses and museums throughout Europe, including the Princessehof Ceramics Museum in the Dutch city of Leeuwarden. Again the value of the items stolen was priceless. Among them was a Chinese ruby bowl from the 11th century, the *Leeuwarder Courant* reported. The Dutch newspaper pointed out that a similar object had sold for more than €30 million ($32 million) at Sotheby's in 2012.

The Princessehof, housed in an 18th-century castle where artist M. C. Escher was born, is the only national museum in northern Netherlands and features a world-class collection of Asian, European, and modern ceramics, including the largest collection of Chinese porcelain in the country.

The robbery took place in the early hours of a Monday morning, February 13, 2023—less than two weeks after another unsuccessful break-in attempt. The burglars entered through the roof of the museum, then made their way to the first floor, where rare Chinese ceramics were installed as part of an ongoing exhibition called "Party!"

Eleven ceramics were stolen from the show. The shards of seven were found scattered in the street outside the museum—broken, most likely as the thieves fled the scene. Four pieces remain missing.

"The perpetrators seemed to have specific knowledge and to have struck in a targeted manner," the Princessehof said in a statement.[3]

"These are valuable pieces of Chinese ceramics," a museum spokesperson elaborated in an email. "For these museum objects, there is a very small market, so we don't expect that the intention was to offer [them] for sale. We don't want to speculate, but a targeted assignment seems more likely."[4]

The Princessehof Museum was founded in 1917 by Dutch notary Nanne Ottema, who had a particular interest in Chinese ceramics and acquired an extensive collection. Of the pieces taken was a porcelain vase decorated with a figure riding a qilin—a mythological animal, sometimes know at the "Chinese Unicorn" because of its single horn. The qilin was considered an auspicious animal in Ming-era China believed to bring prosperity, serenity, and male offspring.

In 1935, Leeuwarden collector Ottema discovered this vase in a small antique shop in Rotterdam. The antique dealer told Ottema that it had been found on Sangir, a small Indonesian island north of

Sulawesi. But how did the vase end up there? And how did it make its way to Rotterdam? One explanation could be that Admiral Zheng took this object with him as a diplomatic gift for a Muslim ruler on the Indonesian archipelago.

Art historians tracked the origin of the vase to the reign of the Ming emperor Yongle (1403–1424), which was known for diplomatic missions to India, the Middle East, Africa, and Southeast Asia. Led by the seven-foot-tall eunuch Admiral Zheng He (described in Chapter 2), these missions comprised fleets of hundreds of ships, which took with them the most beautiful and precious products made in China: silk and porcelain. How it returned to the Netherlands is still a mystery, as is the location of the vase today. Though Dutch authorities speculate that it's back in China.

Ming-era vase decorated with qilin

Then, on December 27, 2019, the French police arrested five Spanish organized crime professionals and a Chinese national, and charged them with planning to rob the Chinese Museum at the Palace of Fontainebleau a second time. The thieves, led by Juan Maria Gordillo Plaza, aka El Niño Juan, admitted that they had been hired by a Chinese triad based in Spain to target three pieces of art belonging to the collection of Empress Eugénie de Montijo, the Spanish wife of Napoleon III, in exchange for over a million dollars (or 800,000 €).

For more than a week, the Spanish National police followed well-known criminal Juan Maria Gordillo Plaza, better known as El Niño Juan or Juan the Kid because of his short stature. Gordillo Plaza was a thirty-three-year-old break-in specialist from the Orcasitas neighborhood of Madrid. He was joined by four other suspects, aged thirty to forty-five, days before their arrest. They aroused suspicion because together, the five men had been arrested more than 120 times.

That's when the National Police informed their French counterparts via Europol, the European Union's agency for law enforcement cooperation, that the group was planning a heist on a French museum. They didn't know which museum was being targeted, only that the thieves were after three pieces of Asian art.

The French investigation dubbed Operation Bamboo followed the five suspects as they traveled to France in two cars. Although they pretended not to know one another, they swapped cars as they traveled to Paris where they visited the Eiffel Tower and the headquarters of the soccer team Paris Saint-Germain. The group also visited the Château de Fontainebleau with the aim of studying the security camera system and the position of security guards.

Then they returned to the budget hotel they were staying at in the nearby town of Nemours. This was their "headquarters" according to

the French police. On the night of December 26, two of the Spaniards met at their hotel with three Asian individuals who were believed to be members of a Chinese triad. One of them, Hu Shouyang, age 45, was later arrested.

Police moved in the early morning of December 28, as the thieves were getting ready to leave for the Fontainebleau. The arrests took place in the parking lot of their hotel. In their two stolen vehicles, investigators discovered crowbars, hoods, gloves, and even pickaxes. According to gendarmerie colonel Didier Berger, investigators also found "photos which confirmed that they were going to steal art objects of Asian origin on display in the Chinese Museum at the Fontainebleau palace."[5]

While in police custody, the suspects denied that they were planning to commit the burglary. They said they were engaged in "simple tourist visits," according to *Le Parisien*. But the evidence proved otherwise.

The Chinese men were later linked to a triad based in Spain. One police officer was quoted by *Journal du Dimanche* as saying that's where the order came from. He explained, "Chinese mafia have a big presence in Spain and have big economic set-ups and enormous financial means."

The connection to the shadowy triads had also been made by investigators in Durham, England, in 2012. Dick Ellis, who headed the Metropolitan Police's Art and Antiques Unit for ten years until he retired in 1999, explained that art had become a "natural target for criminal gangs" as prices for the commodities had risen. "They've seen from reports that Chinese antiquities are fetching a lot of money, so they've set about stealing," he said.[6]

Ellis, who also worked for the London-based Art Management Group, said he did not think a "mastermind" organized the theft. "These people don't set out with wads of money to invest as you would if you're a collector, so anything they steal is sheer profit," he explained. "When they target these objects, they do so not with the expectation

that they'll be making the extremely high prices that these objects would fetch if they were able to sell them on the open market, which they know they can't do. They're relying on being able to shift these pieces relatively quickly, not for a huge amount of money, but every penny of that is sheer profit to them."[7]

He added, "The triads served as the middlemen between the wealthy Chinese collectors and the local criminal gangs that did the break-ins. They saw there was money to be made and little risk, so they made it happen."[8]

By 2018, it was common knowledge among officials in Europe that the PRC was complicit in the thefts and that the PRC didn't care—or else were deliberately turning a blind eye.

Art crime expert Noah Charney—professor of Art History and founder of the Association for Research into Crimes Against Art—warned that the problem was more serious than previously thought. When it comes to winning back their lost art, he said the Chinese couldn't imagine how stealing it back could be wrong. "It's almost like there's a fog around it from a criminological perspective," he said. "It's like another planet, in terms of the way people think about what art is, what authenticity is, what is socially unacceptable to do."[9]

"Triads" were actually a European designation for a number of secret societies operating in China at the end of the 19th century, including the *Tin Tei Wui* (天地會, Heaven and Earth Association), *Saam Hap Wui* (三合會, Three United Association), *Saam Dim Wui* (三點會, Three Dots Society), and *Hung Mun* (洪門, Hung Sect). In Canton, they were known collectively as *Hak Sh'e Wui* (黑社會) or Black Societies.

According to their foundation myth, the triads were founded by a group of Buddhist monks from the Shaolin monastery who aided the

Qing emperor in repelling the Xi Lu barbarians in the late 17th century. Even though the monks were successful and asked for no compensation, the Qing emperor suspected them of plotting against him and ordered their monastery destroyed. The five monks who survived then organized a network of secret lodges dedicated to overthrowing the Manchu Qing dynasty.

Authors Dian H. Murray and Qin Baoqi, in their book *The Origins of the Tiandihui: The Chinese Triads in Legend and History*, concluded that the Heaven and Earth Society and other triad secret societies were usually organized for seditious purposes by people alienated from or at the margins of society. Initially it was a revolutionary movement with underground practices, influenced by numerology and occultism.

Like the Italian Mafia and other criminal groups, most triads were highly secretive and characterized by ceremonial rituals, often in the form of blood oaths.

Triad rites take place at an altar with incense smoke and the sacrifice to the gods of a domestic animal, such as a chicken or a goat. After drinking a potion composed of wine and the blood of the animal or of the candidate, he would pass beneath an arch of swords while reciting an oath. This is one of them:

> I shall not disclose the secrets of the Hung family, not even to my own parents, brothers, or wife. I shall never disclose the secrets for money. I shall be killed by myriads of swords if I do.
>
> I shall never betray my sworn brothers. If through a misunderstanding, I have caused the arrest of one of my brothers, I must release him immediately. If I break this oath, I will be killed by five thunderbolts.

> If I am arrested after committing an offense, I must accept my punishment and not place any blame on any of my sworn brothers. If I do so, I will be killed by five thunderbolts.[10]

A minority was established for mutual protection or the administration of local activities by law-abiding members of a given community. They spread throughout southern China to become a transnational network of secretive cells and were involved in rebellions in the 1850s that threatened Shanghai and aided in the 1911 revolution.

They didn't shy away from using subversion and brutality to build influence and expand power. Their methods were covert. Their roots were deep. Loyalty was sacrosanct.

When Mao Zedong took power and the People's Republic of China (PRC) was formed in 1949, secret societies were suppressed during a "strike hard" campaign against organized crime. Triad groups relocated to the British colonies of Hong Kong and Taiwan, as well as in Southeast Asia and other countries. They turned to drugs and extortion to make money and are now known as some of the toughest criminal organizations in the world today.

Triads now control a large part of the international drug trade, starting with raw opium grown in the Golden Triangle, the mountainous area bordering Laos, Burma, northern Vietnam, and Thailand. Under their supervision the raw opium is processed into heroin and distributed through triads in Hong Kong, Singapore, and Malaysia.

And their role in the drug trade doesn't stop there. They're also responsible for the distribution of methamphetamine, MDMA, and ketamine, as well as the manufacture and distribution of fentanyl into the United States. A recent DEA report said that the Chinese triads now control the money laundering for the Mexican and Colombian

cartels. According to Admiral Craig Faller, commander of United States Southern Command, Chinese money launderers are now the "Number One underwriters" of drug trafficking in the Western hemisphere.[11]

Since the 1880s the triads have been also involved in counterfeiting everything from black market books to watches, DVDs, and designer apparel and cigarettes. Many cells are also heavily involved in the illegal seafood trade as well as poaching and the illicit trade of animals and ivory, prostitution, gambling, and human trafficking. The US government estimates that over 100,000 people are smuggled into the United States annually by the triads. These undocumented workers then work for the triads to pay off the debt.

Anything to make money and grow their influence.

In terms of structure, triad groups are organized according to a pyramid hierarchy, which is not strictly hierarchical in design but instead based on many separate and autonomous cells. Each cell has an area boss who leads fifteen to twenty core members that control a particular area through violence and extortion. They form the middle level of the triad, with the bottom level being made up of youth and juvenile gangs.

Although there is a hierarchy to triad leadership, those lower on the ladder have much more freedom of lateral movement than in more structured groups like the Italian Mafia or Japanese Yakuza. In practice, rarely are the movements and activities of smaller gangs directed by the leaders of a triad, which means that triad members do not typically have to secure permission from the head of a triad in order to engage in a criminal activity, even if the activity involves partnering with people who are not members of the triad or members of a different triad.

With regard to the theft of Chinese artifacts from European museums, this fluid structure makes it easy for individual triads to

cooperate with local gangs like the Rathkeale Rovers or Juan Maria Gordillo Plaza's gang out of Madrid.

Unlike criminal organizations such as the Mafia, where the profit goes to the organization, each triad is granted full autonomy over money. Triad-affiliated gangs (14K being most prominent in Chicago) settle disputes through negotiations and act like a fraternity, even when engaged in criminal activities.[12]

Leaders at the top of the pyramid are designated with colors or numbers derived from Chinese numerology, like Red Pole, Blue Lantern, 489 Dragon Head, or 439 Deputy Mountain Master.

The leadership structure looks something like this:

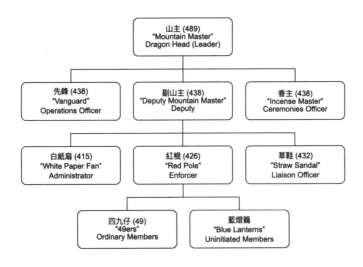

Triad family tree

The number 4—which stands for the four oceans that surround China and the universe—is often used to signify the member's position

in the organization. Interestingly, in modern Chinese numerology, 4 is usually considered an unlucky number and associated with death. That's why it is unlikely to appear on street addresses or vehicle license plates, and most Chinese buildings don't have a fourth floor.

If members of a triad are found violating the gang's secrets, they are severely and brutally punished by a member called "Red Pole," who has been trained in torture. With triad membership at over 250,000 across Asia alone, Red Pole also serves as an advisor to the Dragon Head and assists with decisions concerning the organization. He isn't selected without being highly intelligent and ruthless.

Up until recently, a good friend of mine named Khan was an undercover operator for various Western intelligence organizations. He met with Red Pole in a Hong Kong hotel in 2008 while infiltrating a triad cigarette smuggling and money laundering operation. He remembered the encounter this way:

> Seated, there was a towering six-foot-four-inch Chinese man from Mainland China, wearing an expensive pinstriped suit. His cold, soulless eyes gave away that he had murdered many. He clearly wasn't here to make friends.
>
> Another six ex–Chinese Red Guards were sitting at other tables around the room. They were there to do the killing in case I didn't pass muster.[13]

According to Khan, the triads don't just shoot their enemies. They kill them in colorful and dramatic ways designed to instill terror. "One of their preferred methods of execution," he said, "was for a group of them to rush a target at once, surround him or her, hack them into pieces with meat cleavers and dump the head into the Hong Kong harbor."[14]

Violence is part of triad history, not only turf battles over gambling and prostitution, but used to settle political disputes as well. In 1927, the Chinese Nationalist Party enlisted the powerful Shanghai triad the Green Gang to suppress unionists and kill thousands of communists.

During the 2019 protests in Hong Kong against the Chinese Communist Party (CCP)'s controversial national security law, journalists witnessed men armed with poles in white shirts, believed to be triads, beating up protesters. The *New York Times* suggested the triads were carrying out the bidding of the Hong Kong police or CCP.

The idea of triads embracing the goals of the CCP is a remarkable transition for crime groups that were once arch enemies of communism. But shifting loyalties reflect the malleable nature of organized crime and China's rising power.

The idea of triads embracing Beijing's goals is a remarkable transition for crime groups that once used to be arch enemies of communism.

"As long as these people are patriotic, as long as they are concerned with Hong Kong's prosperity and stability, we should unite with them," Tao Siju, chief of China's Public Security Bureau, said in 1993.[15]

Since Hong Kong's 1997 handover from British colonial rule, some of Beijing's most ardent critics have found themselves at the wrong end of a triad assault. Radio host Albert Cheng, publisher Chen Ping, and Jimmy Lai, owner of the *Apple Daily* tabloid, have all survived triad attacks.

In 2014 former *Ming Pao* newspaper editor Kevin Lau was nearly killed in a machete attack by two men who said they were paid to "teach Lau a lesson."

Two months later a group of men armed with sticks and clubs descended on pro-democracy demonstrators in Kowloon. Many of those later arrested had links with prominent triad gangs Wo Shing Wo and 14K.[16]

Currently, there are four major triads: Wo Hop To, Wo Shing Wo, Sun Yee On, 14K (Sap Sei K), and an additional fifth, Luen. Based in Hong Kong, Wo Hop To, whose name translates to Harmonious Union Plan, was founded in 1908. They expanded their drug distribution network to San Francisco and then the rest of the United States starting in the 1990s.

Wo Shing Wo is also a Hong Kong–based organization with great influence in San Francisco and Toronto. Currently it's active in France, Ireland, Australia, Belgium, Canada, South Africa, and England. In January 2013, four men—Yik Fung Ng, Hiu Nelson Yeung, Chiu Yuen Li, and Siu Hung Yeung—associated with the Wo Shing Wo were convicted of violent disorder following a street fight involving up to thirty men in Manchester, England's Chinatown.

During the trial, it was alleged that one side of the conflict included Wo Shing Wo members and associates who had bullied young men into paying to join their ranks, and that the violence erupted because a group of young men had refused.

Sun Yee On is reputedly the largest triad with 55,000 members around the world. Based mainly in Hong Kong and China, they have a strong presence in Western countries like Belgium and France.

Jimmy Tsui, aka Bighead, is a former member of the Sun Yee On triad based in Hong Kong and New York City's Chinatown. In 1985, he was arrested and charged with robbery and homicide, with his bail set at $1.5 million. The case was later dismissed and three years later he became a "426 general."

Jimmy was involved in extortion rackets, karaoke bars, gambling houses, and various financial scams. In 1992, he was shot five times while sitting in his car, which ended his involvement in mob life. He said, "In New York, I had a lot of soldiers under me. All the gangs in New York have connections in Hong Kong. The movie business in

Hong Kong is totally controlled by triads. If you're not with them you can't even get a spot. And if you don't listen to them, you get punished. A lot of female movie stars are triad members."[17]

Of all the various triad groups, the 14K (Sap Sei K 十四K) triad, is the most violent Hong Kong–based triad. The US government described it as "one of the largest Chinese organized criminal organizations in the world," engaging in "drug trafficking, illegal gambling, racketeering, human trafficking, and a range of other criminal activities." In 2020, the US Department of the Treasury sanctioned 14K leader Wan Kuok-koi, alias "Broken Tooth."[18]

Born in the Portuguese colony of Macau, Wan rose through the ranks of the triad to become one of the territory's most powerful crime bosses, waging a bloody war against rival gangs with bombings, shootings, and stabbings a regular occurrence. He was jailed in November 1999 on a host of charges, shortly before the colony was handed over to China.

Upon his release in 2012 Wan became a member of the CCP People's Political Consultative Conference, one of the country's two main legislative bodies. He also heads the World Hongmen History and Culture Association, a seemingly innocuous organization that helped further China's Belt and Road Initiative (BRI) in Southeast Asia. "This continues a pattern of overseas Chinese actors trying to paper over illegal criminal activities by framing their actions in terms of China's BRI, the China Dream, or other major initiatives of the CCP," stated a 2020 US Department of the Treasury press release.[19]

"The World Hongmen History and Culture Association is spreading across Southeast Asia, establishing a powerful business network involved in the development and launching of crypto currencies, real estate, and most recently a security company specialized in protecting BRI investments," the statement added. All under the leadership of 14K leader Wan Kuok-koi—aka Broken Tooth.[20]

According to the Treasury Department, "The Chinese enterprises behind the BRI projects have several things in common: their leadership has links to criminal networks or actors involved in illicit activities in other parts of Southeast Asia, as well as China; they have preexisting organizations engaged in casinos and crypto currencies; they advertise themselves online to be associated with Beijing's BRI and flaunt connections with key Chinese government agencies; and all of them have established associations that actively seek to assist Chinese nationals."[21]

"There is no question," concluded FBI official Frank Montoya Jr., "about the interconnectivity between Chinese organized crime and the Chinese state."

# 9

# Sun Yat-sen

"The Chinese people have only family and clan solidarity; they do not have national spirit. They are just a heap of loose sand.... Other men are the carving knife and serving dish; we are the fish and the meat."
—Sun Yat-sen

China's millennia-long period of imperial rule ended with the Wuchang Uprising of 1911 and the election of Sun Yat-sen as the provisional president of the Republic of China the following year. But even with the fall of the Qing dynasty the Century of Humiliation continued.

At the close of the 19th century, Chinese intellectuals and political thinkers were looking for new models to govern their vast and ethnically diverse country—one that embodied and preserved their cultural identity and at the same time dealt with foreign commercial interests that continued to plunder their country. Along came a medical doctor, Christian, and reformer named Sun Yat-sen, who offered a political philosophy that seemed to perfectly express Chinese ambitions. Sun called his program the Three Principles of the People.

The first pillar, Mínzú (民族主義; *Mínzúzhǔyì*) or nationalism, called for independence from the foreign domination, which had stymied Chinese ambitions for decades.

As Sun explained:

> Despite four hundred million people gathered in one China, we are, in fact, but a sheet of loose sand [*yipan sansha* (一盘散沙)]. We are the poorest and weakest state in the world, occupying the lowest position in international affairs; the rest of mankind is the carving knife and the serving dish, while we are the fish and meat. . . . If we do not earnestly promote nationalism and weld together our four hundred millions into a strong nation, we face a tragedy—the loss of our country and the destruction of our race.[1]

The second principle, Mínquán (民權主義; *Mínquánzhǔyì*), roughly translated as "rights of the people," or democracy, acknowledged the Chinese people's desire for more control over decisions that directly impacted their lives and away from imperial control. In Mínquán, Sun articulated his vision of a future Chinese political system embodying elements of democracy and autocratic government, which he felt were necessary to rule a country as diverse as China.

While nominally a pro-election republican, Sun was hardly a Jeffersonian democrat. Instead, he believed in strong, centralized leadership (like that designed by Vladimir Lenin in Russia), which would give China the strength and cohesion he thought it needed.[2]

In his own words:

> The individual should not have too much liberty, but the nation should have complete liberty. When the nation can

act freely, then China may be called strong. To make the nation free, we must each sacrifice our personal freedom.[3]

The third principle, Mínshēng (民生主義; *Mínshēngzhǔyì*) or people's livelihood (sometimes translated as welfarism or socialism, imagined a state that takes care of the basic needs of its citizens. It was a direct criticism of unregulated capitalism. He divided livelihood into four areas: clothing, food, housing, and mobility; and planned out how an ideal (Chinese) government can take care of these for its people.

Sun Yat-sen became China's first president and remains its most influential modern leader. He is viewed by both nationalists and communists as China's *guofu*, or father of the nation. While his influence on modern Chinese politics remains strong, he was not a successful political leader. In the words of his biographer Harold Schiffrin, "If Sun Yat-sen had one consistent talent, it was for failure."[4]

Instead, his political life was one of constant struggle and frequent exile. What he did understand was the nature of problems facing China, in particular its need to free itself from the yoke of Western control. In a letter written to fellow political reformer Li Hongzhang, he stated:

> In the West the interests of the state and those of commerce flourish together ... National defense cannot function without money, and money for the military will not accumulate without commerce. The reason why Westerners are ready to pounce like tigers on the rest of the world and why they bully China is also due to commerce.[5]

Sun Yat-sen was born in 1866 in Cuiheng, a village in the very southern tip of Guangdong Province, near the present-day city

of Zhuhai. His father worked as a tailor on the island of Macau. At the age of ten, Sun traveled to Hawaii to live with his older brother and pursue his education. After completing secondary school, he returned to China to study medicine and enrolled in the Guangzhou Boji Hospital (Canton Hospital) founded by the Christian missionary John G. Kerr and, later, at the Hong Kong College of Medicine for Chinese (the forerunner of the University of Hong Kong).

While living in Hong Kong, Sun made two decisions that profoundly affected his life trajectory. First, he was baptized into Christianity. Second, he joined a group of revolutionary thinkers known as the Four Bandits, whom he met at the Hong Kong College of Medicine for Chinese. This began his exposure to other Chinese reformers who believed in the need to end the Qing dynasty and free the country from Western control.

In 1894, Sun founded the Revive China Society, whose goal was the economic revitalization of China. It also served as a platform for future revolutionary activities. The last decade of the 19th century marked the beginning of Sun's involvement with the triads.

Secret societies organized against the imperial order had long been a tradition in China. As early as the second century, the armed uprising that eventually overthrew the Han dynasty was instigated by Taoist sect the Yellow Turbans. Their leader, Zhang Jue, known to his followers as the General of Heaven, was renowned for his gift of spiritual healing and supernatural powers. He coined the slogan:

> The Azure Sky (referring to the Han government) is already dead; the Yellow Sky (referring to the Yellow Turban Movement) will soon rise. When the year is Jia Zi (in the next cycle), there will be prosperity under Heaven![6]

The Yellow Turbans in their mixture of religion and political dissatisfaction may be regarded as the forerunners of the secret societies that have sprung up throughout Chinese history. According to the Chinese saying, "The officials draw their power from the law; the people, from the secret societies."

Having founded the underground Revive China Society, Sun Yat-sen sought the cooperation of the Heaven and Earth Society and other triads in organizing opposition to the Qing dynasty and raising money for the cause. Wrote China expert Martin Purbrick: "Triad and secret society membership were useful for Dr. Sun and his supporters because of the obvious need for secrecy, which triad initiation rituals, hand signs, code words, and sworn brotherhood provided."[7]

In 1895, they helped Sun and the Revive China Society infiltrate 3,000 armed revolutionaries from Hong Kong into China to incite an armed overthrow of the Qing government. But Qing agents discovered the plot and arrested many of those involved. Sun Yat-sen managed to escape and spent the next sixteen years in exile, mainly in Japan and the United States. With the help of the triads, he raised funds for the Revive China Society and spread a new political consciousness—first among intellectuals and the political elite, and then to students and anyone interested in the political future of the country.

"The concept that 'people are the masters of the state' and they have 'rights' were new for the Chinese," explains Professor Xiaowei Zheng in her book *The Politics of Rights and the 1911 Revolution in China*:[8] "For thousands of years the emperor was the Son of Heaven, whose political legitimacy came from his connection to the divine Heaven." Slowly reformers like Sun popularized the idea that the people are the masters of the state, and the concepts of rights, equality, and popular sovereignty gradually took root in the broader population.

Also, while living in exile in Japan, Dr. Sun couldn't help but notice the contrast between Japan's wealth and China's weakness. Expressing a sentiment common among Chinese exiles, he wrote about, "knowing the shame of not being Japanese." His long exile heightened his sense of just how backward China was when compared to Japan and the West.[9]

Sun Yat-sen was in Denver, Colorado, on October 12, 1911, when he learned that a series of army mutinies and mass demonstrations in the central Chinese province of Hubei—and its provincial capital of Wuhan—had provoked eighteen provinces to vote to secede from the Qing dynasty. This was a critical event that caught Sun and other reformers by surprise. He recalled, "On my way, I bought a newspaper and, arriving at the restaurant, unfolded it. Immediately, my eyes were met by a telegram about the capture of Wuchang by the revolutionary troops."

It was also the greatest challenge to the imperial government to date. Sun dropped his fundraising activities and raced back to China where a council of seventeen delegates from the provinces elected him the first provisional president of the Republic of China. But the country was in chaos, with rival factions carving out territory from the old Qing empire and vying for power. One of them, Yuan Shikai, was a former top Qing military leader who had built a strong political base in northern China.

Because Dr. Sun's relationship with the military was weak, he was forced to negotiate with Yuan. Sun promised Yuan the presidency if he could convince Emperor Puyi to formally abdicate the throne and avoid civil war, which he did on February 12, 1912. Less than a month later, Sun Yat-sen stepped aside and Yuan Shikai became China's next provisional president.

Sun's reign had lasted forty-five days. He was a political philosopher and proselytizer, not a Machiavellian practitioner of realpolitik. Nor was he a military officer backed by men with weapons.

Sun now shifted his focus to organizing a national political party, the Kuomintang (KMT) or Nationalist Party, and drafting a new provisional constitution, which weakened Yuan's power under a system of parliamentary government. But Yuan objected and modified the provisional constitution, changing the new system of government from a parliamentary to a presidential one.

Yuan's ambition was to establish a new imperial dynasty, rather than a modern republic. This didn't sit well with Sun Yat-sen, who rallied his followers under the banner of the Kuomintang. Led by Sun lieutenant and KMT cofounder Song Jiaoren, the KMT won a plurality of seats the 1912 National Assembly elections. After pledging to limit the powers of presidency, Song Jiaoren was assassinated. Most people believed that Yuan Shikai had ordered the hit. Fearing for his own safety, Sun Yat-sen once again fled into exile in Japan.

In 1915, with Song and Sun out of the way, Yuan Shikai proclaimed himself the Emperor of China, which sparked a violent backlash from other warlords and the KMT. In the midst of the chaos Sun Yat-sen married his former secretary, Soong Ching-ling. Her father, Charlie Soong, had received his college degree from Vanderbilt University in Nashville, Tennessee, and was a devout Methodist.

In fact, he and Sun Yat-sen had met when they were both attending a Methodist church in Shanghai. The two men found that they shared a lot in common—both hailed from the same region of southeast China, had been educated in the West, had converted to Christianity, and craved political change in China. Perhaps most important, they were both members of the same anti-Qing triads.

Soong Ching-ling's older sister Ai-ling married a prominent Chinese banker, while her younger sister, Mei-ling would later marry Sun's lieutenant and cofounder of the Kuomintang, Chiang Kai-shek. Thus, the Soong family was deeply tied to the Chinese Republican cause.

In 1917, China joined the fight against the Germans in World War I, partly in hope of securing a stronger position in global affairs should the French and British allies prevail. At the Paris Peace Conference of 1919 that marked the end of the war, China learned that Japan had made deals with the allied powers to assume all of Germany's China concessions.

To the Chinese people, this felt like another betrayal, and news of the allied decision sparked riots in Beijing. Several thousand students flooded the Tiananmen Gate at the southern entrance to the Forbidden City. Frustrated and angry, Chinese reformers began to question if any of their liberal ideas were actually leading anywhere.

That same year Soviet Union leader Vladimir Lenin dispatched a diplomat named Lev Karakhan to meet with Sun. Karakhan took the unprecedented step of freely and willingly relinquishing all Russian territorial concessions in China. It seemed as though the Chinese people had finally found an ally in their struggle against Western aggression.

Meanwhile, former followers of Sun Yat-sen like Chen Duxiu and others started to question the Western models of governance. The Marxist-Leninist Soviet Union seemed to offer an attractive alternative. Not only was communism "modern" and "scientific" in the view of many Chinese reformers and intellectuals, it also provided a worldview that blamed the West for China's continuing struggles. In July 1921 in Shanghai, the Chinese Communist Party was officially born. Chen Duxiu was named its first president, and a young Mao Zedong was in attendance.

Some reformers didn't agree with the Marxist-Leninist approach. In 1923, Sun arranged an alliance between China's Nationalist and Communist parties to find the best ways to work together to fight the remaining colonial powers. Sun favored a more intrinsically Chinese approach, believing that traditional Chinese loyalty to family and clan could provide the social cohesion necessary to drive reunification.

The influence of Confucian teachings on him was strong. In one of his lectures from 1924, Sun pointed out that in their eagerness to modernize the Chinese should not abandon their ancient morality of loyalty, filial devotion, kindness, love, faithfulness, justice, harmony, peace, personal refinement, and culture. He believed that these Confucian ethics were superior to Western values and according to historian Ying-shih Yu, who studied them assiduously:

> A complete set of the [Confucian] dynastic histories was found in his dormitory room. At first his schoolmates believed that he had purchased the set only for decoration; to their surprise, they soon discovered that he was familiar with the contents of many of the histories. Only then did they begin to realize that his ambition went far beyond the pursuit of a successful medical career.[10]

Although Sun dreamed of a Chinese version of representative government that protected individual expression, he didn't live long enough to see it happen. In 1925, after a short bout with cancer, he passed away.

Sun Yat-sen may not have been a great writer, nor an original thinker, nor a successful political leader, but his influence on modern Chinese politics remains strong. Despite his political failures and frustrations, he's been hailed by both nationalists, republicans, and communists alike as the father of modern China and the inspiration behind Mao's communist revolution that yielded the People's Republic of China.

The years after Sun's death saw a dark period of civil war and political chaos, and the Century of Humiliation reached its apotheosis with the brutal Japanese invasion of China in 1937. The civil war in China that started in 1927 between the Communists led by Mao Zedong and

the Nationalist Kuomintang—led by General Chiang Kai-shek after Sun's death—impeded them from forming a united front to oppose the Japanese.

China in the past had been unable to resist Japanese aggression—in the First Sino-Japanese War (1894–1895) and later when Japan took over the German concession ports at the end of the First World War and then occupied northern Manchuria in 1931. But no one expected the level of savagery that Japan unleashed on the Chinese in 1937. Some historians have compared it to the shocking barbarity the Nazis displayed in Poland, Russia, and Eastern Europe in the following decade.

It reached its bloody apogee with the Rape of Nanking.

Japan had made no secret of their ambitions for China. In 1928 they sent troops to consolidate their hold on the eastern coastal city of Jinan in Shandong Province, which was part of the German concessions it had inherited as a result of the Treaty of Versailles. In 1931 Japan extended its control through most of Manchuria and created the puppet state of Manchukuo.

But the Japanese were hungry for more and boldly stated their ambitions to grow their empire. They also sought control of Chinese natural resources, including coal, iron, and oil. Japan's emissary to China, Baron Hayashi Gonsuke, declared, "The way to deal with China is for the Powers to insist on what they want and to go on insisting until they get it."[11]

In the early years of the war, the Chinese Nationalist government led by General Chiang Kai-shek tried to fight off the Japanese invasion, but the Chinese army was ill-equipped and its soldiers poorly trained. They were quickly overwhelmed.

The Nationalist government was also hampered by internal corruption and political infighting. Chiang Kai-shek, who had been appointed chairman of the National Government, decided to make fighting the

Communist rebels in the north—whom he called bandits—a priority over a frontal war with Japan. He adopted the slogan: "First internal pacification, then external resistance."[12]

His plans were disrupted in 1937 when the Japanese attacked the Marco Polo Bridge outside Beijing. Chiang wrote in his diary, "The Japanese have challenged us, and we must finally respond with resolution. The time has come!"[13]

In November, fierce fighting broke out around China's most populous city, Shanghai. Japanese generals boasted that they would conquer all of China in three months. Chiang met their challenge, sending 600,000 of his best-trained and equipped soldiers to defend the port city. Japan attacked with 300,000 troops of their own along with ferocious air and sea bombardments. Far outgunning the Chinese in terms of artillery and heavy weapons, the Japanese eventually wore the Chinese army down after over three months of savage fighting. Later, it was confirmed that Japan illegally deployed poison gas at least thirteen times.

An eyewitness at the battle reported that it was "no longer a war between armies, but between races. With mounting fury, the two giants, like two men who have started a boxing match and who suddenly find themselves convulsed with hate, sprang at each other's throat in a tussle in which the only prize was death."[14]

After suffering over 200,000 casualties, Chiang made the decision to withdraw from Shanghai. The Japanese next marched to the Chinese capital of Nanking 168 miles east. Again, Chiang's army made a heroic effort to thwart the Japanese but were ultimately forced to retreat.

On December 13, 1937, the first troops of Japan's Central China Front Army, commanded by General Matsui Iwane entered the city of Nanking. Orders were sent from the headquarters of the Japanese military commander, Prince Asaka Yasuhiko, to "kill all captives."[15]

Tens of thousands of Chinese troops who had surrendered were murdered in batches of fifty or more. Simultaneously and then for weeks afterward, civilians, including women, children, and the old, were indiscriminately slaughtered. The methods of killing were particularly gruesome and frequently designed to inflict the maximum pain and terror, including disemboweling, beheading, bayoneting, burying alive, setting on fire, suspension on meat hooks, crucifixion, tearing apart by dogs, bludgeoning, and drenching in acid.[16]

"What you see on all sides is brutality and bestiality of the Japanese soldiers," testified John Rabe, a German Nazi businessman who tried to protect as many Chinese civilians as he could and is known today as "China's Schindler."[17]

Japanese soldier Kozo Takokoro recalled:

> Women suffered most. No matter how young or old, they all could not escape the fate of being raped. We sent out coal trucks to the city streets and villages to seize a lot of women. And then each of them was allocated to fifteen to twenty soldiers for sexual intercourse and abuse. After raping we would also kill them.[18]

There are no official numbers for the death toll in the Nanking Massacre, though estimates range from 200,000 to 300,000 people. Bodies littered the streets for months after the attack. Determined to destroy the city, the Japanese looted and burned at least one-third of Nanking's buildings.

Soon after the end of the war, Japanese General Matsui and his lieutenant Hisao Tani were tried and convicted for war crimes by the International Military Tribunal for the Far East. Both men were executed.

Some historians have posited that the Japanese belief in their own racial and cultural superiority allowed the invaders to justify their treatment of Chinese people. Iris Chang has written that, "Teachers [in the 1930s] instilled in boys hatred and contempt for the Chinese people, preparing them psychologically for a future invasion of the Chinese mainland."[19]

Sadly, the Nanking Massacre was just one example of Japanese war crimes against the Chinese people. There were many others. On the road to Nanking, two Japanese soldiers famously engaged in a wager as to who would be the first to kill one hundred people with a sword. Incredibly, this savage contest was covered in Japanese newspapers as though it were a joyful sporting event. Throughout the conflict, countless Chinese women were also enslaved and forced into prostitution. Known as "comfort women," they were used and abused as enemy soldiers saw fit.

Then there was Unit 731. This was a laboratory set up by the Japanese in the Chinese territory formerly known as Manchuria. There Chinese civilians and captured allied soldiers were subjected to chemical and biological experiments. As part of these experiments, bacterial infections and diseases were injected into these individuals and body parts and organs removed.

Amid all the death and horror of the war were some quiet acts of heroism. Knowing that about 15,245 antiques, including oracle bones, traditional paintings, books, ceramics, and ancient jade items had been taken by the Japanese during the First Sino-Japanese War (1894–1895) a group of museum curators, including a man named Ma Heng, gathered at the Forbidden City in Beijing. They asked themselves: What would happen to the country's vast collection of imperial art when the inevitable all-out war between Japan and China begins?

The question then prompted an odyssey that spanned sixteen years—through the Sino-Japanese War and World War II. Some

20,000 cases full of imperial artworks were transported across China as war raged on. To avoid Japanese soldiers' attention, the curators carried the art on trucks, steamships, trains, and even bamboo rafts.

China's last emperor, the now-abdicated Puyi, vacated the Forbidden City at gunpoint in November 1924. Less than a year later, the Forbidden City became the Palace Museum and opened its doors to Peking's public. Huge crowds lined up to walk the halls and courtyards that had been home to the emperors of the Ming and Qing empires, and to gaze upon the magnificent imperial art collections for the first time.

For a few short years, the Palace Museum conserved and exhibited a million art objects and texts and grew into one of the principal cultural institutions of the young Republic of China. The objects on display had once constituted the private, hidden treasure of emperors. Now they stood as "national" treasures, property of the young nation state and evidence of a "national" history and patrimony.

By the early 1930s, however, the Palace Museum's leadership began to worry about the threat posed by the Japanese military. In 1931, the Japanese occupied Manchuria. The following year Japanese naval aircraft began bombing Shanghai. The Palace Museum's board of directors feared that Beijing could be next and that Japanese troops might occupy the city and loot its treasures. Their solution: the imperial collections would have to be evacuated from Beijing.

First, the rarest, most irreplaceable pieces were packed by the curators in wooden cases, wrapped in cotton wadding and hemp cord to keep them separated and immobile. Curators packed 28,000 pieces of porcelain, more than 8,000 paintings, and a similar number of jade objects. They also packed ivory, jewelry, swords, libraries, archives, clocks, and tapestries. In February 1933 the first of 19,557 wooden cases containing perhaps a quarter of a million objects and texts from

the Forbidden City and other Peking institutions were inventoried and labeled.

Hundreds of porters started carrying the cases out of the Forbidden City at night and took them by truck and cart to Chien Men railway station to be loaded onto freight cars. The cases then went by train to Shanghai for storage in the French Concession, which might have seemed like a strange choice, but museum officials felt that the extraterritoriality of the foreign concessions might guarantee the collections' safety—at least temporarily. As the war wore on and engulfed most of China, the imperial collections, still safely packed in wooden cases, traveled thousands of miles across China to prevent them being stolen by the Japanese. Their voyage lasted sixteen years.

At the heart of this extraordinary enterprise was Ma Heng, who became acting director of the Palace Museum in 1933. Ma Heng was a wealthy businessman and antiquarian scholar who became a professor at Peking University. He played a significant role in the introduction of modern methods to Chinese archeology. A retiring, cautious figure, he enjoyed a measure of loyalty and respect among the museum's curators.

Ma Heng administered the imperial collections' yearslong, hairraising journey to the far west of China by steamship, train and truck, raft and porter. He found storage for them in a cave in Guizhou Province, and in village temples and ancestral halls in Sichuan. In these remote locations, far from the front line but still within range of Japanese bombers, the collections passed the Second World War under the care of a small band of loyal curators. Their move to the far west, into areas still controlled by the battered Republic of China, followed the wider migration of people, bureaucracy, industries, universities, and schools from east to west in the face of the Japanese advance.

In the late 1940s, as China fell back into civil war, the imperial collections remained packed in their wooden cases, were moved south

to Nanking, and given over to the Central Museum (Zhongyang Bowuyuan). Eight years later, with the Communists gaining ground, Nationalist leader Chiang Kai-shek selected 852 crates of the finest items in the collection of the Central Museum to be shipped to Taiwan. The rest remained in Nanking.

Following the Communist victory in the civil war and the proclamation of the People's Republic of China by Mao Zedong on October 1, 1949, the new Chinese government moved quickly to ensure that the collections of the Palace Museum be reassembled and catalogued. Ma Heng, who had valiantly protected the collections from the Japanese and who had also attempted to thwart and slow down the removal of antiquities to Taiwan by Chiang Kai-shek, remained director of the Palace Museum.

Meanwhile, the scars of the Nanking Massacre remain a point of contention in Sino-Japanese relations to this day. Despite the fact that the two nations do more than $200 billion worth of trade annually, the sense of distrust between them is strong in part because of Japan's unwillingness to admit to and apologize for the atrocities. "Sixty years later, the ghosts of Nanking still haunt Chinese-Japanese relations," said distinguished historian and sinologist William C. Kirby.

On August 15, 1995, the fiftieth anniversary of the surrender of Japan, Japanese prime minister Tomiichi Murayama gave the first formal apology for Japanese actions during the war, in which he said, "I . . . express here once again my feelings of deep remorse and state my heartfelt apology."[20]

Author of *The Rape of Nanjing* Iris Chang criticized Murayama at the time for not providing the written apology that had been expected. She said that the people of China "don't believe that an . . . unequivocal and sincere apology has ever been made by Japan to China" and that a

written apology from Japan would send a better message to the international community.[21]

Historian Takashi Yoshida has argued that "Nanking has figured in the attempts of all three nations [China, Japan, and the United States] to preserve and redefine national and ethnic pride and identity, assuming different kinds of significance based on each country's changing internal and external enemies."[22]

The problem, he pointed out, is that both the Chinese and Japanese see themselves as victims—China of the actual atrocity, and the Japanese as victims of the atomic bombs. For Japan, it's a question they still need to answer but are reluctant to do so. Nor does it help that the Yasukuni Shrine—a memorial for Japanese war deaths up until the end of the Second World War—includes war criminals that were involved in the Nanking Massacre. In the museum adjacent to the shrine, a panel informs visitors that there was no massacre in Nanking, but that Chinese soldiers in plain clothes were "dealt with severely."

In their article, "Remembrance of the Nanjing Massacre in the Globalized Era: The Memory of Victimization, Emotions and the Rise of China," Guoqiang Liu and Fengqi Qian of Deakin University argued that the Nanking Massacre has become another episode in the Century of Humiliation in the Chinese national consciousness. They wrote, "The Nanking Massacre Memorial showcases the way in which the collective memory of victimization is shaped and disseminated under the Communist Party to promote China's national aspirations and legitimize China's claims in the contemporary world."[23]

# 10

# Repatriation

*Bàoyìng* (報應) is a concept of cosmic and moral reciprocity in the Chinese folk religion. It implies that people dwell in a moral universe, a universe that is kept ordained by mores, good actions, thus moral retribution is in fact a cosmic retribution.

—Wikipedia

In the 1930s, director of the Palace Museum Ma Heng put his life on the line to preserve an important part of China's cultural heritage. But it wasn't until 1982 that the government's role in protecting that heritage was written into law.

Article 22 of the Constitution makes it an obligation of the government of the People's Republic of China to protect scenic and historical sites, cultural monuments, and relics significant to China's cultural heritage. Subsequently, China has enacted several national statutes that now constitute the Chinese legal framework for cultural preservation. Most prominent among them is the PRC's Protection of Cultural Relics Law, adopted at the 25th meeting of the Standing Committee of the Fifth National People's Congress on November 19, 1982, which states:

> Strengthening the protection of cultural relics, inheriting the splendid historical and cultural legacy of the Chinese nation, promoting scientific research, conducting education in patriotism and in the revolutionary tradition, and building a socialist society with cultural, ideological and material progress.[1]

The PRC made it clear to the Chinese people and the rest of the world that they were now taking the matter of protecting China's cultural relics seriously. The Relics Protection Law: (1) defines and categorizes the cultural objects, establishing the principles of conservation and the duties of the state to preserve cultural heritage; (2) places all undiscovered cultural heritage under state ownership and prevents their exportation from the country; (3) allows for both state ownership and private ownership of cultural heritage, even guaranteeing legal protections from the state regarding objects belonging to both "collectives or individuals."[2]

Objects that warrant protection from the Relics Protection Law include ancient sites of culture; tombs; cave temples; murals or carvings that have historical, scientific, or artistic value; works of art; important documents; manuscripts and books; and other materials or objects that demonstrate the way of life from different historical periods. In 2002, the law was amended for the fourth time to introduce a cultural-objects grading system and permitted the movement of objects through private transactions. The grading system separated relics into two categories—valuable and ordinary cultural relics—and valuable cultural relics were further separated into grades, with grade-one relics defined as objects that possess important historical, artistic, and scientific value, and are "symbolic of Chinese culture."[3]

It's all worth noting that Chapter One of the Relics Protection Law requires that local governments include cultural heritage protection in their budget allocations, and that the government provides rewards to individuals or groups that work to protect and preserve cultural heritage.

Stricter laws against the movement of cultural relics and the penalties for doing so were enacted in 2002. It meant that the Chinese government was finally signaling to the world and its own people its fierce commitment to protecting its cultural heritage.

In part these laws were passed to address an ongoing problem. Between 1998 and 2002 alone over 220,000 Chinese tombs had been broken into and their contents sold abroad.

At the beginning of the 21st century, the trade in Asian relics experienced an enormous boom. The demand came from collectors all over the world, including in China, which saw the opening of 200 auction houses between 2002 and 2012. The global appetite for relics sparked a gold rush in villages like Xiaoli in Henan Province in south-central China, whose many heritage sites include the ruins of the Shang dynasty (16th–11th centuries B.C.E.) capital city Yin and the Shaolin Temple—recognized as the birthplace of Chan Buddhism and Shaolin Kung Fu.

The closest city to Xiaoli, Luoyang, once served as the capital of at least nine separate dynasties. The fields around the village were literally littered with imperial tombs that often hold valuable artworks and relics.

Middlemen and smugglers let local farmers know that they were willing to buy those relics for as much as what might equal a farmer's yearly income.

The lure for poor local farmers was often too strong to resist. Said one local farmer to *Time* magazine, "You can tell who raided the best tombs just by looking at their houses."

Of course, most of the profit was made by middlemen and dealers. One tricolor female statue dug up in the fields around Xiaoli made 580 yuan ($70) for a local farmer and was eventually sold for 150,000 yuan ($18,000) to a dealer in New York.[4]

He Shuzhong was a college student in Shanghai in the early 1980s, when he first heard about the trafficking of Chinese cultural heritage and wrote an article in his college newsletter calling attention to the problem. In 1998, while working as a teacher at China University of Political Science and Law, he launched a small volunteer group called Cultural Heritage Watch, which later evolved into CHP—a registered Chinese NGO that works at the grass roots level to assist local communities to preserve tangible and intangible local culture through training and capacity building.

In 2003, after the passage of the Relics Protection Law, He Shuzhong saw some gains: more government conservation and archaeological excavation projects, about two thousand museums were established to house collections, and more looters and smugglers being prosecuted. He also saw problems and pointed them out:

> Laws and international conventions are only paper constructs for many people and authorities. Heritage authorities typically are unable and inefficient. Education and training regarding cultural heritage are very lacking, especially among local people. And some large companies are rapacious in their treatment of ancient sites.[5]

He Shuzhong was bringing up two important issues: education and restitution. In order to mobilize the Chinese people's desire to preserve their cultural heritage and recover looted artifacts, He Shuzhong and others believe that more has to be done in the area of public education.

The CCP has taken note. A recent press release from China's National People's Congress stated:

> China, a nation graced with a civilization dating back 5,000 years, boasts a wealth of cultural heritage assets. According to official data, as of October 2023, there were 57 world heritage sites and over 760,000 immovable cultural relics in China, including 5,058 major sites protected at the national level. Meanwhile, China has 108 million pieces (sets) of movable cultural relics.[6]

Said Zhu Bing, former head of the cultural office of the NPC's Education, Science, Culture and Public Health Committee last year, "Currently, in the field of cultural heritage utilization, there exist problems such as a low level of openness, limited means of utilization, and insufficient social participation, as well as issues of excessive development and improper utilization."[7]

Gao Yafang, dean of the tourism school at Lanzhou University of Arts and Science, has advocated for the power of creativity to liberate artifacts from museum shelves, engaging young people to actively inherit the rich legacies of the country.

Said Gao, "It's when cultural treasures come alive and engage young people that our heritage truly embarks on a sustainable and thriving voyage."

A recent example of this is the short web series titled *Escape from The British Museum*, which was released in 2023. It's the tale of a homesick jade teapot—an anthropomorphized artifact from the museum's collection—finding its way back to China to reunite with her family.

Directed by two Chinese vloggers, each episode in the three-part series lasts for ten minutes. The female vlogger who plays the

role of the jade teapot meets a Chinese journalist in London whom she believes to be her long-lost family and asks him to take her back home.

Lines in the series, such as "Family, I have been lost for a long time," and "As long as I'm with family, I'm safe," have resonated deeply with viewers. The face of the "jade teapot" is dirty, and she is surprised that the journalist's residence "only holds two people in such a large cabinet," which is interpreted by netizens as the casual attitude of the British Museum toward Chinese cultural relics, as many of them are crammed into one cabinet for exhibition.

Since its debut, the series has been circulating on Chinese social media platforms, with related hashtags trending on China's Twitter-like platform Sina Weibo. The hashtag #EscapefromTheBritishMuseum had garnered over 310 million views and more than 63,000 comments on Sina Weibo to date.

The popularity of this short series also reflects the Chinese people's growing interest in the repatriation of Chinese cultural relics. Currently, the British Museum houses a total of 23,000 Chinese relics, which span from the Neolithic age to the present day and includes paintings, prints, jades, and ceramics. Some 2,000 of the artifacts kept by the British Museum have been reported stolen.

Many viewers of the web series have left comments. Wrote one Sina Weibo user, "We can see the achievements of Chinese culture from these lost relics. We hope to see more works of this kind."[8]

As Chinese citizens become increasingly aware of the importance of their cultural heritage and recovering looted artifacts, they inevitably confront the problem of restitution. It's one that countries have grappled with for centuries. Invading armies have often paid their soldiers with plunder in the form of valuable objects, including paintings, sculpture, and other forms of art.

It's what British and French military officers did when they let their soldiers loot the Old Summer Palace in October 1860. And when the vanquished have regained power, they have historically wanted their loot back.

As far back as 539 B.C.E., Persian King Cyrus demanded the return of the sacred relics from the Temple of Jerusalem, pillaged a century earlier by the Babylonians. That return is detailed in Book of Ezra in the Hebrew Bible.

More recently in 1815, at the end of the Napoleonic Wars, the Allies ordered the return of artwork taken by Napoleon and his army as they rampaged across Europe. As a result, hundreds of valuable paintings, sculptures, and manuscripts were returned by France to Italy, the Netherlands, Belgium, Austria, and the German states.

Six hundred paintings and sculptures were pilfered from Italy alone, including the Laocoön, a masterpiece of ancient Greek sculpture from the Vatican, and Paolo Veronese's 1563 painting *The Wedding at Cana*, taken from Venice. To date, around half have been returned. The rest, including *The Wedding at Cana*, are still on display at the Louvre Museum in Paris.

More than a century later, after the defeat of Germany in World War II, the Monuments, Fine Arts and Archives section of the Allied Expeditionary Force—aka the Monuments Men—was formed to recovered artworks stolen by the Nazis. This group of about 400 service members and civilians worked to find as many as 5 million works of art and other items of cultural importance.

The stolen pieces included masterpieces from the world's most heralded artists, including da Vinci, Michelangelo, El Greco, Vermeer, Sandro Botticelli, Filippo Lippi, van Gogh, Picasso, and Chagall. Much of it had been confiscated from wealthy Jewish families who were arrested and killed, as well as museums, universities, and religious institutions.

One of the people who were forced to surrender their art collection to the Nazis was Fritz Grünbaum, a cabaret performer and son of an Austrian Jewish art dealer. He amassed a collection of more than 400 pieces, including eighty sketches and paintings by the Austrian expressionist Egon Schiele.

Nazi forces took Grünbaum into custody in 1938 during Germany's invasion of Austria. While imprisoned at Dachau, Grünbaum was forced to give his wife power of attorney. She was then forced to surrender the art collection to the Third Reich. After the war, many pieces in Grünbaum's collection began to resurface in auction houses and prominent museums.

Finally, in September 2023, seven of those pieces valued collectively at $9.5 million were returned to Grünbaum's heirs. They had been fighting for decades to reclaim the looted art.

According to *Artland Magazine*, over 30,000 pieces of art stolen by the Nazis are still missing. Many have been destroyed. Others are hidden from the public or are circulating privately for large profits. In innumerable cases the restitution of confiscated pieces was contested and the owners of those masterworks never lived to see their return.[9]

Historically, the repatriation of stolen artifacts has been difficult at best, and is often fraught with legal challenges and controversy. Before World War II, laws governing the recovery of stolen or looted artifacts were either nonexistent or weak. Some claim they still are.

When objects have been moved from one country to another, there are practical difficulties involving identification, who pays for the investigative work, prosecution, and return of the objects. And overlaying all are the legal standards used to determine who the owner is and whether the objects should be returned.

Author Alexander Herman, in his book *Restitution*, explains: "Many courts were unwilling to enforce the export laws of foreign countries,

meaning heritage protection legislation was of little use beyond a country's own borders."[10]

In the early 1930s the Office International des Musées tried to fill the gap in international law. But despite three draft conventions, none were passed. Then came World War II, which saw the widescale appropriation of art from private collections and museums alike. Clearly something needed to be done.

UNESCO, the United Nations education, scientific, and cultural organization, founded in 1945, addressed the issue. The 1954 Hague Convention signed by 135 countries, including China, the United States, the United Kingdom, and France, defined rules to protect cultural property, such as monuments of architecture, art or history, archaeological sites, works of art, manuscripts, books, and other objects of artistic, historical, or archaeological interest during times of war. But it said nothing on the subject of looting or trafficking in stolen art during peacetime.

That subject was addressed sixteen years later in the Convention on the Means of Prohibiting and Preventing the Illicit Import, Export and Transfer of Ownership of Cultural Property. But while it set rules to combat the illegal trade in cultural property, including a clear right of restitution, it offered no legal means of enforcement, only a process of seeking return through diplomatic channels.

It's only in recent years, with the rise in public interest in the issues of cultural appropriation and the abuses of colonialism, that countries and museums have started to think about the return of ethnological material and looted artworks to their countries of origin.

A major sign in this shift in attitudes came in November 2017 in a speech given by French president Emmanuel Macron during a visit to former French colony Burkina Faso. He called for an end to cultural appropriation and said, "I want to see within five years that conditions

are met for the temporary or permanent restitution of African heritage to Africa."[11]

A year later, France released a commissioned report in which authors Felwine Sarr and Bénédicte Savoy proposed a comprehensive system for returning cultural objects to the countries of Sub-Saharan Africa—especially items during the French colonial period (1885–1960). It covered more than 90,000 pieces currently housed in French museums.

But what the authors really had their sights on, according to author Alexander Herman, were artifacts taken during "certain notorious instances of looting by imperial forces."[12]

In response to the report at the end of 2020 the French Parliament passed a law returning twenty-seven cultural artifacts looted by 19th-century French soldiers to the countries of Benin and Senegal. They avoided the more radical proposals of the Sarr-Savoy report calling for the restitution of all items taken during France's colonial exploits.

At least it was a start. Other countries followed suit, including Germany, which established a framework for returning cultural items taken during its colonial period to countries in Africa and around the world. In a statement released in 2019, they said, "The injustices committed during the colonial era and their repercussions, some of which pertain still today, must not be forgotten."[13]

Next came the Netherlands, Italy, and even Britain, with smaller institutions like the British Library, which agreed to return a digitized version of the Maqdala manuscripts, which had been looted from Ethiopia in 1868 in a punitive expedition much like the one the British had dispatched to China eight years earlier.

Meanwhile, some 23,000 Chinese artifacts remained in the British Museum, including ritual bronzes from the Shang and Zhou dynasties and stone Buddhist sutra scrolls of the ancient Wei and Jin dynasties.

When pressed about returning them, museum authorities referred to the British Museum Act of 1963, which prevents trustees from giving away, selling, or otherwise disposing of collection items.

Chinese officials I spoke to are well aware of the hypocrisy of the British Museum and other Western governments and museums. They point out that Western governments see the need to return art works that were stolen by the Nazis in World War II. But they don't feel the same about artifacts looted from China a century earlier.

Why? they ask.

While no satisfactory answer is offered, China continues to grow as a global power. As they've shown, they aren't shy about using their new economic might to recover looted cultural artifacts. And when stymied by laws and intransigent museum officials, they're willing to resort to other means.

Said journalist Alex Palmer, who has written about the subject, "For many years, the Chinese have been talking about their desire to reclaim this art, and they had sort of put out bulletins to Western museums saying, 'Hey, you should return this stuff.' But it really got serious in about 2009 when the government started sending out what it called 'treasure hunting teams' to museums across the West, like the Metropolitan Museum in New York, and then some of these European museums that ended up getting burgled."[14]

## 11

# The Chinese Civil War

> "The Chinese Communist Party refers to its victory in 1949 as a 'liberation.' The term brings to mind jubilant crowds taking to the streets to celebrate their newly won freedom, but in China the story of liberation and the revolution that followed is not one of peace, liberty, and justice. It is first and foremost a history of calculated terror and systematic violence."
> —Frank Dikötter, *The Tragedy of Liberation*

Although experts and historians agree that China's long Century of Humiliation started in 1839 when British gunboats steamed up the Yangtze River to force China's emperor to open their ports and markets to the opium trade, they still haven't reached consensus on when that long "century" ended.

Some claim it came to a halt after the surrender of Japan at the close of World War II. They argue that at the time China had recently been named one of the guarantors of postwar peace by President Franklin Roosevelt—one of the so-called "Four Policemen" along with the United States, the United Kingdom, and the Soviet Union.

It's true that as early as 1942, Roosevelt conceived of a group of regional powers that would be responsible for keeping order in their respective spheres of influence: Britain in Western Europe and Africa; the Soviet Union in Eastern and Central Europe; the US in the Western Hemisphere; and China in the Far East. To prevent future conflicts, Roosevelt proposed that the Four Policemen be the only countries allowed to possess weapons more powerful than a rifle.

After the war, President Roosevelt's vision of a postwar alliance to further world peace evolved into the United Nations, which would consist of three branches: an executive branch with the Big Four, an enforcement branch composed of the same four great powers acting as the Four Policemen, and an international assembly representing other nations. Later, in a compromise to internationalist critics, the Big Four nations became the permanent members of the UN Security Council, with significantly less power than had been envisioned in the original proposal. When the United Nations was officially established later in 1945, Winston Churchill insisted that France be added as the fifth permanent member of the Security Council.

To many international observers, China was finally being acknowledged by Western powers as a leader on the world stage. Further proof of this came in October 1943 when the Chinese ambassador to the Soviet Union Foo Ping-Sheung was invited to join UK foreign minister Anthony Eden, US secretary of state Cordell Hull, and Soviet foreign minister Vyacheslav Molotov in signing the Declaration of the Four Nations. The declaration formally established the four-power framework that would later influence the international order of the postwar world.

Nine months later at the Dumbarton Oaks Conference of August 1944, representatives of the UK, US, Soviet Union, and China held talks on peace and postwar security and established the framework for the postwar United Nations organization.

It seemed clear that Franklin Roosevelt's goal was to establish a peaceful postwar order with China playing a prominent role. But other world leaders like Stalin and Churchill privately expressed their reluctance at recognizing China as a "great power." Stalin because of the Soviet Union's designs on Manchuria, which had been previously occupied by Japanese, and Churchill because he was trying to restore Great Britain's colonial prestige in areas where it had once been dominant.

Stalin, Churchill, and others also questioned China's reliability, since the country was still divided by civil war. At the end of World War II communist and nationalist forces each controlled large swathes of territory, and it was unclear which side would prevail.

One thing that the leaders of the two sides agreed on was the belief that their country's bitter experience with foreign occupation had to be avenged. After Japan's initial invasion of Shandong Province in 1928, KMT leader Chiang Kai-shek wrote in his diary, "From this day on, I will rise out of bed at six o'clock. I will remind myself of this humiliation and continue to do so until the national humiliation is wiped away completely."[1]

Two decades later, his nationalist government was still too weak to fend off the Japanese invaders and his only possible saviors came in the form of foreign powers: Germany, the Soviet Union, Great Britain, and the United States.

Following the Japanese sneak attack on Pearl Harbor on December 7, 1941, President Roosevelt had been willing to overlook China's internal political problems for strategic reasons. He needed to keep China in the Allied war camp, so they could tie down Japanese forces that otherwise might be deployed against the US fighting in the Pacific.

In return, China's political and military leader, General Chiang Kai-shek, received substantial aid and support from the United States, which he used to resist the Japanese invasion, and, at the same time,

fight his main political rivals—the Communists led by Mao Zedong. According to the arrangement Chiang made with Roosevelt, the United States provided military support in terms of advice, air assets, and material assistance, and the Chinese Nationalists carried out the brunt of the fighting against the Japanese on the Asian mainland. The deal paid off from the US perspective because the Chinese Nationalist Army under Chiang's command did tie down hundreds of thousands of imperial Japanese army soldiers.

On paper, China had a formidable army with 3.8 million men under arms in 1941. But many of the 246 frontline divisions in the Chinese Nationalist Army were more loyal to their former regional warlords than to Chiang's new central government. Also, Nationalist Army units were not only uneven in loyalty but also in quality. Despite the training they received from German and Soviet advisors and the $250 million worth of tanks, trucks, and aircraft gifted by the Soviet Union, Western military experts regarded the Nationalist Army as generally under-armed and badly organized.

President Roosevelt quickly realized that it was unrealistic to hold out any hope of uniting the Nationalist Chinese and Red Chinese armies and shelving China's internal political problems until the Japanese invaders were defeated.

China was divided along party lines with Communists occupying some northern provinces, Nationalists in the south, and some powerful local warlords controlling areas along the coast and in the center of the country. Although both Nationalists and Communists had initially pledged a united front against Japan, their precarious truce broke down in mid-1941. After that, civil war was more likely than joint military action.

Since the Chinese Nationalist Army served primarily as a political tool of Chiang Kai-shek and as the foundation of the Nationalist

regime, political considerations often came before what the US and its allies considered sound military strategy. Any action that modified the structure of the Nationalist Army or risked its destruction was assiduously avoided by General Chiang. To his mind, it was more important that the army be maintained, rather than reformed. Military commanders were selected for their political loyalty to Chiang Kai-shek rather than for their leadership abilities, and risking excessive casualties through offensive operations was unacceptable. Because Chiang was still fighting a civil war, his priority was keeping his communist rivals at bay. He habitually used his best troops for that purpose.

Strategically, by the summer of 1939, Japan controlled most of northeastern China and all the major coastal seaports, except for the British Crown Colony at Hong Kong. It meant that at the beginning of World War II, China was isolated militarily, and its supply lines were problematic. Additionally, the maintenance of millions of ill-trained and under-equipped troops was a heavy drain on the already sagging economy.

The United States, even if it wanted to, couldn't fulfill the Nationalist Army's needs. It was impossible to arm such large numbers of Chinese troops from its limited stocks while building up its own forces and assisting other countries. Also, they faced a huge logistical problem.

Because of the Japanese Navy's control of all major Chinese ports, Lend-Lease aid from the United States had to cross nearly 14,000 miles by sea to India, then travel by rail to Lashio in northern Burma, and then 715 miles by truck over the Burma Road to Kunming, China. The route was so precarious that only a trickle of supplies ever arrived at Kunming.

On December 25, 1941, the Japanese occupied Hong Kong and China lost its air link to the outside world. The following May, the Japanese defeated a coalition of British, Indian, Burmese, and Chinese

defenders and held most of Burma. China was almost completely blockaded.

The solution was found in an air route along the southern edge of the Himalayas from Assam, India, to Kunming in southwest China and north of Vietnam. This dangerous air route became known as "the Hump." In March 1942 the China National Aviation Corporation (CNAC) began flying freight over the Hump, and the United States launched a transport program the next month.

But shortages in China were so severe that it wasn't until December 1943 that cargo planes were able to carry as much tonnage as had been previously carried along the Burma Road. Although supplies of military equipment and gasoline were getting through, they hardly met China's needs.

The military situation in China wasn't good and the Nationalists and Communists were constantly on the verge of fighting, but President Roosevelt remained committed to shoring up the Nationalist Army as much as possible as a way to stymie the Japanese. In the late spring of 1941, he earmarked over $145 million in Lend-Lease funds for China to acquire both ground and air equipment. A month later, Secretary of War Henry Stimson approved a Chinese request to equip and outfit thirty infantry divisions, intended for delivery by mid-1942. Prompted by his personal adviser and retired US army air corps officer Claire L. Chennault, Chiang Kai-shek also obtained Roosevelt's support for an American Volunteer Group (AVG) of about one hundred US civilian volunteers to fly the one hundred recently purchased P-40 Warhawks. Called the "Flying Tigers" these American pilots began arriving in Burma in late 1941 and fought alongside the Chinese.

President Roosevelt appointed army Lieutenant General Joseph W. Stilwell head of the US China-Burma-India theater, and General Chiang appointed him chief of staff of the combined forces in the

theater. Arriving in China in early March 1942, Stilwell—known as Vinegar Joe—found himself in a military and political quagmire.

From the beginning of his tenure, Stilwell was dismayed by the rampant corruption of Chiang's Nationalist government and the sad state of its military preparedness. In his diary he kept tabs on the $380,584,000 he believed Chiang and his government squandered in 1944. According to the *Cambridge History of China*, 60–70 percent of Chiang's Nationalist conscripts did not make it through their basic training, with 40 percent deserting and the remaining 20 percent dying of starvation before their full induction into the military.

Trying to ameliorate the situation, Stilwell lobbied hard for the creation of a 90-division Chinese army trained by American troops and equipped with American Lend-Lease to be put under his command. Their first mission would be to reclaim Burma from the Japanese. But Stilwell's proposal threatened Chiang Kai-shek, who felt troops not under his immediate control were a threat and who saw the Chinese Communists as a greater rival than Japan.

The two generals clashed to the point that Stilwell recommended suspending US aid until the Nationalist government got its house in order. This caused an annoyed Chiang to call for Stilwell's recall. President Roosevelt reluctantly agreed, but thereafter his relationship with Chiang soured as well.

Wrote historians Orville Schell and John Delury, "For someone as proud and as fixated on China's weaknesses as Chiang, to be so beholden to the Americans and British during the war years was not easy."[2]

US frustration with Chiang, whom General Stilwell called "a stubborn, prejudiced, conceited despot," coincided with the gradual loss of support for the Nationalist government among many segments of the Chinese population. Some of this had to do with surging inflation

caused by the government pumping large amounts of paper currency to make up its fiscal deficits. Salaries of government employees, army officers, teachers and other wage earners fell far behind rising prices. This led to growing poverty and dissatisfaction with the Chiang government.

Also due to inflation, Nationalist soldiers, the majority of whom were poorly treated conscripts, mutinied or deserted in large numbers. Soldiers also engaged in rape, looting, and other acts of brutality against the civilian population. General Chiang's reputation suffered another blow when he repeated a tactic he had previously used against the Japanese, ordering the diversion of the Yellow River to split enemy forces. The outcome was around five hundred villages flooded and 400,000 people displaced.

As the war dragged on, intellectuals and students increasingly spoke out against the growing corruption. The Chiang government responded to this criticism like other repressive governments had in the past, by silencing dissent. Secret police activity increased and efforts at thought control were aimed not only against Communists but also against all influential critics of the government.

American journalist Edgar Snow gave this scathing analysis of Chiang's actions: "Chiang Kai-shek wanted absolute power. Chiang was not resolute, only obstinate; not wise, only obsolete; not disciplined, only repressed; not original, only a scavenger among the relics of the past; and not ruthless, merely vain."[3]

Whether Snow was exaggerating or not, the fact remains that Chiang Kai-sek and his government were growing increasingly unpopular. In the midst of this disaffection, an extended drought, combined with locust plagues and high winds, swept across the central and lower reaches of the Yellow River basin. The result was huge crop failures, which led to a devastating famine, the likes of which had not been seen

for decades. The region affected was enormous, extending to northern Hubei in the south, Beijing and Tianjin in the north, the coast to the east, and Shanxi in the west.

In the face of all these problems, Chiang Kai-shek and his Nationalist Army continued to struggle to fend off the Japanese with help from the United States. US bombers used Chinese air bases to strike Japanese targets, and much-needed food, medical supplies, and weaponry arrived from the United States. But it didn't help the Nationalists' reputation that they accepted support from another foreign power, the United States.

Meanwhile, Mao's CCP forces had spent much of the early part of the war hiding in the mountains. The Japanese had largely focused on securing control of Chinese cities and strategic infrastructure, ignoring China's massive countryside. The Nationalists, on the other hand, had focused on defending the south of China. This created a power vacuum in rural areas, which the CCP came out of hiding to exploit. Once in control of rural villages, the Communists spread their political propaganda.

Mao and the military and political leadership of the CCP acted strategically—building and conserving their forces for what they saw as an inevitable confrontation with Chiang and the Kuomintang. From his base in the city of Yan'an in northern Shaanxi Province, Mao spread his message through several texts, including *Philosophy of Revolution*, which offered an introduction to the Marxist theory of knowledge; *On Protracted Warfare*, which dealt with guerrilla and mobile military tactics; and *On New Democracy*, which laid out his ideas for China's future.

The Red Army's last major campaign against the Japanese took place in late 1940 in what they called the Hundred Regiments Offensive. Starting on the tenth of August, Communist forces roughly 400,000

strong attacked the Japanese simultaneously in five northern provinces, including Shaanxi. Specifically targeted was the main Japanese-controlled railway line. The Red Army succeeded in blowing up bridges and tunnels and ripping up 600 miles of track. In September, the Communists attacked Japanese garrisons and the Jingxing coal mine, which was vital to the Japanese war industry. The Hundred Regiments Offensive was considered a military success that resulted in the death of 20,000 Japanese soldiers.

But in October, the Japanese responded by sending great numbers of garrison troops to reestablish control over the railways. They quickly drove the Chinese Communist regulars out of Shaanxi province and pushed them farther north. For the rest of the war, the Communists reverted back to local resistance from their northern bases and the tactics of guerilla warfare.

While their subsequent sabotage missions certainly annoyed the Japanese and were effective in winning more recruits, they did not have a significant impact on the Japanese Army. Even the Japanese North China Area Army, which patrolled the northern areas where the CCP was located, continued to see defeating the Nationalists as its primary objective.[4]

Despite problems of corruption, uneven leadership, and lack of morale in the Nationalist Army, the defensive campaign of Chiang Kai-shek succeeded in diverting 600,000 to 800,000 Japanese troops, which might otherwise have been deployed to the Pacific. The toll that the combined Second Sino-Chinese and Second World wars took on the Chinese people was immense. Out of a total population of roughly 517,568,000 in 1945, China suffered an estimated twenty million deaths—including over three million soldiers. The rest were civilian victims of war, famine, and disease. Plus, the economy and infrastructure lay in ruins.

Professor Rana Mitter and other historians have calculated that the war forced one hundred million Chinese, approximately one-sixth of the country's population, to become refugees in their own country.[5]

And the fighting wasn't over. When the Japanese surrendered in August 1945, most observers expected the civil war in China to resume. "There is a sense in which the Chinese Civil War has not ended," wrote historian Michael Lynch, "no formal peace treaty or agreement has ever been made."[6]

In late 1945 the United States and other foreign powers made an attempt to head off a continuation of the civil war by brokering peace talks between the CCP and the Nationalists in the southwestern city of Chongqing, which had served as Chiang's provisional capital during the war. The meeting was notable for the civility and frequent shows of goodwill between CCP leader Mao Zedong and Nationalist leader Chiang Kai-shek. At one dinner Mao even raised a glass and toasted, "Long live President Chiang Kai-shek!"

Signs continued in a positive direction when at the end of three weeks of negotiating Mao and Chiang agreed to form a coalition government and end all fighting. But the pact didn't last. Fighting between the CCP and Nationalists soon flared up again with skirmishes in Manchuria, an area that was still controlled by the Soviet Red Army.

US General George Marshall called for a fifteen-day ceasefire as all sides jockeyed for position. Soviet leader Joseph Stalin played the CCP and Nationalists off one another to his own advantage. He negotiated with Chiang Kai-shek to allow Soviet troops to remain in Manchuria. Chiang thought he was buying time until he could amass sufficient troops in the area to counter any threat from the CCP. But what Stalin was really doing was training and arming the CCP's army before his army withdrew.

Soviet support helped Mao's Communist guerrilla fighters in Manchuria to transform into a more conventional military force. George Marshall continued to push for further negotiations but grew frustrated and returned to the US in January 1947.

American president Harry Truman expressed his own frustration weeks later, saying that the "selfish interest of extremist elements, equally in the Kuomintang as in the Communist Party, are hindering the aspirations of the Chinese people."[7]

Wholesale fighting between the two rivals broke out in late March with the Nationalist Army initially wresting control of 165 towns from the CCP. But very quickly it became evident that the political dynamic in the country had changed. China's peasantry, particularly in the northern part of the country, was now firmly allied with the Communists, who had promised to pay off their debts and give them property seized from landlords.

On the other hand, Chiang was viewed by many as a corrupt leader, who had done little to help people's lives in a time of grave economic problems. The war against the Japanese had caused government revenues to shrink, forcing the nationalists to release large amounts of paper money not backed by financial reserves. The result was hyperinflation, which in journalist Jonathan Fenby's words "undermined everyday lives and ruined tens of millions."[8]

Wrote historian Michael Lynch, "In 1940, 100 Chinese yuan bought a pig, in 1943 a chicken, in 1945 a fish, in 1946 an egg, and in 1947 one third of a box of matches." By 1949 hyperinflation was approaching the levels seen in Weimar Germany in 1923, with some Chinese observed hauling their money in carts.

For these reasons and others, the tide of war increasingly shifted toward the communists. American public opinion became equally concerned. In October 1947, an Army advisory group was formed to

counsel Chiang Kai-shek and provide his government with $27.7 million in aid. The nationalists requested more and were eventually granted another $400 million in 1948.

By September 1947 the civil war was being fought on two fronts: the huge Manchurian theater in the north and the triangle of Shandong, Anhui, and Henan in east-central China. Then in late 1947 the Red Army captured the cities of Shenyang and Changchun, the latter having endured a siege. The tactic was designed to starve nationalist forces inside the city, but extended for 150 days, causing as many as 160,000 civilians to die of hunger. Another 30,000 died when they were trapped between the communist lines and the city walls.

At this point the Truman administration had lost faith in Chiang's Nationalist government to unite China. In 1949, after Truman won reelection, he refused to provide them with further aid.

On April 21, 1949, Communist forces crossed the Yangtze River, capturing Nanking which had been capital of the Nationalists' Republic of China. By late 1949, the People's Liberation Army was pursuing remnants of KMT forces southward in southern China. In December, Chiang Kai-shek and approximately two million Nationalist Chinese retreated from the mainland to the island of Taiwan. There he established a rival government, declaring Taipei to be the capital of the Republic of China.

Chiang Kai-shek's departure marked the end of the nationalist era in China and the beginning of control by the CCP, led by Mao Zedong.

In his book *The Tragedy of Liberation*, historian Frank Dikötter describes the casual attitude of both communists and nationalists when it came to the civilian loss of life during the civil war.

"After decades of propaganda about the peaceful liberation of China," wrote Dikötter, "few people remember the victims of the Communist Party's rise to power." While statistics vary, it has been

suggested that up to 2.5 million people died during the 1945–1949 phase of the Civil War.[9]

Other historians estimate that the total number of fatalities could be as high as 7.5 million. What they don't dispute is that the country was ravaged by conflict, starvation, and disease.

To this date, no peace treaty or armistice has ever been signed between the two sides of the Chinese civil war. More than seventy years later, the issue remains contentious. The People's Republic of China's position is that Taiwan is a breakaway province that must be retaken, while most people on the island now regard it to be a separate state—even though independence has never been formally declared.

# 12

# The Seventh Earl of Elgin

"Blind are the eyes that do not shed tears while seeing,
O, Greece beloved, your sacred objects plundered by
profane English hands that have again wounded your
aching bosom and snatched your gods, gods that hate
England's abominable north climate."
—Lord Byron, "Childe Harold's Pilgrimage"

Remember James Bruce, the 8th Earl of Elgin, the man who ordered the destruction of the Old Summer Palace in 1860? He may be little known in the West, but he is firmly fixed in the Chinese collective consciousness, as is the belief that China is the exploited party in a struggle over economic and political superiority that is still playing out today.

Educated at Eton and Christ Church, Oxford, James Bruce was the younger son of Thomas Bruce, the 7th Earl of Elgin—the man who removed the infamous Elgin Marbles from Greece. Both father and son had careers as diplomats and were members of the UK aristocracy.

In the 19th and early 20th centuries, members of the British elite were selected as administrators and diplomats to ensure that the

expansion of the empire remained under the leadership and governance of individuals who shared a common vision of colonialism, British maritime supremacy, and military administration.

Both father and son Elgin also happened to be Freemasons. Thomas Bruce was initiated into the Freemasons in 1819 and was exalted into the Royal Arch and held the rank of Grand Zerubbabel from 1827 until 1835. And both served as Earl of Elgin, a title in the peerage created in 1633. The family seat is Broomhall House, three miles southwest of Dunfermline, Scotland, which served as the de facto capital of the Kingdom of Scotland between the 11th and 15th centuries. Most important, both men played critical roles in shaping the British Empire.

Before ordering the looting and burning of the Old Summer Palace, James Bruce (the 8th Lord of Elgin) served as the governor general of Jamaica (1841–1846), then became governor general of Canada (1847–1856). In 1857 he was appointed high commissioner and plenipotentiary in China and the Far East to assist in the process of opening China and Japan to Western trade. That was the position that brought him to Beijing in 1860 and caused him to inflict an incalculable loss on Chinese culture that is still felt today.

James Elgin was the man who compelled the Qing dynasty to sign the Convention of Peking, adding the Kowloon Peninsula to the British crown colony of Hong Kong. Subsequently he served as viceroy of India until his death in 1863 of a heart attack while crossing a swing rope and wooden bridge over the Chadly River in Tibet.

His father, Thomas Bruce, 7th Earl of Elgin, was also a prominent Scottish nobleman, a distinguished member of the Scots Guards, a diplomat, and a collector of art.

In November 1801, while serving as the British ambassador to the Ottoman Empire stationed in Constantinople, Thomas Bruce, the 7th Earl of Elgin, obtained permission from Kaimakam Segut

Abdullah, the Grand Vizier in Constantinople, to allow his people to perform excavations around the Acropolis in the city of Athens, provided that they would not damage the monuments.

At the time the Ottomans were foreign rulers of Athens—a city-state associated with the development of democracy, philosophy, science, mathematics, drama, literature, art, and many important advances in world culture and civilization. Athens was burned to the ground by the Persians in 480 B.C.E. and rebuilt by statesman Pericles (495–429 B.C.E.).

The city fell to rival Sparta after the Second Peloponnesian War (413–404 B.C.E.), but again revived to assume a significant position of leadership among the city-states. After the Battle of Actium, Athens became a province of Rome and thereafter a favorite of a number of Roman emperors, especially Hadrian (117–138 C.E.) who spent money to beautify it. The Apostle Paul is depicted in the Book of Acts as preaching to the Athenians, and it later developed into an important center of Christian theology.

After Greece was conquered by the Ottoman Empire in 1458, Athens entered a long period of decline. In 1801 when Thomas Bruce visited, it was a ghost of its glorious past, occupied by a few thousand mostly peasants living among its ruins.

As an art collector, the 7th Lord of Elgin was fascinated with Athens and Greek antiquities. Especially the Parthenon, which stood on top of the Acropolis—a rocky outcrop rising 490 feet above the city of Athens. At the time of the Parthenon's construction, begun in 447 B.C.E. and overseen by the artist Phidias, the Athenian Empire was at the apex of its power under Pericles. The Parthenon was built as a temple dedicated to Athena, the patron of Athens, and also served as the city treasury. The building itself is the apotheosis of ancient Greek architecture, and according to Greek scholars Arnold Walter Lawrence

and Richard Allan Tomlinson "came as near perfection as is humanly possible, both in design and in meticulous execution."[1]

The building itself was decorated with marble sculptures representing scenes from the Athenian cult and mythology in three categories: The frieze (carved in low relief) ran high up around all four sides of the building inside the colonnades. The metopes (carved in high relief) were placed at the same level as the frieze above the architrave surmounting the columns on the outside of the temple. The pediment sculptures (carved in the round) filled the triangular gables at each end.

The ninety-two metopes depicted scenes of mythical battle. Those on the south flank of the temple included a series featuring human Lapiths in mortal combat with Centaurs. The Centaurs were part-man and part-horse, thus having a civil and a savage side to their nature. The Lapiths, a neighboring Greek tribe, made the mistake of giving the Centaurs wine at the marriage feast of their king, Pirithous. The Centaurs attempted to rape the women, with their leader Eurytion trying to carry off the bride. A general battle ensued, with the Lapiths finally victorious.

After the fall of Athens, the Parthenon served as a church, then a cathedral, then a mosque, each time undergoing more structural changes that had a deleterious effect on the sculptures themselves. The worst damage came in 1787 when Venetians, as part of an alliance of European states trying to recover territory from the Ottoman Empire and commanded by Francesco Morosini, laid siege to Athens. Venetian cannons placed on the ancient Hill of the Muses fired 700 shots at the Acropolis. One cannonball hit the Parthenon's inner chamber, which was being used by the Ottomans as a gunpowder magazine. The resulting explosion killed three hundred people and did extensive damage to the building and its sculpture.

The Venetians succeeded in capturing the Acropolis, but held it for less than a year. Further damage was done in 1687 when Venetian

engineers attempted to remove sculptures from the west pediment and the lifting tackle broke and sculptures fell and were smashed.

After the departure of the Venetians in 1688, and the return of the Ottomans, the building again housed a mosque. The pieces of marble scattered around the ruins, including fragments of metopes, were reduced to lime or reused as building material. In the 18th century, increasing numbers of Western travelers seized pieces of sculpture and took them home as souvenirs.

The Parthenon—the 7th Earl of Elgin saw in early 1800—was a ruin. Initially, he hired a team of artists to produce plaster casts and detailed drawings of ancient Greek buildings, sculptures, and artifacts. In this way he hoped to make his embassy "beneficial to the progress of the Fine Arts in Great Britain."[2]

Among the artists he hired was Neapolitan landscape painter Giovanni Battista Lusieri, who made sketches for Lord Elgin of Greek antiquities. Some historians contend that it was Lusieri who persuaded the reluctant Elgin to remove the sculptures in order to protect them from local Turkish merchants, who were breaking off bits to sell to tourists.

Whether Lord Elgin obtained legal permission to remove the sculptures or not—which is still a subject of debate—the decision to remove marbles attached to the structures was made by Elgin's chaplain and one of his representatives in Athens, Philip Hunt. What is certain is that Elgin's agents removed about half of the Parthenon friezes, fifteen metopes, and seventeen pedimental sculpture fragments, in addition to a caryatid (a woman's figure sculpted into a column), another column from the Temple of Athena Polias on the north side of the Acropolis and sculptured slabs from the Athenian temple of Nike Apteros on the southwest corner—the first fully Ionic temple on the Acropolis—and various antiquities from Attica and other districts of Hellas.

It was a massive haul of some of the world's most important antiquities. Adding insult to injury is the fact that while removing the friezes, Elgin's crew caused considerable damage to the sculptures and the monument itself.

Lord Elgin himself was not present for the removal, but he funded the entire operation to the tune of £70,000 and issued instructions, at one point telling his team, "I should wish to collect as much marble as possible."[3]

The antiquities were then packed in boxes for transport back to England. By mid-1802, a total of twelve huge boxes were loaded onto Lord Elgin's ship, called the *Mentor*. Its journey to England had an auspicious start. On September 16, a favorable wind pushed the *Mentor* to Cape Matapan, the southernmost point of mainland Greece. After being forced to spend the night there because of a strong easterly wind, the next morning the *Mentor* continued its journey. It was during this leg of the trip that the captain realized his ship was taking on water. The captain and crew, being unfamiliar with the geography of the area, set out for a port on the nearby island of Kythera.

Upon reaching the shores of Cape Avlemonas, two anchors were cast, but they failed to catch the bottom. Unmoored and continuing to take on water, the *Mentor* crashed into the rocks of Cape Avlemonas and sank into the sea. Fortunately for the men on board, they were rescued by a passing Austrian vessel named the *Anikitos*. But the sixteen boxes of Greek antiquities sank to the bottom of the sea.

Upon hearing of the disaster, a horrified Lord Elgin quickly organized a salvage mission. In a monumental effort that took three years and involved local authorities and divers from the island of Kythera, as well as British and other diplomatic personnel, the Parthenon sculptures were successfully salvaged, loaded onto another ship, and made their way to England.

Lord Elgin joined them in 1806, and the Elgin Marbles remained in his castle in Scotland for the next ten years.

Meanwhile, an outcry arose among British intellectuals over Elgin's actions. He was assailed in print by Lord Byron and others of vandalism, dishonesty, and naked greed for hauling the Greek treasures to London.

In Lord Byron's poem "The Curse of Minerva," he imagines Minerva—goddess of wisdom, justice, law, victory, and the sponsor of arts—appearing before Lord Elgin and addressing him:

> *Mortal!—'twas thus she spake—that blush of shame Proclaims thee Briton, once a noble name; First of the mighty, foremost of the free, Now honour'd less by all, and least by me: Chief of thy foes shall Pallas still found. Seek'st thou the cause of loathing?— look around.*

Lord Elgin was surprised by the harsh reception he received. After all, he wasn't the first European to haul away pieces of the Parthenon. Two decades before him in 1784 a promising French artist named Louis-François-Sébastien Fauvel received a commission from his country's ambassador to the Ottoman sultan to make exact drawings and casts of Greek antiquities on the Acropolis. For years, the French envoy instructed his young protégé to go much further than drawing or molding, and "Remove all that you can, do not neglect any means, my dear Fauvel, of plundering in Athens and its territory all that is to be plundered."[4]

So, like in the looting of the Old Summer Palace in Beijing almost a century earlier, two of the world's foremost colonial powers were in competition over dividing up the cultural legacy of another country.

To deal with the controversy raging in Britain, a select committee of Parliament was established in 1810 to examine the sculpture and

the possibility of acquiring it for Britain. In an attempt to vindicate himself, Lord Elgin published a defense of his actions in 1810 titled "Memorandum on the Subject of the Earl of Elgin's Pursuits in Greece." In it he claimed that he had merely been securing the survival of precious objects that would otherwise have disappeared. In evidence provided to the special Parliamentary committee, he insisted that "in amassing these remains of antiquity for the benefit of my country, and in rescuing them from imminent and unavoidable destruction with which they were threatened . . . I have been actuated by no motives of private emolument."[5]

He further argued that if the sculptures had remained in Athens, they would have been "the prey of mischievous Turks who mutilated [them] for wanton amusement, or for the purpose of selling them piecemeal to occasional travelers." And he tried to persuade the committee that he had enlarged the scope of his antiquarian project—from merely drawing or molding ancient sculptures to taking them away—only when it became clear to him that the unique treasures were in danger.

His claims were met with skepticism for a number of reasons. One, upon his arrival in Istanbul, he had declared an interest in decorating his own house with ancient treasures. Two, contrary to his stated fears, the sculptures that remained in Athens did not vanish. Instead, after the Ottomans left the Acropolis and handed it to the new nation of Greece in 1833, the great citadel and its monuments became a focus of national pride. Protecting, restoring, and showcasing the legacy of the Athenian golden age has been the highest priority for every Greek government since then.

In the face of public pressure, the British parliamentary committee made a very political decision, publicly supporting the conduct of Elgin and ordering the sculptures to be purchased by the British government. This took place in 1816 when the British government paid

Elgin £35,000 (he maintained that he had spent almost £75,000) and deposited them in the British Museum where they remain today.

Starting in 1832, with the dawn of their independence, the Greeks have pleaded for the return of the sculptures taken from the Acropolis and housed in the British Museum and the Louvre. In 1983, the Greek government made its first official claim for the return of the marbles. It also disputed the British Museum trustees' legal title to the sculptures.

The British say the marbles were legally acquired and are best shown alongside other artifacts in a universal museum. The Greeks view them as looted treasures that are a foundation of their national heritage.

The following is the official position of the British Museum:

> The British Museum tells the story of cultural achievement throughout the world, from the dawn of human history over two million years ago until the present day. The Parthenon Sculptures are a significant part of that story. The Museum is a unique resource for the world: the breadth and depth of its collection allows a world-wide public to reexamine cultural identities and explore the complex network of interconnected human cultures. The Trustees lend extensively all over the world and over two million objects from the collection are available to study online. The Parthenon Sculptures are a vital element in this interconnected world collection. They are a part of the world's shared heritage and transcend political boundaries.
>
> The Parthenon sculptures in London are an important representation of ancient Athenian civilization in the context of world history. Each year millions of visitors, free of charge, admire the artistry of the sculptures and gain

insight into how Ancient Greece influenced—and was influenced by—the other civilizations that it encountered.

The Trustees are convinced that the current division allows different and complementary stories to be told about the surviving sculptures, highlighting their significance within world culture and affirming the place of Ancient Greece among the great cultures of the world.[6]

Under its current governing legislation, the British Museum Act of 1963, its trustees are prevented from giving away, selling, or otherwise disposing of collection items. Because the British Museum operated under an act of Parliament which established the museum in 1753, it would require another act of Parliament for the Elgin Marbles to be permanently returned to Greece. And the UK government has been adamantly opposed to proposing any legislation of that sort.

When Andrew Douglas Alexander Thomas Bruce was asked in 2004 to comment on the Greek belief that the marbles are stolen property, he replied, "Totally unfair and completely untrue," before explaining that everyone in Britain "should be proud of what was done" by his ancestor.[7]

The dispute over the Elgin Marbles continues and ranks above all other restitution claims in terms of longevity, notoriety, and insolvability. The fact is that European powers took cultural relics from the places they colonized; the loot from the Old Summer Palace, the Rosetta Stone from Egypt, the Benin bronzes from Nigeria, the Parthenon Marbles from Greece, and the Kohinoor Diamond from India, (now part of the British Crown Jewels).

Museums such as the Louvre and the British Museum are repositories of colonial enterprise. Artifacts belonging to the conquered are displayed in beautiful showcases, offered as objects of study and

research. But these items carry meaning for other peoples and are an important part of their cultural and ritual life. Removed from their social and historical context, they become devoid of their power and meaning, and are treated as mere objects.

There is growing momentum across the world asking for these items to be returned. But, as author Alexander Herman points out, "restitution almost always involves larger issues, which are often historical as well as political." And these issues still need to be overcome.

While it is true that for the Greeks, the marbles of the Acropolis represent a symbol of their own emergence out of a recent oppression, the larger political reality is that Greece as a country currently doesn't rank high in terms of global political or military power. So, despite all the legal conventions of the U.N. and other international bodies, their claims to the Elgin Marbles are stymied and ignored.

China, however, is in a very different position. In terms of economic and military status, they are one of the world's top superpowers and growing stronger every year. For the Chinese people, the artifacts once belonging to the Old Summer Palace are their equivalent of the Acropolis marbles. They, too, represent a symbol of their own emergence out of a recent oppression.

The West seems slow to appreciate the Chinese perspective, which only fuels their sense of *wòxīn-chángdǎn* (臥薪嚐膽), "sleeping on sticks and tasting gall." Like King Goujian, could they be biding their time, slowly undermining their enemy, and waiting for the moment of conquest and revenge?

# 13

# Mao Zedong

"They never really care about culture. This is the nature of the communists. To destroy the old world to rebuild the new one. They are not clear about what is most important in the so-called traditional art classics. The zodiac is the perfect example to show their ignorance on this matter."
—Chinese artist Ai Weiwei

With his victory, ascension to power, and establishment of the People's Republic of China (PRC), Mao declared the Century of Humiliation officially over. Standing before the Consultative Conference in Beijing in an olive-green polyester suit, he announced on September 21, 1949:

> Fellow delegates, we are all convinced that our work will go down in the history of mankind, demonstrating that the Chinese people, comprising one quarter of humanity, have now stood up. The Chinese have always been a great, courageous, and industrious nation, it is only in modern times

that they have fallen behind. And that was due entirely to oppression and exploitation by foreign imperialism and domestic reactionary governments.... Ours will no longer be a nation subject to insult and humiliation.

It is because we have defeated the reactionary Kuomintang government backed by US imperialism that this great unity of the whole people has been achieved.[1]

The suit—known as the Zhongshan suit (中山裝, *zhōngshān zhuāng*)—included baggy pants and a tunic-style button down jacket, and was a modified version of the Chinese military uniform worn during the Sino-Japanese War. Once it was worn by Mao, it became ubiquitous among men in China.

Though the suit looked plain enough it was loaded with symbolic significance. The four pockets represented the Four Virtues in 管子 (*Guǎnzi*), a compilation of the philosophical work named after the 17th-century philosopher, 管仲 (*Guǎn Zhòng*). The five buttons allude to the five branches of government in the constitution of the Republic of China, which are executive, legislative, judicial, control, and examination. And the three buttons on the cuffs stood for Sun Yat-sen's *Three Principles of the People* (三民主義)—nationalism, people's rights, and people's livelihood.

Mao clearly understood the importance of optics in everything he did. After hanging an enormous devotional portrait of himself in Tiananmen Square, he declared that it was time to remake China and to mold the Chinese people into his vision of a new society. To his mind, they were uniquely prepared. He explained why in an essay he wrote in 1958. "Apart from their other characteristics, China's 600 million people have two remarkable peculiarities. They are, first of all, poor and secondly, blank. That may seem a bad thing, but it really

is a good thing. Poor people want to change, want to do things, want revolution. A clean sheet of paper has no blotches, and so the newest and most beautiful words can be written on it. The newest and most beautiful pictures can be painted on it."[2]

And Mao had no doubt that he was the one person that history had chosen to fulfill that legacy. "The great actions of the hero are his own," he wrote as a young man. "In them are the expression of his motive power, lofty and cleansing, relying on no precedent. His force is like that of a powerful wind arising from a deep gorge, like the irresistible sexual desire for one's lover, a force that will not stop, that cannot be stopped. All obstacles dissolve before him."[3]

He believed that his personal struggle embodied that of the Communist Party and that his victory was that of the CCP and thus China itself. He explained this historical process to American journalist Edgar Snow in *Red Star Over China*. Each period of his life, he said, followed a similar pattern: Mao recognized right from wrong and was punished for pointing it out. But after gathering allies to fight with him, he and his ideas eventually emerged victorious.

Mao's narrative of his life story reflected China's struggle for independence from the foreign nations that had established their power over China since the 1839–1842 Opium War. He struggled with his highly traditional father to educate himself in new, Western topics including Marxism. He persevered and struggled with enemies outside the Party and rivals within it, until he won the right to lead the CCP, which was fighting against both the Japanese and Chiang Kai-shek's Nationalist government.

Thus, he saw his personal struggle as analogous to that of the Chinese people and China itself. Born into a rich peasant family, he had witnessed along with the majority of the Chinese people the failure of the imperial system to meet the challenges of modern times.

His solution was to create a socialist society based on the Marxist-Leninist model with a decidedly Chinese twist. Instead of the classic model where a vanguard would seize power on behalf of the urban proletariat and establish a one-party socialist state, a dictatorship of the proletariat, Mao reasoned that in an agricultural, preindustrial society like China, the revolutionary class (or vanguard) could be drawn from the millions of peasants he referred to as *the popular masses.*

In Mao's mind the end-goal of revolution was a utopian conception of a world without government. In June 1949, he wrote: "Don't you want to abolish state power? Yes, we do, but not right now; we cannot do it yet. Why? Because imperialism still exists, because domestic reaction still exists, because classes still exist in our country. Our present task is to strengthen the people's state."[4]

The people's state was the Chinese Communist Party (CCP)—which was the collective manifestation of the people's will. And the state, in the classic Leninist-Stalinist application, would control the means of production and suppress opposition, counterrevolution, the bourgeoisie and promote collectivism, to pave the way for an eventual communist society that would be classless and stateless. From 1949 until 1956, Mao presided over the CCP's control of China, rooting out all opposition, real or imagined, and transforming the ownership of the means of production from private hands to state control.

In a speech titled "On the People's Democratic Dictatorship," delivered on June 30, 1949, Mao explained:

> When classes disappear, all instruments of class struggle—parties and the state machinery—will lose their function, cease to be necessary, therefore gradually wither away and end their historical mission; and human society will move to a higher stage. We are the opposite of the

political parties of the bourgeoisie. They are afraid to speak of the extinction of classes, state power and parties. We, on the contrary, declare openly that we are striving hard to create the very conditions that will bring about their extinction. The leadership of the Communist Party and the state power of the people's dictatorship are such conditions. Anyone who does not recognize this truth is no Communist.[5]

As the scholar-diplomat Richard Solomon first pointed out, Mao reveled in *luan*, or upheaval. For change to come about, Mao wrote early in his career, China must be "destroyed and reformed." In his model, the peasantry, not the urban proletariat, would comprise the vanguard of change.

The "Sinification" of Marxism allowed Mao to maintain popular support for his programs even with early opposition from anarchists, republicans, and others. His ability to meld Marxist ideology with traditional Chinese values made his concepts resonate more with the Chinese people. Because he phrased his teaching in a way that all people could understand, he was able to gain support from both the educated and the peasantry.

His remaking of China started from the ground up. In his land reform program, which he had initiated in the mid-1940s, he and other Communist Party activists encouraged farmers to seize landlords' fields and other property in part to weaken the Nationalists' rural class base and strengthen the Communists' support among the poor. Teams of CCP activists moved through villages mostly in the Communist-controlled North where they organized the poor into "speak bitterness" meetings. These served to crack poor people's age-old fear of the local elite, overcome the traditional respect for property rights, and unleash

their bitterness for being oppressed. Landlords were punished and often killed and their land and property seized.

In 1949, with the CCP in control, Mao unleashed the full hatred of the oppressed peasantry. The party tried to control the process in order not to alienate the broad middle ranks among the farmers and laborers, but land revolution had a dynamism of its own. As a result, China went through a period of terror during which landlords were eliminated as a class, land was redistributed, and, after some false starts, China's countryside was placed on the path toward collectivism.

In every village at least one landlord, and usually several, were selected for public execution. The *Cambridge History of China* estimated that the number of deaths of Chinese landlords ranged between two million and five million. Another 1.5 to 6 million people were sent to "reform through labor" camps where many died. Mao played a personal role in organizing the mass repressions and established a system of execution quotas that he defended as necessary for the securing of state power.

According to historian Michael Lynch, "Mao unashamedly condoned the use of terror. For him, violence was never arbitrary. Cruelty served a revolutionary purpose. . . . The genuine sympathy that inspired and infused his reports on the peasantry somehow became stifled when he suspected that those same peasants were betraying the revolutionary cause."[6]

"Our revolutions come one after the other," Mao stated in 1950. The first had focused on land reform. The next stage of his transformation of China was to turn it into a modern industrial power. Again, Mao invoked the necessity of freeing China from foreign commercial interests, which had strangled the country and its people for one hundred years. In the *People's Daily* in 1953 Chairman Mao explained that "only with industrialization of the state may we guarantee our economic independence and non-reliance on imperialism."[7]

China's First Five-Year Plan ran from 1953 to 1957 and set ambitious goals for industries and areas of production deemed priorities by the CCP. As with land reform and his other programs, Mao claimed that only with total acceptance could the Five-Year Plan achieve success. In the words of Michael Lynch, "anything short of total acceptance of the plan was deemed counterrevolutionary."[8]

The Five-Year Plan was supported by Stalin and Soviet Russia, which contributed advice, logistics, and material support in the form of a modest loan of $300 million and, more important, the services of several thousand Soviet engineers, scientists, technicians, and planners. The immediate results were impressive. Industrial output more than doubled, with an annual growth rate of 16 percent. Steel production grew from 1.3 million tons in 1952 to 5.2 million tons in 1957; the 16.56 million tons produced in 1953–57 was double China's combined steel production between 1900 and 1948.

Steel, coal, and petrochemicals saw the largest increases, with coal production almost doubling between 1952 and 1957. While the First Five-Year Plan achieved its targets of increasing heavy industry and stimulating the economy, the advances worsened the imbalance between rural and urban populations.

A good deal of China's economic growth in the mid-1950s derived from urban, industrial, and infrastructure projects. These served to enhance the quality of life for urban populations, whose numbers grew from fifty-seven million to one hundred million between 1949 and 1957. Life expectancy rose from thirty-six to fifty-seven years, city housing standards improved and urban incomes increased by 40 percent. Workplaces were organized on socialist principles; urban and industrial workers received subsidized housing, medical care, and educational facilities.

While communes exerted a form of social control in rural areas, the *danwei* or work unit was the urban equivalent. David Bray describes

the *danwei* as "the foundation of urban China. It is the source of employment and material support for the majority of urban residents; it organizes, regulates, polices, trains, educates and protects them; it provides them with an identity and face; and, within distinct spatial units, it forms integrated communities through which urban residents derive their sense of place and social belonging."[9] This instilled a form of collective responsibility over daily life, and people were not only accountable to their family, friends, or work colleagues, but to those in leadership positions of the *danwei*.

With the growth of communes in the countryside and *danwei* in the cities, Mao's economic reforms served to centralize state control. The result was that private ownership became virtually impossible. By 1956, approximately two-thirds of industrial enterprises were state-owned, and the remainder were jointly owned by private owners and the state.

Because of central planning and national demands, local needs were often overlooked. This was especially true in the countryside. While 84 percent of the population lived in rural areas, 88 percent of government investment was pumped into heavy industry in towns and cities. The state monopoly on grain and the impact of collectivization also caused disruption and dissatisfaction in rural areas. Many questioned whether the struggling countryside could feed the rapidly expanding cities. As the state diverted grain supply, grain reserves fell, causing food shortages and hunger in some places. New farming techniques and technologies, used with success elsewhere in Asia, were largely ignored.

At a party meeting in Nanking in January 1958, Mao announced a new program that he called the Great Leap Forward. He told delegates that China had followed a different path into socialism than the Soviet Union, and therefore had to allow the peasants to participate in economic modernization and make more use of their labor. Rural collectivization, which had been encouraged previously, now had to

become official government policy. All private farmland, which had been previously confiscated from landlords and redistributed to peasants, was now abolished. In addition, 740,000 agricultural cooperatives were reorganized into 26,000 huge people's communes.

It was an ambitious plan and one that Mao imagined peasants would readily embrace because it would lead them "toward a happier collective life."[10] What he didn't anticipate is that the program to abolish private farmland and collectivize farming would divert millions of peasants to jobs in industry. Or that rural officials, under huge pressure to meet quotas, would vastly overstate how much grain had been produced.

Also, as part of Mao's Great Leap Forward, CCP officials launched the Four Pests Campaign to rid the country of rats, mosquitos, flies, and sparrows. Mao's slogan, *ren ding sheng tian*, meaning "man must conquer nature," became the campaign's rallying cry. But it was a departure from the Daoist philosophy of finding a harmonious balance between man and nature. Instead, Mao was going to utilize China's massive supply of manpower to subdue nature for the benefit of the country and its people.

The reason given for targeting sparrows was that the birds were stealing valuable grain from warehouses and fields—according to official government estimates, four pounds per sparrow per year. One propaganda poster read, ERADICATE PESTS AND DISEASES AND BUILD HAPPINESS FOR TEN THOUSAND GENERATIONS.

A reporter for *Time* magazine described the anti-sparrow campaign in action:

> At dawn one day last week, the slaughter of the sparrows in Peking began, continuing a campaign that has been going on in the countryside for months. . . . And so divisions of soldiers deployed through Peking streets, their

footfalls muffled by rubber-soled sneakers. Students and civil servants in high-collared tunics, and schoolchildren carrying pots and pans, ladles and spoons, quietly took up their stations. The total force, according to Radio Peking, numbered 3,000,000.[11]

The massive anti-sparrow force netted and scatter-gunned the exhausted birds or snared them with long, gum-tipped bamboo poles. According to one report 310,000 sparrows were felled in Peking alone, and an estimated 1,000,000,000 throughout the rest of Red China. The hero of the campaign was sixteen-year-old Yang Seh-mun from Yunnan who claimed that he killed 20,000 sparrows by sneaking around during the day and locating their nests. At night, *China Youth* proudly reported, he climbed trees and strangled whole families of sparrows with his bare hands.[12]

What Mao and the CCP failed to realize was that the mass killing of sparrows would bring ecological repercussions that would cause a humanitarian crisis of epic proportions. The absence of sparrows, which traditionally kept locust populations in check, allowed swarms to ravage fields of grain and rice. The resulting agricultural failures, compounded by misguided policies of the Great Leap Forward, triggered a severe famine from 1958 to 1962. The death toll from starvation reached a staggering 15 to 55 million people, making it the deadliest famine and one of the greatest man-made disasters in human history.

Wrote Dutch historian Frank Dikotter:

> After years of famine, an eerie, unnatural silence descended on the countryside. The few pigs that had not been confiscated had died of hunger and disease. Chickens and ducks had long since been slaughtered. There were no birds left

in the trees, which had been stripped of their leaves and bark, their bare and bony spines standing stark against the empty sky. People were often famished beyond speech.[13]

One thing the Mao government did accomplish was to finally end both the consumption and production of opium in China. At the beginning of his reign in 1949, there were an estimated 70 million opium addicts in China. Launched in 1949 and lasting until 1952, the National Drug Campaign utilized propaganda, rallies, rehabilitation centers, and waves of mass arrests and executions. At the peak of the campaign, the CCP directed that around 2 percent of drug offenders should be sentenced to execution, and authorized the execution of up to a dozen high-level suppliers in strategically chosen cities. The majority of offenders were sentenced to rehabilitation or periods of imprisonment.

In addition, the CCP directed that drug-producing areas within the country be planted with new crops. As a result of the National Drug Campaign, opium production shifted south of the Chinese border into the Golden Triangle region of Thailand, Burma, and Laos.

Although powerfully charismatic, Mao was a man of odd habits and obsessions. He rarely showed himself in public, preferring to conduct state business by his pool, deep inside his palace complex, often garbed in a terry cloth robe and slippers. When he did travel, he did so in secrecy and bringing his own wooden bed.

He followed no schedule or conventional expectations of time, constantly confusing his staff with his erratic habits and bursts of energy. And although married, he had his staff procure a stream of beautiful young women for him to sleep with as he believed that sexual climaxes halted the aging process.

He also believed that by swimming all of China's great rivers, including the mighty Yangtze, he could imbibe the spirit of China.

He also developed an almost maniacal focus on imperialism—which Lenin had called the highest state of capitalism—as the cause of the world's major problems, especially in countries like China that had been targeted because of their wealth or natural resources. It was foreign imperialism, in his mind, that had held back China and forced so many of its people into poverty and mental slavery.

In the essay *On People's Democratic Dictatorship*, Mao explained his own frustration with the West and his ideological transition to Communism. "From the time of China's defeat in the Opium War of 1840, Chinese progressives went through untold hardships in their quest for truth from Western countries. . . . Only modernization could save China, only learning from foreign countries could modernize China. . . . Imperialist aggression shattered the fond dreams of the Chinese learning from the West. It was very odd—why were the teachers always committing aggression against their pupils? The Chinese learned a good deal from the West, but they could not make it work and were never able to realize their ideals. Their repeated struggles, including a countrywide movement known as the Revolution of 1911, all ended with failure."[14]

The depth of his hatred for what he saw as the imperialist West shocked Western leaders. An example of this came in November 1950 during the early days of the Korean War when Mao sent Ambassador Wu Xiuquan to address the United Nations Security Council. Even though that body did not recognize Wu or his government, President Truman and members of his national security staff hoped that Ambassador Wu's presence in New York City would open the door to peace talks.

But when Wu opened his mouth to speak to the packed chamber of the U.N. Security Council, he dashed any hope of reconciliation. "I am here," he said, "in the name of the 475 million people of China

to accuse the United States of an unlawful and criminal act of armed aggression. It is an integral part of the overall plan of the United States to intensify its aggression, control, and enslavement of Asian countries, a further step in the development of interference by American imperialism in the affairs of Asia. The American imperialists have always in their relations with China been the stunning aggressor."[15]

Ambassador Wu made this statement even though the Korean War had started on June 25, 1950, when the Communist leader of North Korea sent his armies into South Korea with the support and advice of the CCP. And every word of his speech had been written by ministers in Beijing with direct consultation from Mao himself.

Later in the speech, Wu expressed Mao's, and what he claimed was the Chinese people's, deep-seated animus toward the United States. According to Mao as voiced by Wu, the United States had always been at war with China in one way or another. Sometimes in the form of a cultural or trade war, sometimes military action. Either way, the United States couldn't seem to help insinuating itself into China's domestic affairs. He cited as proof of US aggression America's interference during the Boxer Rebellion, the patronizing slights of American missionaries, Washington's support of Chiang Kai-shek, and US ground forces driving through North Korea on their way to Manchuria.

"The real intention of the United States," he said, "is to dominate every Asiatic port from Vladivostok to Singapore."[16]

But it wasn't Mao's animus toward the United States that severely dimmed the Chinese people's enthusiasm for Mao's reforms. It was the colossal failure of the Great Leap Forward. The huge loss of life and suffering that resulted also soured many members of the CCP on Mao's vision of socialist transformation.

Mao had been proven fallible, but he still had popular support. And he wasn't finished. Audaciously, his next step was to try to change

how the Chinese people thought about themselves and their history. His goal was to wipe their minds clean of what he called old ideas, old culture, old habits, old customs, and old ways of thinking. Again, to Mao a good part of what had infected Chinese culture, were customs and ways of thinking derived from the influence of Western imperialism.

He and future leaders of China and the CCP would continue to use Western imperialism and the century of humiliation as a justification for its policies toward the United States and Europe. They were themes promoted in textbooks, speeches, and other forms of media, and began to manifest in Chinese attitudes, including those of millions intent on recovering ancient artifacts.

In 1966, at the age of seventy-three, Mao observed that his personality was a blend of contradictory forces, the Tiger Spirit 虎氣 and Monkey Spirit 猴氣—two archetypes in Chinese literature. His Tiger Spirit, Mao explained, had given him the confidence and sense of destiny to defeat Chiang Kai-shek and lead the Chinese revolution. While his anarchic Monkey Spirit made him somewhat paranoid and unpredictable. Now, in the last decades of his life, his Monkey Spirit was ready to take on the Tiger with devilish glee.

In 1961, shortly after his split with the Soviet Union, Mao wrote a poem in praise of the Monkey Spirit (Sun Wu-kung) called *Reply To Comrade Kuo Mo-Jo*.

*A thunderstorm burst over the earth,*
*So a devil rose from a heap of white bones.*
*The deluded monk was not beyond the light,*
*But the malignant demon must wreak havoc.*
*The Golden Monkey wrathfully swung his massive cudgel*
*And the jade-like firmament was cleared of dust.*

> *Today, a miasmal mist once more rising,*
> *We hail Sun Wu-kung, the wonder-worker.*[17]

Sun Wukong 孫悟空 (or the Monkey King or Spirit) was the hero of the late-Ming comic novel *Journey to the West* 西遊記 by Wu Cheng'en 吳承恩, which was later made into a popular TV series starring Liu Xiao Ling Tong and Dehau Ma.

It's a fictionalized account of an actual 7th-century pilgrimage to India made by Xuanzang—in the novel, he's called Tripitaka—a Chinese Buddhist monk searching for sacred texts. One of Tripitaka's disciples is Sun Wukong—also known as the Monkey King—who spends the early section of the novel learning Taoist philosophy on his path to enlightenment. Despite his intellect and accomplishments, Sun Wukong is a chaotic spirit who grates at authority. He eventually rebels against the Taoist deities and leads an assault against heaven. As punishment for his impulsive, conflict-causing ways, the Buddha traps Sun Wukong inside of a mountain for five hundred years.

When he is finally released, forgiveness proves elusive. Instead, he must accompany Tripitaka on his journey, protect him from harm, and aid the monk's mission to find and return Buddhist scriptures to China. He has to work to earn forgiveness through his good deeds. By the story's end, the Monkey King has undergone immense change and learned enough to attain the enlightenment and divinity that long eluded his impulsive and quick-to-anger younger self.

As a fictional character, Sun Wukong represents the untamed mind and the potential for spiritual growth. Through Sun Wukong (the Monkey King), author Wu Cheng'en explores the idea that even the unruliest of spirits can achieve enlightenment through perseverance, self-reflection, humility, and devotion—thus mirroring the Buddhist path to enlightenment.

In his poem "Reply To Comrade Kuo Mo-Ko" and other public statements, Mao shared his relationship with his own Monkey Spirit and how it informed his personal journey. Since he saw himself as a perfect representation of the Chinese people's struggle for liberation and enlightenment, he was in effect announcing the next steps in their (and his) spiritual and political journey. He was working through them and for them. Their spiritual and political evolution was his own. Because he was fully trusting or unleashing his Monkey Spirit, he was warning the Chinese people that his actions would be necessarily bold, unpredictable, and anarchic.

This soon became evident. One of Mao's first steps was to announce his ideological split with the Soviet Union. Since the mid-1950s, the Socialist Bloc led by the Soviet Union was controversial as a result of both of repressive Soviet expansionism in Europe and the ideological uncertainty generated by Nikita Khrushchev's denunciation of Stalin and de-Stalinization of the USSR, which began in 1956. The ideological quarrel between China and the Soviet Union broke into the open at the Romanian Communist Party Congress of 1960, where Khrushchev characterized Mao as being a Chinese nationalist, a geopolitical adventurist, and an ideological deviationist from Marxism-Leninism. The CCP's senior officer Peng Zhen returned the insult calling Khrushchev a revisionist whose regime showed him to be a "patriarchal, arbitrary, and tyrannical" ruler.[18]

In response to these insults, Khrushchev withdrew 1,400 Soviet technicians from the PRC, which canceled some 200 joint scientific projects. In response, Mao blamed Khrushchev for China's great economic failures and the famines during the period of the Great Leap Forward.

Then in late 1962, Mao's government formally broke relations with the USSR because Khrushchev did not go to war with the US over the

Cuban Missile Crisis. In his role as leader of the socialist revolution in Asia and in support of his allies in the Communist bloc, Mao in 1950 had committed 1.4 million Chinese soldiers to defeat the United States in Korea.

Regarding the Soviet loss of face in Cuba, Mao said that "Khrushchev has moved from adventurism to capitulationism" with a negotiated, bilateral, military stand-down. Khrushchev replied that Mao's belligerent foreign policies would lead to an East-West nuclear war.[19]

Mao in his break with the Soviet Union was in effect laying claim to ideological leadership of the world Socialist revolution. He stated unequivocally that Chinese and Soviet differences over the interpretation and practical application of Orthodox Marxism were the result of a counterrevolution in the USSR and reestablishment of capitalism.

The disruptive Monkey King didn't stop there. In 1966, Mao announced that the language and thoughts of ordinary people should act as a guide to the whole country, and launched the Cultural Revolution, which lasted until his death in 1976. He did so by both fomenting and supporting a grass-roots youthful rebellion against the very communist state he had created. And he institutionalized the concept of "permanent revolution" as a way of keeping political fervor and change at a fever pitch in an attempt to guarantee that the people's revolution would never be corrupted by revisionist, foreign, or capitalist influences.

The first group to respond to Mao's call to action was a group of middle-school students in Beijing, who composed a series of manifestos declaring that they, like the Monkey King, would support Chairman Mao in creating an uproar in heaven and smashing the old world to pieces. Proclaiming that "Rebellion is Justified," they quoted a line from Mao's 1961 poem:

*The Golden Monkey wrathfully swung his massive cudgel.* 金猴奮起千鈞棒，
*And the jade-like firmament was cleared of dust.* 玉宇澄清萬里埃[20]

Soon spontaneously organized groups of young people wearing red armbands and carrying a volume of quotations from Mao and bits of his revolutionary wisdom—known as the Little Red Book—swept the country, purging moderates and capitalist revisionists from the party. Calling themselves the Red Guards, they attacked anyone suspected of being a class enemy including their own parents and teachers. Revolutionary posters appeared on campuses throughout the country spurring them on. One read: "Beat to a pulp any and all persons who go against Mao Zedong though no matter who they are, what banner they fly, or how exalted their positions be!"[21]

As one group of Red Guard students wrote in the popular magazine *People's China*, "Revolutionaries are Monkey Kings, their golden rods are powerful, their supernatural powers far-reaching, and their magic omnipotent, for they possess Mao Zedong's invisible thought."[22]

Taking their cue from one of Mao's poems, these youth of Beijing chose the classical symbol of Chinese rebellion, the Monkey King, to express their new spirit of rebellion.

One Western witness was in Tiananmen Square on National Day, October 1, 1966. He wrote, "Millions of young Chinese . . . in their new Red Guard arms bands and Mao badges, poured into Tiananmen Square . . . waving their little red books and shouting, 'Chairman Mao! Chairman Mao!' . . . Along with their shouting was hysterical weeping. It was a far cry from the orderly parades of past years. . ."[23]

Two months earlier, in what became known as Bloody August, Mao and his deputy Lin Biao had encouraged the Red Guards to destroy

what he called the Four Olds: Old Ideas, Old Culture, Old Habits, and Old Customs. A wave of youthful revolutionary fervor swept that country that sometimes manifested itself in violence, as anyone representing what the Red Guards considered the old order was denounced, attacked, beaten, and even killed.

Mao is said to have written to Jiang Qing, his wife and partner in revolutionary extremism, declaring that "Once heaven is in great disorder a new kind of order can emerge 天下大亂達到天下大治."[24] He believed that throwing the political establishment and social order into confusion would liberate the true potential of people to achieve what was otherwise seemingly impossible. A high tide of revolutionary enthusiasm would allow people to cast aside the deadening bureaucracy and revitalize industry, agriculture, research, and society itself. Under the guidance of Mao Zedong the goal of making China great again could be realized on the world stage.

But as he had done during the Korean War, which resulted in the deaths of an estimated half a million poorly trained soldiers, or the rural famine caused by the Great Leap Forward, Mao showed little sympathy for the massive loss of human life that resulted from his programs, or the disruption and pain it caused the Chinese people. Or the destruction the Cultural Revolution brought to thousands of cultural artifacts.

After launching the Four Olds, nothing related to traditional Chinese culture was safe from the Red Guards. Libraries were ransacked, monuments destroyed or severely damaged, and religious sites and tombs of historical figures were looted and desecrated. They included the tomb of the Ming dynasty Emperor Wanli and the remains of the emperor and his wife, which were unearthed and burned.

The damage to China's literature, scrolls, and other classics was massive and incalculable. Antiques were destroyed or stolen by the Red

Guards, who searched and ransacked homes of people considered to be bourgeois—middle-class people who were thought to have materialistic values. Even families' long-held genealogy books and ancestor paintings were confiscated or reduced to ashes.

It was, in a sense, a bizarre self-inflicted echo of the looting of the Old Summer Palace—an effort to wipe the cultural, historical, and religious consciousness of China clean and start over.

Then, incredibly, the Red Guards attacked the Old Summer Palace itself. This monument to British and French imperialism, this vast complex of palaces, gardens, and lakes was built during the 18th and 19th centuries by the emperors of the Qing dynasty. It had been looted and burned to the ground by French and British troops in 1860 during the Second Opium War in an act of cultural terrorism. Red Guards now destroyed what remained of the Palace.

Then they turned their wrath on the birthplace of Confucius, perhaps China's greatest and most influential philosopher. The Temple of Confucius had been consecrated by Emperor Gao of the Han dynasty and was located in Qufu in southwest China. It was a UNESCO World Heritage Site. One of the largest and most renowned temples in East Asia, it contained many important artifacts, including ancient tablets, calligraphy, and bronze vessels. In November 1966, roughly 200 staff members and students from Beijing Normal University led by prominent female student leader Tan Houlan (谭厚兰),—described by Mao as "quite young with two small braids, but with cannons" pointed at her rivals—descended on the temple vandalizing it and destroying more than 6,000 artifacts.

Next, they moved on to the nearby Cemetery of Confucius where they dug up the corpse of Qing dynasty official and distant relative of Confucius Duke Yansheng Kong Lingyi and hung it naked from a tree.

It is difficult to estimate the total number of objects that were destroyed during the Cultural Revolution, as many of the losses were not recorded. In the book *Mao's Last Revolution* authors Roderick MacFarquhar and Michael Schoenhals claimed that by the end of the Cultural Revolution, 4,922 of the 6,843 officially designated historical interest sites in Beijing had been destroyed. Other scholars believe that the number of valuable artifacts destroyed was much higher—probably in the hundreds of thousands. Most agree that the loss of those objects and sites represented a significant blow to China's cultural heritage, and their destruction had a profound impact on the country's people.

By the spring of 1967, as the chaos spiraled out of control and Red Guard factions began to fight pitched battles against each other, Mao allowed his first vice chairman, Zhou Enlai, to call in the People's Liberation Army to restore order. But it wasn't until Mao's death a decade later that the Cultural Revolution fully ended.

The Cultural Revolution was indeed the culmination of Mao's efforts to transform Chinese society. It did overturn traditional family relationships and called into question traditional knowledge and learning. Anything that didn't conform to Mao's concept of communist revolution was discredited, along with all political and intellectual authority. The concept of class was redefined from ownership of property, education, knowledge, and family background to membership and rank within the Communist Party. To some critics the Cultural Revolution was a period in which traditional Chinese society was destroyed, with deep repercussions to the present.

Mao did succeed in driving out imperialism, advancing women's rights, and almost doubling the Chinese population from 550 million to 900 million during his twenty-seven-year reign. But it also saw the highest death toll of any 20th century leader, with estimations of the collective number ranging as high as 80 million.

# 14
# Antiquities Traffficking Unit

> "Truth is not always beautiful, nor beautiful words the truth."
>
> —Lao Tzu

René Magritte once declared that "Art evokes the mystery without which the world would not exist."[1] Author Leo Tolstoy called art "a human activity consisting in this, that one man consciously, by means of certain external signs, hands on to others feelings he has lived through, and that others are infected by these feelings and also experience them."[2]

To Pablo Picasso, "the purpose of art is washing the dust of daily life off our souls."[3]

Though there is no universal definition of what constitutes art, there is a general consensus that art is the conscious creation of something beautiful or meaningful using skill and imagination. The German philosopher Immanuel Kant defined art as "a kind of representation that is purposive in itself and, though without an end, nevertheless promotes the cultivation of the mental powers for sociable communication."[4]

Clearly, the definition and perceived value of works of art have changed throughout history and in different cultures. A Jean-Michel Basquiat painting that sold for $110.5 million at Sotheby's auction in May 2017 would probably have had trouble finding a buyer in Victorian England. The soapstone sculpture of Chinese philosopher Lao Tzu probably holds more cultural significance to someone born and raised in China than to a Western tourist viewing the Swedish royal family's collection of ancient Chinese artifacts.

One sees them as looted cultural icons, symbols of their country's shameful past. The other as a visually pleasing object from another time and place, not understanding how it ended up in Europe.

H. W. Janson, author of the classic textbook *The History of Art* wrote, "We cannot escape viewing works of art in the context of time and circumstance, whether past or present. How indeed could it be otherwise, so long as art is still being created all around us, opening our eyes almost daily to new experiences and thus forcing us to adjust our sights?"[5]

In the 21st century people are starting to examine the meaning of art and cultural artifacts in the context of time, place, and history. They're asking questions about the circumstances under which certain works of art ended up in another country and how they relate to the legacy of colonialism.

How, for example, did Ethiopia's Maqdala Collection end up in London's Victoria and Albert Museum? Why are thousands of Benin bronzes housed in the British Museum?

The answer to these questions is that they were taken by military force and later sold as the spoils of war. Today many of them are housed in the world's most prestigious museums like the Louvre, the British Museum, and New York's Metropolitan Museum of Art, where they are

beautifully displayed and labeled and their aesthetic value is explained in guided tours. But the museums rarely offer any mention of their ignominious past.

According to the International Council of Museums, their member museums are:

> ". . . in the service of society that researches, collects, conserves, interprets, and exhibits tangible and intangible heritage. Open to the public, accessible and inclusive, museums foster diversity and sustainability. They operate and communicate ethically, professionally, and with the participation of communities, offering varied experiences for education, enjoyment, reflection, and knowledge sharing."[6]

Backed by governments, boards of directors, world-renowned curators, and distinguished trustees, these museums give the appearance of institutions impervious to shame. But scratch the surface or examine the provenance of individual items and what reveals itself is often a history of violence and colonial exploitation like that which took place in China at the end of the 19th century.

As author Alexander Herman wrote: "Traditionally the museum's perspective is focused on the object's aesthetic appeal, its authenticity, and its cultural importance, not on the method of its removal or any of the subsequent dealings that led to its deposit at the museum."[7]

Many looted antiquities end up in the world's major art and artifacts markets. And the problem is huge. According to Alex W. Barker, writing in the *Annual Review of Anthropology*, "Growth in the scale and impact of looting continues to outpace remedies; causes for looting have expanded . . . and a growing range of arguments and theoretical constructs challenge both the efficacy of efforts to combat looting and

the ethical mandate for archaeologists or governmental authorities to do so.[8] A UN report issued in 1999 estimated the annual trade in illicit antiquities at $7.9 billion.[9]

Said Barker, "The scale of looting is daunting . . . ranking behind only drugs and arms trafficking."[10]

In western Turkey, of the 400 Lydian burial tombs inspected, 90 percent showed signs of looting. Similarly, experts report that an estimated 80–90 percent of Djenné-Djenno sites in the Niger River Valley and the archaeological sites in the southwestern region of the entire Republic of Niger have been looted. The same fate applies to 95 percent of Native American graves in southwestern Virginia and 98 percent of the Buddha statues that once stood at Angkor Wat in Cambodia. In China, the State Bureau of Cultural Relics estimated that over a five-year period more than 220,000 tombs were robbed.

Looted art, until recent years, hasn't been treated as a serious crime. But now that that interest has grown in the legacy of colonialism and protecting cultural heritage, federal and state prosecutors have taken aim at dealers, collectors, and museums alike.

In 2003, in a landmark case the Second Court of Appeals in New York upheld the conviction of Frederick Schultz, an antiques dealer and president of the National Association of Dealers in Ancient, Oriental and Primitive Art, for conspiracy to receive stolen antiquities from Egypt and bring them into the United States. In its decision the Court affirmed that the export of cultural material in contravention of a country's heritage law would be considered theft for the purposes of US criminal prosecution. It also added legal heft to the 1970 Convention on the Means of Prohibiting and Preventing the Illegal Import, Export, and Transfer of Ownership of Cultural Property. Art dealers and museums took notice.

Important convictions followed in which the Republic of Iran sued the Barakat Gallery in London over Bronze Age artifacts smuggled out of Iran. Then in 2007 the Getty Museum in Los Angeles was forced to return forty pieces looted from an Etruscan tomb north of Rome.

Perhaps the most active prosecutor in the area of restitution is assistant district attorney of New York County Matthew Bogdanos, a retired Marine colonel and amateur middleweight boxer who became chief of the Antiquities Trafficking Unit (ATU). The unit, which is comprised of lawyers and a team of art trafficking analysts, came into being during an uptick in the illegal trade in antiquities, bolstered by the terrorist group ISIS's systematic looting of archaeological sites in Syria.

Said Manhattan district attorney Cyrus Vance Jr., "Since 2012, my office has recovered several thousand trafficked antiquities collectively valued at more than $150 million, including the beautiful stolen statues being returned to the Lebanese Republic. When you put a price tag on these artifacts, however, it is too easy to forget that these... are rare, celebrated remnants of entire civilizations' culture and history."[11]

In October 2011, New York prosecutors seized an Iranian limestone bas-relief from a London dealer, a wine glass dating from the 4th century B.C.E. and a fish plate that was being auctioned at Christie's.

While some cases are about outright looting or fraud, in many instances the origins of the antiquities were obscured or hidden. Emma C. Bunker was a prolific scholar, publishing extensively on Chinese and Southeast Asian art until she died in 2021. And she was a board member of the Denver Art Museum, which named its Southeast Asia art gallery in her honor. Ms. Bunker was credited, along with Bangkok-based dealer and collector Douglas Latchford, with writing three books on Southeast Asian art.

Starting in 2011, she was also named in five civil and criminal cases over the sale of illicit antiquities. Court records and personal emails showed that Bunker used her lofty position and reputation to help Latchford fabricate ownership histories for looted artifacts and market his stolen antiquities to wealthy collectors and museums.

A Federal agent explained the consequences of the practice in a 2016 criminal complaint: "Misrepresenting the true provenance of an antiquity is essential for selling stolen items in the market, because false provenance prevents the items from being easily traced and enables ownership records to be falsified to predate the patrimony laws of the antiquity's country of origin."[12]

Other tactics used by shady brokers have been to attribute provenances to dead collectors or to photocopy provenances to use in multiple sales.

Said one restorer after pleading guilty to assisting in a large looted antiquities ring, "I avoided asking questions, because I was suspicious that the answers would reveal that the objects were stolen."[13]

In 2018 Kim Kardashian—who is arguably one of the most photographed women in the world—appeared in an image that caught the attention of Matthew Bogdanos and members of the ATU. Outfitted in a body-hugging gold Versace gown, the reality TV superstar posed alongside a gold 2,000-year-old Egyptian coffin inside a private gallery at the star-studded Met Gala.

The Met Gala is held every year in New York's Metropolitan Museum of Art, which is the largest museum in the United States. And it's regarded as the world's most prestigious and glamorous fashion event.

The event has had its own share of controversy. In 2015 the theme of the Gala was "China: Through the Looking Glass." To some critics it was, "A reminder of the subtle institutionalized racism that's been compounded by centuries of Asian isolationism across the board, and

enduring Western stereotypes exacerbated by ignorance and the memeable nature of social media."[14] One of the most criticized actresses was Sarah Jessica Parker, who wore a headdress that was thought to conform to the Dragon Lady stereotype that had been previously applied to Empress Cixi.

None of the thousands of tweets and social media messages posted about the event mentioned the gold 2,000-year-old Egyptian coffin that Kim Kardashian posed alongside. But D.A. Bogdanos and the ATU took a great interest. An investigation revealed that the Met had bought the piece from a dealer who had provided the museum with a poorly forged export license. The coffin had indeed been looted from Egypt. In early 2019, the museum agreed to return it.

The gold Egyptian coffin involved one of nine separate search warrants Bogdanos and the ATU have obtained since 2017 to seize artifacts from New York's Metropolitan Museum of Art, which is the largest museum in the United States. Six of them came in 2022 and involved more than thirty cultural artifacts from Greece, India, Egypt, Libya, and other countries.

In December of 2021, billionaire New York collector Michael Steinhardt surrendered 180 stolen objects worth $70 million after authorities determined that they were looted and illegally smuggled out of eleven countries, and were trafficked by a dozen criminal smuggling networks. They also lacked verifiable provenance prior to appearing on the international art market.

Among the pieces surrendered was *The Larnax*, a small coffin from the island of Crete, dating back to 1400 B.C.E. It was valued at $1 million and was bought by Steinhardt for $575,000 in October 2016 from known antiquities trafficker Eugene Alexander, the D.A. said.

Payments for the piece were made using Seychelles-headquartered FAM Services and Satabank, a Malta-based financial institution

that was suspended for money laundering, according to the D.A.'s office.

While complaining about a subpoena requesting provenance documentation for another stolen antiquity, Mr. Steinhardt pointed to the *Larnax* and said to an Antiquities Trafficking Unit investigator, "You see this piece? There's no provenance for it. If I see a piece and I like it, then I buy it."[15]

Countered Bogdanos, "People who deal in antiquities are capable of the same criminality as common hoodlums on the streets of lower Manhattan." And he told the International Consortium of Investigative Journalists, "The pace is picking up. Expect it to pick up more."[16]

Bogdanos and his team have delivered on their promise. Since 2017, the Antiquities Trafficking Unit estimates that it has recovered 5,776 artifacts worth an estimated $457 million. In April 2024 alone, thirty-eight artifacts were returned to China, twenty-seven to Cambodia, ten to Egypt, and three to Indonesia. All were stolen, according to New York State law.

Some museums in other states have questioned the ATU's jurisdiction. Currently the Art Institute of Chicago is challenging Bogdanos's effort to return an Egon Schiele painting named *Russian War Prisoner* (1916) that the ATU claims was stolen from Jewish art collector Fritz Grünbaum during the Holocaust. Last year the Cleveland Museum of Art sued the Manhattan D.A.'s office to prevent it from seizing a bronze statue of a Roman emperor worth $25 million, which is the centerpiece of its classical galleries. D.A. Bogdanos alleges that it was removed illegally from a Turkish archaeological site before it was sold in New York in 1986.

Dealers, collectors, and museums have been put on notice. Some have protested. Joanna van der Lande of the British trade group, the Antiquities Dealers' Association said of Bogdanos, "He's used a

sledgehammer to crack a nut. He's destroyed the New York market" by creating "massive uncertainty" among collectors and dealers. In 2016, Sotheby's moved its antiquities sales to London, which D.A. Bogdanos has pointed out is beyond his jurisdiction.[17]

The ATU is not the largest art-crime fighter in the United States. That distinction goes to the FBI's Art Crime Team, created in 2004, partly as a result of the looting of the Iraq Museum. Currently it's comprised of twenty-five agents, who take the lead or assist the FBI's fifty-six field offices with cultural properties crime investigations. Since its inception, the team has recovered tens of thousands of objects valued at over $900 million.

The FBI Art Crime Team is a member of the Cultural Antiquities Task Force (CATF). Created by the US State Department in 2004 at the direction of Congress, the CATF comprises federal agencies that share a common mission to combat antiquities trafficking in the United States and abroad. Since its creation, the CATF has supported more than ninety-five domestic and international cultural property training programs. CATF is managed by the State Department's Cultural Heritage Center.

The FBI Art Crime Team's largest seizure came in 2013 after it received a tip about an amateur archeologist named Don Miller living in rural Rush County, Indiana, who had amassed a vast collection of ancient artifacts including Native American skulls and bones. When Tim Carpenter of the FBI's Art Crime Team knocked on Don Miller's door, he was greeted by a tall, thin ninety-one-year-old man who was eager to show him his collection.

FBI Special Agent Carpenter didn't know what to expect. Upon entering the basement, he said, "I just stopped. I stood there and looked around, like, you've got to be shitting me."[18]

Before him stood floor-to-ceiling glass cases, lighted and hand-labeled like in a museum. In them were displayed an Egyptian

sarcophagus, Ming-era vases, 2,500-year-old Chinese jewelry, Aztec figurines, Nazi helmets, and much more. A mind-blowing 42,000 objects in all.

Miller explained how he had traveled the world as a Christian missionary and had personally dug up each single artifact. As his wife Sue served tea, he explained to Carpenter that in the 1940s he had worked at the Los Alamos National Laboratory on the Manhattan Project for J. Robert Oppenheimer. One of the glass cases held a radio system that Miller said sent the signal that detonated the first atomic bomb. He even had a picture of himself standing outside the bunker.

The visit led to the greatest seizure of cultural property ever. Miller, who it turned out did work for three decades at the Naval Avionics Center in Indianapolis, did philanthropic work in his community, and spent his vacations with his wife going on archeological digs all over the world, cooperated with the FBI.

The agency was still in the process of cataloguing the items and repatriating them to Native American groups, as well as Mexico, Peru, Iraq, and other countries when Miller passed away in 2015. He was never charged with any crime.

When asked in 2024 how Miller was able to smuggle into the United States over 40,000 ancient artifacts he claimed he dug up himself, the FBI answered, "The investigation is still ongoing."[19]

In February 2019, 361 artifacts in Miller's collection that rightfully belonged to China were returned at a ceremony held at the Eiteljorg Museum of American Indians and Western Art in Indianapolis. Included were Ming dynasty vases, jewelry, and other art. Hu Bing, deputy administrator of the Chinese National Cultural Heritage Administration, called the event a "new starting point to, together with the US side, establish and improve mechanisms for information sharing of stolen cultural property."[20]

"The items should be displayed in China to let people have a look," added Jun Liu, deputy consul general of the Chinese Consulate General in Chicago, who was also at the repatriation ceremony. He went on to praise the cooperation between the US and China, and added that such cooperation shows "respect for cultural rights and national emotions of peoples from across the world."

The largest dedicated art crime unit in the world is Italy's Carabinieri Art Squad, that has a staff of several hundred compared to the ATU's nineteen and the FBI's twenty-five.

Scotland Yard established its Art and Antiques Unit in 1969, disbanded it, and then reestablished it in 1989. The unit has seen remarkable success in recent years as museum theft in London has gone down by more than 60 percent, with an average annual recovery of £7 million ($11.3 million) worth of stolen art.

Spain and France also have dedicated art squads. Recently, law enforcement bodies in Canada and the Netherlands have established their own. Most countries have no dedicated art crime units, indicating that their government administrations may not consider art crime of sufficient severity to warrant a department of its own.

Today, Interpol's Stolen Works of Art Department acts as an information-gathering point for world art police, keeping track of reported crimes and stolen objects in a database and functioning as a point of reference. In 2016, Interpol, along with Europol and the World Customs Organization, launched Operation Pandora, an international effort that has connected operatives with dedicated experts who help to confirm, find, and identify stolen items. As of last year, they recovered 147,050 cultural artifacts and they arrested over four hundred people for illegally trafficking stolen cultural artifacts including coins, paintings, and sculptures. Among the countries participating are Austria, Belgium, Bulgaria, Bosnia and Herzegovina, Croatia, Germany,

Greece, Italy, Malta, the Netherlands, Poland, Portugal, Romania, Serbia, Switzerland, and the UK.

Noah Charney is an art and art crime historian, as well as a published author. In 2009 he founded the Association for Research into Crimes Against Art (ARCA), to create a bridge between academics and law enforcement by teaching police about art crime strategy with theory and practical knowledge. ARCA focuses on bringing together experts from diverse art, archaeology, criminal justice, and law backgrounds to collaborate and share knowledge, research, and resources, with the intent to analyze and address the nuances of cultural property crime more efficiently.

In the last decade and a half, the effort to identify, track down, and arrest dealers and collectors of stolen cultural artifacts has grown more robust. Major museums around the world are feeling the pressure. An investigation published last March by the International Consortium of Investigative Journalists (ICIJ), in collaboration with the UK-based nonprofit Finance Uncovered, found more than 1,000 relics in the Metropolitan Museum of Art's collection with links to traffickers, 309 of which were still on display.

"The Met sets the tone for museums around the world," said Tess Davis, executive director of the Antiquities Coalition, an organization that campaigns against the trafficking of cultural artifacts. "If the Met is letting all of these things fall through the cracks, what hope do we have for the rest of the art market?"[21]

Met spokesperson Kenneth Weine responded by defending its acquisition practices. "The Met is committed to the responsible collecting of art and goes to great lengths to ensure that all works entering the collection meet the laws and strict policies in place at the time of acquisition," he said.[22]

By May 2023, after more than a year of repeated seizures of looted or stolen artifacts by the Manhattan District Attorney's Office, and

publication of the ICIJ report, the Met finally changed its approach. In an internal letter to staff, Met director and CEO Max Hollein announced that the museum would create a dedicated four-person provenance research team to proactively identify looted artworks in its 1.5 million–piece collection.

Later published on the Met website, the letter read: "The emergence of new and additional information, along with the changing climate on cultural property, demands that we dedicate additional resources to this work."[23]

The Met isn't alone. Since 2020, the Art Institute of Chicago has maintained three positions solely dedicated to provenance research. Other museums have followed in Boston, Philadelphia, and San Antonio. The Getty Museum in Los Angeles, which has been the subject of several court-ordered restitutions, has a staff specialist who is dedicated to their provenance project, which includes a collections management database that enables users to track the provenance of every object in their collection.

Said Cathy Herbert, who has over twenty years of experience at the Philadelphia Museum of Art (PMA) as coordinator of collections research and documentation, "We are making progress. And a big part of that is looking at the question of repatriation claims, not just from the point of view of what's strictly legal and therefore should be returned. But now looking at things through an ethical lens."[24]

Victoria Reed, the provenance researcher at the Museum of Fine Arts Boston (MFA Boston) for the last twenty years, said that earlier in her career, "museums were primarily looking at Nazi-era provenance. They were assessing their collections and seeing where they might have gaps or questions about works of art that may have been looted as a result of the Holocaust or World War II."

Since then, however, the scope of that work has changed. "In the first decade of the century, museums began to scrutinize the provenance of their antiquities, particularly classical antiquities and other archaeological materials. The museum guidelines changed in 2008, requiring any new acquisitions of ancient archaeological materials to have a documented provenance back to 1970."[25]

Now, she added, "there are calls to examine works of art that may have been acquired, traded, or looted under periods of colonial occupation, whether that is European occupation of countries in Africa or settler colonialism here in North America."[26]

While provenance is important in terms of the legal ownership claims of items in auction houses and museums, it can still be extremely challenging to establish an unbroken chain of documented ownership from the time of an object's creation to the present. This chain of documented ownership becomes a major stumbling block when trying to lay claims to items that were looted from the Old Summer Palace.

As Professor Louise Tythacott of the SOAS University of London has pointed out there exists no record of the artifacts at Yuanmingyuan at the time it was overrun by French and British troops in October 1860. Adding to the complexity of establishing what specific objects were at Yuanmingyuan when it was looted is that Chinese imperial collections were often moved from one royal palace to another.

Although British and French troops led the takeover of the Old Summer Palace, Indian army troops and local villagers also participated in the pillage. James M'Gee, a chaplain attached to the British Army, described seeing large parties of local Chinese from the adjacent village of Haidian "plundering their own emperor."[27]

And while descriptions of the collections were made by a number of British and French officers as they toured the imperial buildings the night before the looting took place, few of them mentioned specific items. That makes it difficult to trace the path of individual artifacts as they moved from auction houses to personal collections to museums.

After being pillaged from the Old Summer Palace, some imperial objects were sold by local art markets in Beijing. Others were sent by individual looters to Shanghai, Tiajin, Canton, and Hong Kong, where they were sold to dealers and collectors. Nick Pearce of the University of Glasgow wrote, "The war and its aftermath offered opportunities for looting other sites and indeed for acquisition in other ways and once objects entered the marketplace the provenance becomes even more tenuous."[28]

Linking specific objects to the looting of the Summer Palace became more complicated in 1900 after Beijing and areas of northern China were pillaged by eight foreign armies at the end of the Boxer Rebellion. Additional Chinese artifacts were looted and showed up for sale in auction houses in Europe. Again, at the end of the 19th century additional works from renowned Chinese collections entered the market during the financial and political upheaval that occurred during the dissolution of the Qing dynasty.

There are unexpected practices complicating the provenance issue as well. During the 20th century, the fact that an object was associated with the looting of the Old Summer Palace seemed to increase its value. According to Chinese art expert Joe-Hynn Yang:

> It became a selling point if the provenance were embellished by saying it came from the sacking of the Summer Palace.... People collected these things without actually noting the

record for every particular item. There was very little paperwork and documentation.[29]

Art historian Louise Tythacott maintains that a number of artifacts can be securely provenanced to the Old Summer Palace. For example, artworks looted from the Old Summer Palace were acquired by Lord Elgin's first attaché, James Frederick Stuart-Wortley, who gave them to his brother, the 1st Earl of Wharncliffe, whose collection was later sold at Christie, Manson and Woods in 1920. A gold jug presented to Lieutenant-General Sir James Hope Grant, commander-in-chief of British forces, was later donated to the Edinburgh Museum of Science and Art in 1884. These are just a few.

As mentioned before, the Chinese artifacts looted from the Yuanmingyuan by French troops and presented to Emperor Napoleon III and his wife Eugénie were split between the Musée de L'Armée and the Château de Fontainebleau. The Musée Chinois at the Fontainebleau holds the majority of the pieces, at several hundred.

Increasingly, in the postcolonial world of the 21st century, museums are addressing the problematic histories of certain collections. The current description of the Chinese collection at the Château de Fontainebleau reads, for example:

> Arranged by Empress Eugénie, wife of Napoleon III, in 1863 on the ground floor of the Gros Pavillon of the château, the Chinese Museum of Fontainebleau exhibits remarkable collections of artwork and furniture from the Far East, showcasing the fashion of the era.
>
> The 800 or so objects on display—300 of which come from the Sack of the Summer Palace of Beijing in 1860—originate

from China, Japan, Cambodia, and Korea. They reveal the eclectic taste of nineteenth-century art collectors.[30]

While these steps by Western museums to admit to the troubled histories of certain collections and objects might be considered a step forward to the perspective of Western sensibilities, to the Chinese they still fall short of the restoration of their cultural legacy.

## 15

# Deng Xiaoping

"Observe calmly; secure our position; cope with affairs calmly; hide our capacities and bide our time; be good at maintaining a low profile; and never claim leadership."

—Deng Xiaoping

When Mao launched the Cultural Revolution in the summer of 1966, Deng Xiaoping was considered the fourth most powerful man in the country and Mao's presumed successor. A much more practical man than Mao, Deng refused to buy into Mao's extremist policies. For this, he was taunted and attacked by the Red Guards, who took over his house in the summer of 1967.

One of his daughters wrote:

> The Zhongnanhai rebels (Red Guards) swarmed into our home. They took Papa and Mama out to the garden and surrounded them. Rebels pushed their heads down and forced them to bend at the waist, demanding that they confess. Roar of "Down with them!" shook the air. A string of accusations

followed, and a babel of voices yelled questions. . . . Papa was rather deaf. Standing, half-bent, he could hardly hear anything, and could answer none of their questions. He tried to offer an explanation, but the words were barely out of his mouth when he was rudely interrupted. The rebels said he had a bad attitude, that he was feigning ignorance to avoid replying.[1]

In 1968, Deng was dismissed from all CCP and government positions and sent to a remote section of Jiangxi Province to work in a tractor factory. His son, Deng Pufang, was hounded by Red Guards until he jumped from a window at Peking University. He didn't die, but was left a paraplegic.

Deng himself was forced to write a self-criticism in which he confessed, "because of my bourgeois world view . . . I have ended up as the greatest follower of capitalism within the Party."[2]

Four years later, as Mao saw events spiraling out of control, he summoned Deng back to Beijing to help restore stability in the government and the CCP, and jump-start the economy. Following Mao's death on September 9, 1976, Premier Hua Guofeng succeeded him as chairman of the CCP and de facto leader of China.

But Deng, who was given high-level positions in the party, military, and government, was the person running much of the country. Not as ideological as Mao, he was focused on producing results. He explained his philosophy for restoring production: "I would support whatever type can relatively easily and rapidly restore and increase agricultural output, and whatever type the masses are willing to implement should be adopted. If it is not yet legal, then it should be legalized. Yellow or white, a cat that catches mice is a good cat."[3]

In December 1978 at the Eleventh Party Congress, Deng elaborated. "Let us advance courageously to change the backward condition of our

country and turn it into a modern and powerful socialist state. . . . From this day forward, we renounce class struggle as the central focus, and instead take up economic development as our central focus."

"With that single sentence," wrote historians Orville Schell and John Delury, "Deng summarily canceled two decades of Maoist policy."[4]

His pragmatic approach appealed to a party and country still reeling from the disruption of the Cultural Revolution. Within two years, the man Mao had described as "a needle wrapped in a ball of cotton" completely outmaneuvered Hua and took over the leadership of the CCP. On September 13, 1982, Deng was named chairman of the Central Advisory Commission of the Communist Party and started to guide China toward developing what he called "a socialist market economy."

This unprepossessing 4'10" man in his mid-seventies quickly became the most important leader in modern Chinese history. He systematically transformed an economically deflated China, reeling from the Great Leap Forward and Cultural Revolution where 88 percent of the people were living in poverty, into a modern world superpower.

In 1952, China's GDP was roughly $30.55 billion. By 1998 it had reached $1 trillion and in 2009 overtook Japan as the world's second largest economy.

This explosive growth was credited to Deng's policy. Even today, he is acknowledged as the man who made China great again.

He did this by opening China to the world and opening the economy to market forces. He also ended communal farming and opened farmland to private ownership. Suddenly private business ownership was not only allowed, it was encouraged.

By the mid-1980s, the signs of this transformation were apparent throughout the cities of China: private merchant stalls on every corner, the appearance of private cars, women getting their hair done

and wearing makeup and modern clothes, the openings of discos and nightclubs, even the resurgence of prostitution.

Deng famously proclaimed that "to get rich is glorious." With more prosperity came more opening to foreign businesses and trade with the rest of the world. It's a policy that continues today as China's current president Xi Jinping has repeated on many occasions: "China's door of opening-up will not be closed and will only be opened wider."[5]

During Deng's eighteen-year reign, living standards rose dramatically for hundreds of millions of people and personal wealth grew. But while Deng was happy to see people thrive economically, he made it clear that the one thing he wouldn't let take hold in China was democracy. He explained, "If all one billion of us undertake multi-party elections, we will certainly run into a full-scale civil war. Taking precedence over all China's problems is stability."[6]

Deng believed the CCP's source of legitimacy was an expanding economy. He left behind a newly confident nation on the verge of becoming a superpower.

For the most part, Deng's successors have continued his policies that have made China an economic giant, which has produced a surge in national pride. This pride has spurred the Chinese to take increased interest in their culture and history.

During the past two decades the Chinese Communist Party has encouraged its citizens to embrace culture as "a foundation for China to compete in the world," in the words of President Xi Jinping. The CCP's official position is that art can "lead people to live a life abiding by the code of morality," and in that way contribute to social stability.

Today, China openly promotes efforts to repatriate works pillaged during its self-defined "century of humiliation," from the 1840s to the establishment of the People's Republic of China in 1949. According to art crime expert Noah Charney, that policy gave Chinese collectors

a green light to recover previously looted artifacts by any means necessary. "Chinese collectors can purchase stolen Chinese art and still have the pride of display," he explained, "perhaps with the rationale that, whether or not the object was stolen, it should be in China, and therefore the collector was somehow aiding its liberation."[7]

Today the site of the Old Summer Palace is a ruin of scorched masonry, lakes with overgrown plants, lawns with a few scattered stones where magnificent buildings once stood. It's often described in social media posts and popular films as China's "Ground Zero." Day after day the site is visited by swarms of Chinese visitors taken there as part of a government-sponsored program of "patriotic education."

Schoolchildren in China are taught that the Summer Palace—or Yuanmingyuan, translated as the Garden of Perfect Brightness—was once a huge complex of palaces and other elegant buildings built by Chinese emperors and filled with the most magnificent cultural treasures the world has ever seen.

This deep, unhealed cultural wound has helped fuel a wave of Chinese interest in repatriating stolen art. Additionally, during the past decade the county's nouveau riche have taken up art collecting with great enthusiasm as a way to express national pride, while the Chinese economy has grown by leaps and bounds.

In 2000, the Chinese represented a mere 1 percent of the global art auction market. By 2014, it accounted for 27 percent.

The market for Chinese art seems to adhere to a certain nationalistic logic: The closer an object's connection to one of China's ignominious defeats, the more it is worth. In recent years, vases, bronzeware, and a host of other items previously plundered from the Old Summer Palace have sold for millions. Behind most of these purchases is a well-connected Chinese billionaire eager to demonstrate China's modern resurgence on the world stage.

"Buying looted artwork has become high-street fashion among China's elite," Zhao Xu, the director of Beijing Poly Auction, told the *China Daily*.[8]

In 2010, a Chinese vase bearing the imperial seal of 18th-century Emperor Qianlong went up for sale at an auction house in a suburb of London. The starting price was $800,000. Half an hour later, the final bid—from an anonymous buyer in mainland China—reached $69.5 million!

In 2014, a taxi driver turned billionaire named Liu Yiqian paid $36 million for a small porcelain "chicken cup" that was also once a part of the imperial collection. According to the *Wall Street Journal*, Liu completed his purchase by swiping his American Express card twenty-four times and then promptly drinking from the cup. A few months later, he paid an additional $45 million for a silk tapestry from the Ming era.

Today according to the *Huran Report*, China boasts more billionaires than any other country in the world, with 814. One of them is Huang Nubo, founder and chairman of the Beijing Zhongkun Investment Group. Huang is an interesting man who in addition to being a real estate developer and entrepreneur is a mountaineer who has summited Mount Everest three times. He's also a published poet with a passion for Chinese culture, which has helped make him famous, as well as through an effort called the National Treasures Coming Home campaign.

Huang's father was a colonel who fought with the communists during the civil war and had been jailed in one of Mao's earlier purges. He later committed suicide when Huang was three. In one of his poems, published under the name Luo Ying, Huang laments, "When they buried him in the dunes, his eyes were still staring. . . . An enemy got no gravestone, so he rotted like a nameless dog."[9]

Despite his father's treatment at the hands of the communists, when Huang was young he became a fervent Red Guard. He admitted in verse to punching a landowner with his "steel fists." The landowner later died. "We were demons, myself included," he told an audience at Peking University.[10]

Huang was one of the more than a million youngsters who were "sent down" by Mao to toil alongside farmers in the countryside and correct their elitist ways. In a time of victimhood and complicity, neighbors condemned their neighbors, children denounced their parents, and workers were pitted against their colleagues in "struggle sessions."

His book *Memories of the Cultural Revolution*, written under the pen name Luo Ying, is filled with visceral recollections: corpses torn open, female bodies floating downriver with sticks in their genitals as testament to their rape, and the execution of an elderly woman for singing the wrong lyrics to a patriotic song.

One of them is called "Chairman Mao's Little Red Guards."

> *At ten I was already a little red guard, a fighter for Mao*
> *The Chairman Mao badge I got was pinned to my chest night and day*
> *We broke all the windows at our school as a sign of revolution*
> *We ordered teachers to clean toilets, made them hang their heads and confess . . .*[11]

According to Huang, the Cultural Revolution had a huge impact on him as a person. "I am a victim, a participant and a perpetrator; I denounced others and was denounced."

Initially taking a job in the propaganda department of the CCP, he left to create the Zhongkun real estate and tourism conglomerate. He believes that China's meteoric economic rise of the last three decades

was built on the foundations of the Cultural Revolution's destructive legacy.

Ironically, it fueled the capitalist ambitions of a generation of businesspeople and builders. "The Cultural Revolution taught this generation of mine that you must act like a wolf in order to survive," he explained.

It destroyed old value systems and replaced them with the belief "that winner takes all, that if you can beat someone, then you're a hero, that if you're rich, you're in the right."

As a poet, Huang feels a responsibility to write about what he witnessed. "When at the end you look at your current position in society, you'll think back and wonder whether the nightmare you lived through was in fact right or not," he said. "But the harm it's brought to your heart can never be got rid of in a lifetime."

Huang, the poet and entrepreneur, also has a passion for Chinese culture and was one of the leading figures in the National Treasures Coming Home campaign that focused on the reclamation of lost relics.

After the second break-in at the KODE Museum in Bergen, Norway, in January 2013, Huang contacted the museum. He said that he wanted to fly to Bergen and tour the China exhibit, which was closed due to damage sustained in the break-in. Once there, he was shown a collection of seven marble columns taken from the Old Summer Palace.

The baroque columns, 80 to 92 centimeters high, were originally from the Western Mansion (Xiyang Lou) area of Yuanmingyuan. A long-term exhibition displaying these relics, together with related old pictures, has opened at the Zhengjue Temple of Yuanmingyuan Ruins Park.

They are thought to have been originally set on roofs and by stairways. Some of their frontal façades feature typical Western decorations

while the sides were carved with Chinese patterns such as orchids, lotuses, peonies, and chrysanthemums.

The columns are part of a 2,500-piece collection of Chinese artifacts in the KODE Art Museums of Bergen that were donated by the aforementioned former Norwegian cavalry officer who settled in China, Johan Wilhelm Normann Munthe.

Seeing the columns displayed at the KODE, Huang began to get emotional. Wiping tears from his eyes, he told the museum director that the columns had no business being displayed in Norway. Huang agreed to donate $1.6 million to KODE, which he said would be used to upgrade its exhibition space. Others reported that the money was being used to upgrade museum security.

Soon thereafter the museum shipped seven of the marble columns back to China to be displayed at Peking University on permanent loan. (Huang denies any connection between his donation and the return of the columns.) Five years later, the Norwegian government approved transfer of ownership of the marble columns. China's National Cultural Heritage Administration then transferred them to the administration of the Yuanmingyuan Ruins Park.

"It's a key achievement of cultural relic repatriation," explained Li Qun, director of the National Cultural Heritage Administration, "as we bring the columns back to their original place."[12]

The looting of the columns and their open display in a European museum "were our disgrace," Huang told *China Daily*, and their return represented "dignity returned to the Chinese people."

Following the exhibition at Peking University, the seven marble columns were returned to Yuanmingyuan Ruins Park, where together with old pictures, they are on display in the rebuilt Zhengjue Temple.

Marble columns from Yuanmingyuan

Meanwhile in August 2011, Huang Nubo proposed something that raised fears of Chinese domination, or the Chinese using their newfound economic might to buy up pieces of the Western world. In this case the country was Iceland and the proposition that raised so much unease was Huang Nubo's bid to purchase 300 square kilometers, or 116 square miles, of Iceland's harshly beautiful, remote northeast—0.3 percent of the country's land area—and turn it into a luxury 120-room hotel, airport, golf course, and horse-riding facilities.

"Is Mr. Huang an agent of domination like Dr. No, the half-Chinese, half-German villain of the eponymous 1962 Bond film?" asked the Icelandic political commentator Egill Helgason, in *The Reykjavik Grapevine*. Or was this the beginning of the Nordic nation's very own "Century of Humiliation?"[13]

"We face the fact that a foreign tycoon wants to buy 300 sq km of Icelandic land," Interior Minister Ögmundur Jónasson wrote on his website. "This has to be discussed and not swallowed without chewing."[14]

He said China was known for its "long-term thinking alongside buying up the world" and warned against Iceland accepting the purchase without full consideration."[15]

The scale of the purchase made it the equivalent to a foreigner buying nearly all the Chinese province of Hainan Island—legally impossible, and an unimaginable scenario, analysts said.

Political commentors wondered if, perhaps, this was a harbinger of things to come for Europe, as the continent struggled with enormous debt and low economic growth while China zoomed ahead. At the time the Chinese were purchasing shares in the port of Piraeus in Greece—the fourth-biggest container port in Europe—and the sovereign debt of the struggling country Portugal, which once rented the Chinese enclave of Macau for 500 taels (about 19 kilograms, or 42 pounds) of silver per year.

"Was the dark hand of the Chinese Communist Party behind Mr. Huang's initial bid of 1 billion Icelandic krona, or about $8.6 million, for the snow-swept Grimsstaðir a Fjöllum farm, with the real goal access to frozen sea passages destined to become economically and strategically important as the globe warms up?" asked reporter Didi Kirsten Tatlow in the *New York Times*.[16]

"No," Mr. Huang answered emphatically. "I was moved by that bleak, wild nature," he told the *International Herald Tribune*, a newspaper affiliated with Xinhua, the state-run news agency.

"Why do people want to ruin this win-win investment?" he asked.

"One answer," one analyst said, was deep suspicion about a country with increasing global weight but little "soft power."[17]

*The Oxford English Dictionary* defines the phrase "soft power," popularized in the 1980s by author Joseph Nye as "power (of a nation, state, alliance, etc.) deriving from economic and cultural influence," rather than "hard power," which is associated with coercion and military strength.

"People often conflate soft power with investment and economic development, but I define it as culture, education, and diplomacy,"

said Elizabeth Economy, senior fellow and director of Asia studies at the Council on Foreign Relations.[18] But what it really refers to is a nation winning influence abroad by persuasion and appeal rather than by threats or military force.

"The phrase gets bandied about in various ways," said Jeremy Goldkorn, a sixteen-year resident of China and founder of danwei.com, a Web magazine and research firm. "It should mean that you have the power of attraction, and China's been very bad at that," he said, citing its lack of transparency, harsh treatment of dissidents, hardline stance over claims in the South China Sea, and other scandals.

Chan Koonchung, the Chinese-born, Hong Kong and Taiwan–raised author of *The Fat Years*, a dystopian political fantasy, took the idea of China's lack of soft power even further. "The soft power they're getting is exclusively because of their money. They haven't managed to build a country where people feel safe." And "China is still trying to build up a narrative to justify the legitimacy of the ruling regime. People keep reminding them about their past atrocities and policy failures."[19]

The aspect of China's soft power that continues to have the strongest international appeal is its traditional culture, which the CCP has extended by creating several hundred Confucius Institutes around the world. Over the last two decades, China has steadily increased its support for cultural exchanges, sending doctors and teachers to work abroad, welcoming students from other nations to study in China, and paying for Chinese-language programs abroad.

By late November 2011, Iceland's interior ministry announced that Huang Nubo's bid to buy 116 square miles of Iceland's harshly beautiful, remote Northeast did not comply with land sale rules.

"The ministry believes that it's not possible to look past how much land the company wanted to purchase," Iceland's ministry said in a

statement. "There is no precedent for land on this scale being sold to foreigners."[20]

Mr. Huang accused the West of double standards. He told BBC News, "If I had known that we were not qualified, I wouldn't have wasted so much time and money on the case," he told the newspaper.[21] He also said that he had not been made aware of the land-sale requirements.

"The rejection sent a message to Chinese investors that you are welcome to emigrate, or to buy properties and luxury goods, but if you want to engage in anything related with natural resources, you're not welcome here," Mr. Huang told the newspaper *Global Times*.[22]

## 16

# China Poly Group

"Those who control the present, control the past and those who control the past control the future."
—George Orwell, *1984*

Author Grace D. Li's debut novel *Portrait of a Thief* came out in 2022 and quickly became a *New York Times* bestseller. Later in the year, the *Times* named it the best crime novel of the year.

The *Seattle Times* called it: "An impressive 2022 debut novel in which a team of thieves plots to steal five priceless sculptures of ancient China from five world museums, returning them to their homeland—and earning $50 million in the process. The twist: the thieves are all brilliant, young, high-achieving Chinese Americans, working out their own complicated feelings toward China."[1]

The publisher's press release reads: "History is told by the conquerors. Across the Western world, museums display the spoils of war, of conquest, of colonialism: priceless pieces of art looted from other countries, kept even now."[2]

The protagonist of Li's book, Will Chen, is an art history major and sometime artist at Harvard who is trying to fulfill his parents' promise

of the American dream. When a mysterious Chinese benefactor offers him $50 million to steal back five priceless sculptures that were looted from Beijing centuries ago, Will recruits a team to help him out. Irene Chen, a public policy major at Duke; Daniel Liang, a premed student with a knack for picking locks; Lily Wu, an engineering student with a penchant for racing cars; and hacker and MIT dropout Alex Huang.

Because of their complicated relationships with China and what it means to be Chinese American, the team members form a tight and cohesive unit.

Grace Li has said that her inspiration for the project drew from the real-life heists and the *GQ* article by Alex W. Palmer that brought them to the public's attention. In the thefts, she admitted, she saw both a compelling storyline and a connection to her own experience in terms of "grappling with what it means to be Chinese American and not feeling enough of both."[3]

The state-owned China Poly Group is the catalyst for the novel's plot. That is the organization that recruits the five-man team of university students to carry out the heists. In another case of fiction mirroring fact, the same China Poly Group is suspected by many international investigators of acting as the intermediary between the CCP and the triad gangs that hire local thieves in Europe (like the Rathkeale Rovers) to break into museums, steal looted Chinese antiquities, and return them to China for a price.

In real life the Rathkeale Rovers are not a group of college students struggling with their identity, and the China Poly Group is not a patriotic organization solely dedicated to repatriating looted Chinese art. It's true that in 1998, the China Poly Group set up the two-room Poly Art Museum in their corporate headquarters in Beijing, and its main purpose is to receive and house repatriated art and antiquities.

The China Poly Group has spent as much as $100 million at auction buying back China's lost treasures, but according to one Chinese collector who requested anonymity, "If you are a collector like me, the China Poly Group can connect you to people who will help you get the specific piece of art you want. But its primary function is to make money."[4]

In other words, to Chinese billionaires looking to recover specific looted Chinese artifacts, the Poly Group acts as a facilitator.

One other thing the Poly Group is not is a Western-style NGO. Instead, it's an extension of the Chinese government, and as the CCP states on its website:

> China Poly Group Corporation Ltd. is a large-scale central State-owned enterprise under the supervision and management of the State-owned Assets Supervision and Administration Commission of the State Council (SASAC). Upon the approval of the State Council and the Central Military Commission of the P.R.C., the Group was founded in February 1992. Over the past three decades, Poly Group has established a development pattern with main business in multiple fields, including international trade, real estate development, light industry R&D and engineering services, arts and crafts raw materials & products management services, culture and arts business, civilian explosive materials and blasting service and finance services. Its business covers over 100 countries worldwide and over 100 cities in China.[5]

Founded in the early 1990s, China Poly Group boasts $95 billion in assets, according to *Fortune* magazine, and 76,000 employees in one

hundred countries. By the end of 2018, the group's total assets exceeded one trillion yuan, ranking 312th among the Fortune 500.

But the company's opaque organizational structure has led to questions about how its different entities relate to each other and who's in charge. A 2013 *New York Times* article said China experts were not sure "how Poly functions as a corporation, how power is shared internally, to whom its executives are really accountable or how its revenues and benefits are distributed."

Its art wing—Poly Auction—functions more like an auction house than a patriotic organization dedicated to recovering looted artifacts. In fact, according to the *Financial Times*, Poly Auction and China Guardian are now the world's top two auction houses in terms of sales. Poly Auction is first.

In 2016, China's fifth-largest insurance company, Taikang, bought a 13.5 percent stake in Sotheby's, making it the largest shareholder in the world's largest auction house. Taikang's chairman, Chen Dongsheng, is married to the daughter of Mao Zedong. He's also the founder of China Guardian. Early in his career, Chen worked as deputy editor of *Management World*, a publication of the Development Research Center of China's State Council. According to the International Consortium of Investigative Journalists (ICIJ) he's a member of China's Red Nobility—children and close relatives of China's revolutionary heroes who have found big success in the business world.

China Poly Group chairman, Xu Niansha, is a member of the World Economic Forum founded by German engineer Klaus Schwab. Xu is also the Chairman of China's Machinery Industry Federation, a member of the 12th and 13th CPPCC (National Committee of the Chinese People's Political Consultative Conference). In 2018, he talked to CNBC about China Poly Group's ambitions to expand its operations

in the United States. He said, "Poly came into the US not only to earn money... Of course we hope that our projects are profitable but not only for this. The American market is a very strong market and a very advanced market. We can learn a lot of experience and technology with our US partners and US companies."[6]

He claimed that Poly Group's main activities in the United States were culture and real estate. He was heeding the advice of President Xi Jinping when Xi spoke at the 19th Communist Party Congress in October 2018 and called on members of the CCP to enhance the country's cultural soft power.

There's no doubt that Poly Group has been extending China's soft power. But it's even more active in extending China's hard power. Richard Fadden, director of the Canadian Security Intelligence Service from 2009 to 2013, said in an email, "Canadians generally, including all governments and the private sector, should treat our relations with China and Chinese companies differently than we do with companies from other countries."

Without referring specifically to the China Poly Group, Fadden said that Chinese companies were more likely to be "up to something that we would not approve of" than "virtually any other country."[7]

The nonprofit global peace and security organization C4ADS recently found the China Poly Group among a group of PRC state-owned conglomerates supporting Russia's invasion of Ukraine with legal weapons.

> We identified 281 previously unreported shipments of sensitive goods by China Poly Group Corporation (hereafter Poly Group) subsidiaries to Russian defense organizations between 2014 to 2022. For example, in January 2022, Poly Group's subsidiary Poly Technologies Inc. reportedly

exported one shipment containing anti-aircraft missile radar parts to the sanctioned Russian state-owned defense company Almaz-Antey, which reportedly supports Russia's war in Ukraine.[8]

They also found that data on Chinese trade is expensive, unreliable, and incomplete. It seems designed to mislead and confuse. For example, corporate records for China Poly Group show that it is made up of more than 2,900 companies in more than 100 sectors with convoluted ownership structures across many layers of subsidiaries. It is practically impossible to figure out which company or subsidiary is responsible for manufacturing and shipping a particular military product.

C4ADS concluded that PRC state-owned conglomerates like Poly Group proliferate weapon- and missile-related products to support Russia's military and help undermine global efforts to sanction Russia's defense sector. And while the international community has advanced a number of policies intended to limit Russia's access to defense technologies from abroad, PRC conglomerates like Poly Group continue to support the Russian military in Ukraine.

There also seems to be a certain degree of obfuscation when it comes to the degree to which the Chinese government is invested in repatriating looted artifacts from the Old Summer Palace. Although that has been stated PRC policy since 1991, the Chinese are not big players in the game of repatriation.

Said art historian Sonya Lee, "The Chinese government has *not* been very active in pursuing repatriation."[9] This is in contrast to the governments of Thailand, Cambodia, and Benin, which have all put forth great effort to retrieve looted art and have seen significant success.

Most repatriation efforts in China are done by individual collectors and outside parties. One example is Portland, Oregon–based entrepreneur Raymond King. When he was helping his mother clear out old belongings from her New York apartment, little did they know an unassuming bronze vessel, nestled among other antiques, was a lost treasure crafted at least 2,800 years ago in China.

King discovered its origin in 2023 when he invited a researcher from Sotheby's auction house to look at his mother's collection and learned that the bronze was stolen from China in 1984.

"My grandfather got it from a dealer . . . and then gave it to my mother," he explained to *China Daily*. "We had no idea (when and for how much it was bought), but once we understood it was stolen, my mom's reaction was just, 'Give it back.'"[10]

The bronze ritual vessel, named "Feng Xingshu Gui," was created sometime between 877–771 B.C.E. in the Western Zhou dynasty. Measuring 18 centimeters (7 inches) high and 21 centimeters (8.3 inches) in diameter, and weighing about 6 kilograms (13.2 pounds), it is composed of a large bowl adorned by double handles in the design of a coil-nose animal face, resting on three animal-shaped feet.

When the bronze ritual vessel was returned to China in 2024, the head of China's national cultural heritage administration lauded it as a significant achievement in US-China cooperation.

But was it, really? Or was it just an individual act of kindness?

Other artifacts have gained attention in China not just for their value, but also for the narratives told of their recovery. Most notably, state broadcaster CCTV ran a segment in 2021 on this in China's most-watched TV program—its annual Chinese New Year Eve gala show (*chunwan*)—about a recently recovered Buddha head that had been stolen from a cave wall in Shanxi's Tianlongshan Grottoes almost a century ago. It was purchased and donated to the Chinese government

by a Chinese individual living in Japan, where the artifact had surfaced for auction.

Mr. Zhu Chengru, deputy director of China's national committee for the compilation of Qing dynasty history, said in a 2022 article that the *chunwan* segment had increased the level of public attention on the issue of lost relics.

"We have to increase research on the lost relics, recognize the value in having Chinese relics abroad, and promote the return of relics to the motherland through various means," he wrote.[11]

The state's approach, meanwhile, seems to lean less on concerted legal action than on cooperation with foreign governments, and donations from private entities, who are patriotic or well-meaning.

Also, in recent years, China has found success in flexing its economic might and growing markets as a way to incentivize the return of its cultural heritage. One successful instance of this approach occurred on March 22, 2019, during Chinese president Xi Jinping's state visit to Rome, when the Italian cultural ministry agreed to repatriate 796 cultural artifacts that were illegally taken from China. It was hailed as the largest repatriation of artifacts to China in over twenty years.

The items resembled those unearthed during archaeological excavations in Gansu, Qinghai, and Sichuan provinces in China. Some dated back as far as the Neolithic period, with more recent items hailing from the Ming dynasty (907–1664 CE). Italian authorities couldn't explain how the artifacts had ended up in Italy, though they confirmed that they were "of illicit origin."

Others have pointed out that the return of the artifacts was not simply an expression of cultural sensitivity. The Italian government returned them shortly after being the first Western government to agree to join China's controversial investment and infrastructure

Belt and Road Initiative (BRI). Unprecedented in scale, the BRI project consisted of two parts. First, an economic belt to direct trade to and from China, which offered Chinese development money to member countries for roads, railways, bridges, and power plants. The second part—called the maritime silk road—offered trillions of dollars in Chinese investment in a chain of seaports from the South China Sea to the Indian Ocean that direct maritime trade to and from China.

The BRI was promoted as a win-win for everyone. Many of the countries involved needed new and rebuilt infrastructure and access to new markets. In return, China got massive new projects for its growing construction industry.

According to Rory Green, a China and North Asia economist at TS Lombard, the deal with Italy was "a really big coup for Xi Jinping, and it will give him a foothold in the heart of Europe."[12]

But, he added, "in terms of Italian-EU relations, it's going to add more strain to their relationship. From the Italian perspective, it shows they are willing to turn to an outside backer, and that could be used to show the EU, and France and Germany in particular, that they have other friends they are willing to turn to." He also noted that the deal was likely to accelerate "an ongoing shift" in Europe's view of China as "a strategic competitor."[13]

Others accused China of using the BRI as a form of a global strategy called "debt trap diplomacy," whereby they would fund major infrastructure projects in developing nations with unsustainable loans and then use the debt to gain leverage over those governments.

The accusation was leveled as a result of projects such as the Hambantota Port Development in Sri Lanka. When the Sri Lankan government was unable to service the Chinese loans that funded the project, the port was handed to the Chinese as a 99-year lease in

2017. To some observers, it echoed tactics employed by 19th-century European imperialists against Qing dynasty China.*[14]

Whatever the relative risks and benefits of the BRI, it was a global economic program that was unimaginable during the reign of Mao. But once the class-struggle and radical reform ideology shattered at the end of the Cultural Revolution, the CCP shifted to embracing capitalism and globalization. They did this, according to Chinese author and scholar Zeng Wang, by promoting nationalism as the new ideological underpinning of CCP legitimacy. And they adopted the Century of Humiliation as the master narrative of modern Chinese history.

By making China the victim of Western imperialism, the victimization narrative identified the West as the group responsible for China's suffering.

In his book on the CCP, *The Party*, Richard McGregor explained this dynamic:

> The Party treats history as an issue of political management, in which the preservation of the Party's prestige and power is paramount. Just as personnel decisions and corruption investigations are decided upon in-house, so too are sensitive historical debates all settled within the Party itself. The debates over history are invariably held in secret and often conducted in code.[15]

Thus, the CCP absorbed the lesson of George Orwell's *1984*: "Who controls the past controls the future: who controls the present controls the past."

---

\* In December 2023, Italian prime minister Giorgia Meloni announced that Italy was withdrawing from the Belt and Road Initiative, calling Italy's decision to join it "a serious mistake."

The use of the Century of Humiliation as a political rallying point was not new. Sun Yat-sen used it, as did other early nationalists and reformers. Chiang Kai-shek claimed that he wrote in his diary every day for twenty years: AVENGE HUMILIATION. Mao echoed the same message when he took power in 1949 and said, "The Chinese have always been a great, courageous and industrious nation, it is only in modern times that they have fallen behind. And that was due entirely to oppression and exploitation by foreign imperialism and domestic reactionary governments.... Ours will no longer be a nation subject to insult and humiliation."[16]

Born and raised in China, Zheng Wang worked for a top government research institute for many years before completing his graduate studies in the United States. In his book *Never Forget Our National Humiliation*, he argues that the CCP's search for a new political narrative became much more urgent after the Tiananmen Square Massacre of 1989. In response to that event, which received intense internal and global attention, the party made a conscious decision to promote a more nationalist view of history. As a result, history textbooks were rewritten and a whole panoply of new museums built all over the country—with the explicit purpose of showcasing past national humiliations.

Nationalism quickly replaced Marxism as the raison d'être of the ruling party. "Nobody understands Marxism. It is ridiculous," said Li Rui, a former secretary of Mao Zedong. "The ideals of the past don't exist anymore. So it is right to turn to nationalism. It is the means by which the party can maintain its system and ideology."[17]

In the *1994 Outline on the Implementation of Education in Patriotism*, the CCP explicitly laid out a series of major objectives of this education campaign:

> If we want to make the patriotic thoughts the core theme of our society, a very strong patriotic atmosphere must be created so that the people can be influenced and nurtured by the patriotic thoughts and spirit at all times and everywhere in their daily life. It is the sacred duties for the press and publishing, radio, film and television departments of all levels to use advanced media technology to conduct patriotic education to the masses.[18]

One vehicle for this revision of "historical memory" was through the construction of historical monuments. In March 1995, the Ministry of Civil Affairs announced that, after a careful nomination and selection process, one hundred sites had been selected as the national-level "demonstration bases" for patriotic education, wrote Zheng. Among the one hundred bases, forty were "memory sites" of China's past conflicts or wars with foreign countries—including battlefields, museums, memorial halls, and monuments in memory of fallen soldiers—half of them in remembrance of the Anti-Japanese War (1931–1945). Twenty-four other sites represent a remembrance of the civil wars between the CCP and the KMT (1927–1949).

The museums included an Opium War Museum in Guangdong; a Nanking Massacre Memorial Hall in Nanking—and a lavish new history gallery in the Beijing National Museum, which presents China's past as a story of national humiliation, redeemed by the courage and strength of the Communist Party.

One of these memory sites, the September 18 Historical Museum, was built in 1991 in Shenyang, a city in northeast China. The museum was built on the exact same site where the Japanese army, which had been occupying parts of China, launched a surprise attack

on Shenyang as part of its full-scale invasion of China. Within a week, the Japanese conquered most of Manchuria. The Japanese occupation lasted fourteen years, from 1931 to 1945, and according to the Chinese historical narrative, is one of the darkest times in Chinese history.

The museum is meant to remind future generations about this humiliating period. On one side of the museum hangs a huge bronze bell engraved with the four Chinese characters Wuwang Guochi (勿忘國恥), meaning "Never Forget National Humiliation" in traditional Chinese, or 国耻 in simplified Chinese. A sculpture outside the museum shows a group of students listening to a senior citizen talk about the horrors she faced during the Japanese invasion. Not far from the bell sits a huge marble stone inscribed with former Chinese President Jiang Zemin's dedication: "Never forget September 18."

In February 2004, the government initiated a more ambitious project of "patriotic education." The Central Committee proposed new programs for "Further Strengthening and Improving Ideological and Moral Education of Minors." Eight months later, ten government ministries and CCP departments proposed improving the political education of the young by exploiting "entertainment as a medium of education." The Ministry of Education and the Propaganda Department jointly proposed a program to recommend one hundred films, one hundred songs, and one hundred books that would promote the common theme of patriotism. One of the recommended history books was entitled *Never Forget Our National Humiliation*.

Professor Zeng Wang points out that no Chinese history courses were taught in Chinese high schools prior to the implementation of this campaign. But beginning in 1992, new textbooks were written, and all high school students were required to learn the victimization narrative as, according to Wang "the CCP leaders realized the very survival of the party depended largely on whether (and how soon)

they could change the younger generation's attitude toward both the Western powers and the party itself."

"The lessons of the new narrative are front and center in the highly competitive entrance exams for China's universities," he continued, "as well as forming the core of newly required university courses," making them "one of the most important subjects in the national education system."[19]

According to the *Chinese Modern and Contemporary History Textbook (Vol. I)*:

> Chinese modern history is a history of humiliation that China had been gradually degenerated into a semi-colonial and semi-feudal society; at the same time, it is also a history that Chinese people strived for national independence and social progress, persisted in their struggle of anti-imperialism and anti-feudalism, and was also the history of the success of New-Democratic Revolution under the leadership of the CCP.[20]

Wrote historian William Callahan, "It would not be an exaggeration to argue that the master narrative of modern Chinese history is the discourse of the century of national humiliation. . . . The PRC's very deliberate appeal to national humiliation in state education policy can tell us much about how historical memory informs both domestic and international politics."[21] The Chinese people's pride over their ancient civilization (chosen glory) and their collective memory about the one hundred years of humiliation (chosen trauma) have greatly contributed to shaping their national identity.

Every year, this theme is underscored by the celebration of 国耻节 guochijie ("National Humiliation Day"). This CCP-orchestrated

annual ritual sometimes takes place at the ruins of Old Summer Palace, sometimes at the Nanking Massacre Museum, and more recently at the Mukden Incident Museum. Sites and dates have varied over the past decade, but not the message. President Xi Jinping, while proclaiming to the international media the importance of peaceful globalization, compels Chinese youth to dwell on humiliation and to rally around the red flag of the CCP.

Jeffrey Legro is a professor of political science at the University of Richmond. In the newsletter *Focus: Postcolonial Dialogues*, he points out that many societies have "dominant ideas" or "national ideas," which he defines as "the collective beliefs of societies and organizations about how to act." This unique set of dominant or national ideas distinguishes one country from the other. They are also difficult to change once they become ingrained in public discourse and the language and ideological framework of public institutions. "These ideas," he wrote, "often unconsciously but profoundly influence people's perceptions and actions."[22]

Professor Zeng Wang goes on to explain that in order to understand China's future intentions, we must first learn to appreciate the building blocks of those intentions: their national ideas. "For example, while people in the world are talking about China's rise, the Chinese like to use another word: *rejuvenation (fuxing)*. By choosing the word 'rejuvenation' (复兴), the Chinese emphasize their determination to wipe out past humiliations and to restore themselves to their former glory. The word 'rejuvenation' is deeply rooted in China's historical memory."[23]

The problem the CCP now faces is that its domestic propaganda clashes with its stated goal of building cooperative relationships with Western countries—if that really is its goal. Or as Gerrit Gong has stated, China's "overreliance on history to provide national legitimization could challenge the ability of any Chinese government to satisfy its own people or to engage easily internationally."[24]

Without a satisfactory solution to the Century of Humiliation conundrum, how can China sincerely embrace global norms, rules, and institutions? How can it be a truly responsible stakeholder in global affairs and a confident member of the international society?

A recent opinion piece in the *South China Morning Post* suggested a solution: It's time for China to abandon the Century of Humiliation narrative.

> ... Beijing must undergo a thorough foreign policy review, elevate its manner of relating to others, and start deprioritizing old grudges. Adjustments need to be made often; China seems unduly and neurotically self-centered. If it wants to leave the Century of Humiliation behind, it could stop living in the past.[25]

While it's certainly an interesting suggestion, and one that could broaden China's perspective in dealing with other countries, it's probably not in the best interests of the CCP, which relies on the Century of Humiliation narrative for its survival.

# 17

# Unrestricted Warfare

"The surest way to defeat an enemy is to so arrange matters that you do not have to go to war with him to win, for you will have made it so that he cannot defeat you. You render him unable to sustain the battle, and see to it that he knows he cannot. Then, since he cannot defeat you, you advance your position forward at the expense of his."
—Sun Tzu

According to clinical psychologists David Lotto and Bettina Muenster in *The Social Psychology of Humiliation and Revenge*:

Social humiliation is associated with retaliatory behavior, even at additional cost to the retaliator. When humiliated, individuals and groups seem to have a particular appetite for revenge. The self, it is feared, will never be the same unless such injustice is appropriately addressed. What renders humiliation such a dangerous source for generating violence is the fact that such experiences are often fueled by long-lasting and extremely negative emotions.[1]

That first line bears repeating: *Social humiliation is associated with retaliatory behavior.* There certainly seems to be a lot of that coming from the PRC and CCP in recent years.

According to philosopher and theologian Jonathan Sacks, "By turning the question 'What did we do wrong?' into 'Who did this to us?,' [hate against an out-group] restores some measure of self-respect and provides a course of action. In psychiatry, the clinical terms for this process are splitting and projection; it allows people to define themselves as victims."[2]

He also said that "a society that suffers from humiliation is an unstable one. The cognitive dissonance between the way in which the society is perceived and the way in which it sees itself can be so great that violence can result in a massive scale against people belonging to an out-group."[3]

That out-group in China's case has been any foreign entity that has offended the Chinese people, whether that entity is a government, country, and even in some cases, individuals. The CCP has regularly mobilized Chinese netizens to respond to such transgressions with orchestrated rage and threats of boycotts. Behind such actions are accusations that foreign entities are not respecting China's territorial integrity, sovereignty, or rights to development.

In most cases, the PRC has unapologetically relied on the national humiliation narrative to justify its actions. In 2019, luxury brands Coach, Givenchy, and Versace were forced to issue apologies after a T-shirt designed by them appeared to list Hong Kong and Macau as countries instead of special administrative regions in China.

Shortly after images of the T-shirts began circulating online, social media users in China called for boycotts of the companies' products. Within days, a hashtag relating to the Coach T-shirt had already been read more than 1 billion times on Weibo. That's when supermodel

Liu Wen, one of Coach's brand ambassadors, took to the platform to announce that she was severing ties with the label.

"At any time, China's sovereignty and territorial integrity are inviolable!" she wrote. "My carelessness in choosing which brand to work with has brought harm to everyone; I apologize to everyone here! I love my motherland and resolutely safeguard China's sovereignty."[4]

Similarly, Jackson Yee, a member of one of China's most popular boy bands, TFBoys, announced on Weibo that he would stop working with Givenchy. And actress and singer Yang Mi announced that she was terminating her contract with the fashion house Versace in response to a similar T-shirt design. An announcement posted through Yang's studio, Jiaxing Xingguang, said, "China's territorial integrity and sovereignty are sacred and inviolable at all times," adding: "As a company of the People's Republic of China and Yang Mi as a citizen of the People's Republic of China, we are deeply offended."[5]

All the foreign labels issued apologies. Coach announced that it was pulling the offending T-shirt from all channels globally and issued a statement that added, "Coach is dedicated to long-term development in China, and we respect the feelings of the Chinese people."[6]

China's state-run *People's Daily* newspaper criticized the foreign brands for making "foolish mistakes" during a "sensitive period."[7]

The same hair-trigger sensitivity was on display when Marriott International included both "China" and "Taiwan" as selections in a webpage reservations menu, and the PRC ordered that the company's Chinese website to shut down for a week. In another case, when the clothing manufacturer The Gap did not include Taiwan on a map of China, the CCP mobilized netizens to express outrage and threaten a boycott.

Chinese censorship has become a global threat. In addition to long-standing practices such as censoring access to foreign media, limiting funding from overseas sources to domestic civil society groups, and

denying visas to scholars and others, Beijing has taken full advantage of the corporate quest for profit to extend its censorship to critics abroad. In recent years, a disturbing number of companies have given in to Beijing for their perceived offenses or for criticism of China by their employees.

Volkswagen's former chief executive, Herbert Diess, told the BBC he was "not aware" of reports about detention camps holding thousands of Muslims in Xinjiang, even though Volkswagen has had a plant there since 2012. Hong Kong–based Cathay Pacific airlines threatened to fire employees in Hong Kong who supported or participated in the 2019 pro-democracy protests there. Hollywood is increasingly censoring its films for Beijing's sensibilities, such as the digital removal of a Taiwan flag from Tom Cruise's bomber jacket in the recent sequel to the 1986 movie *Top Gun*.

In October 2019, when Houston Rockets general manager Daryl Morey tweeted, "Fight for freedom. Stand with Hong Kong" on his personal Twitter account, the CCP mobilized PRC netizens, and within hours, the Chinese Internet was filled with demands for Morey's firing. Concurrently, the Chinese broadcaster canceled scheduled Rockets games, advertisers canceled contracts, and NBA exhibition games scheduled later that month were canceled. At the time, Hong Kong was in the midst of political protests challenging CCP authority. Once again, the CCP used the tweet by Rockets GM Daryl Morey to criticize foreigners who supported "separatism" and "inappropriately dishonored China's sovereignty."[8]

Morey quickly took down the tweet, and NBA commissioner Adam Silver issued a statement that tried to absolve it of any responsibility. "It is inevitable that people around the world—including from America and China—will have different viewpoints over different issues," Silver said. "It is not the role of the NBA to adjudicate those differences."[9]

But the CCP was not satisfied. Seven months later, the situation was still unresolved. NBA China tried to ameliorate the situation by appointing a Chinese national as their president. Hours later, the *Global Times*, a CCP tabloid, reiterated that until Morey was fired, the NBA ban would continue. In October 2020, a year after the tweet was posted, the NBA announced that the Rockets GM was resigning after thirteen seasons to spend more time with his two college-aged children.

These are just a few examples of what historian Zeng Wang calls the CCP's "grievance-based nationalism." He explained, "China's new accomplishments and growing confidence have ... served to activate, not assuage, people's memory of the past humiliation. This is why it is very important for today's people to understand the Chinese historical consciousness. China's rise should not be understood through a single lens like economic or military growth, but rather viewed through a more comprehensive lens which takes national identity and domestic discourse into account."[10]

As part of its campaign to never forget humiliation, the CCP insists on engaging the world on its terms. Citizens of the United States and other countries around the world generally understand that the "rule of law" is vital to a properly functioning society. Ideally, the law is impartial, independent, and applied evenly and consistently to all, and it serves to protect the innocent, including from the state. According to author and *Atlantic* magazine contributor Michael Schuman, China's leaders eschew the principle of the rule of law and have adopted the concept of the "rule *by* law" instead "in which the legal system is a tool used to assure Communist Party dominance; courts are forums for imposing the government's will. The state can do just about anything it wants, and then find some helpful language in the 'laws' to justify it."[11]

In other words, the CCP bends the law to serve their purposes. President Xi's most recent global initiative, the 2023 Global Civilization

Initiative, is a case in point. Yale Law School professor Paul Gewirtz calls it, "China's most fundamental challenge to the current rules-based international order." In it, Xi purports to "advocate the common values of humanity" and the "common aspirations of all peoples," but believes that much of the existing rules-based international order governing human rights needs to change. "The initiative calls first and foremost for 'respect for the diversity of civilizations,'" writes Professor Gewirtz. Xi insists that states refrain from imposing their own values or models on others. "These principles indicate resistance to a universal human rights regime that binds states regardless of their 'diversified cultures.'"[12]

The CCP sees human rights as an existential threat. According to numerous human rights activists, its reaction could pose an existential threat to the rights of people worldwide.

Why? Because at home, the CCP has constructed an Orwellian high-tech surveillance state and a sophisticated Internet censorship system to monitor and suppress public criticism. According to Human Rights Watch, "abroad, it uses its growing economic clout to silence critics and to carry out the most intense attack on the global system for enforcing human rights since that system began to emerge in the mid–20th century."[13]

Beijing has long focused on building what they call a "Great Firewall" to prevent the people of China from being exposed to any criticism of their government from abroad. Now the CCP is increasingly attacking the critics themselves, whether they represent a foreign government, are part of an overseas company or university, or join real or virtual avenues of public protest.[14]

A technology consultant in Vancouver explained, "If I criticize the [Chinese Communist Party] publicly, my parents' retirement benefits, their health insurance benefits, could all be taken away." A

Toronto-based journalist for a Chinese-language newspaper whose parents in China were harassed for her work said, "I don't feel there is free speech here. I can't report freely."[15]

Human Rights Watch warned, "Governments committed to human rights should be sensitive to the double standards of 'China exceptionalism' that can creep into their conduct and enable Beijing to get away with abuses for which poorer and less powerful governments would be challenged."

In part out of its feelings of victimhood, China wants the rest of the world to play by their rules. This extends to trade policy and international property protections, too. As former diplomat and senior vice president at the Center for Strategic and International Studies (CSIS) James Lewis reported, China does not hesitate to use "unfair practices and policies to advance its firms, extract concessions, or block competition by foreign companies in China."[16]

The loss to others has been enormous. According to *Foreign Policy* magazine, Chinese IP theft costs the United States as much as $600 billion a year. In 1980, the PRC became a fully vested member of the World Intellectual Property Organization and has since signed most of the international agreements dealing with the protection of copyrights and patents. But, in practice, China very rarely enforces these laws.

For example, the Chinese government-sponsored search engine Baidu provides links to third-party websites that regularly offer online counterfeit products as well as access to counterfeit hardware and merchandise. While the Chinese government dominates 70 percent of its country's search engine revenue and has been called on by US and EU officials to limit the activity of online counterfeiting groups, they have done little to restrict it.

Whether it's the design for a new line of sneakers or the technology and manufacture of a massive industrial water pump, the typical

Chinese practice is to steal the IP, replicate it in China using cheap labor and substitute materials, push the owner of the original IP out of the Chinese market, and then work to displace that company from the global market altogether.

These predatory Chinese business practices extend to the use of triad gangs to conduct espionage against foreign companies, steal trade secrets, intimidate and corrupt employees of rival companies, and manufacture cheap counterfeit products to flood new markets.

And even though China is a member of the World Trade Organization (WTO), it routinely ignores WTO rules. It justifies this publicly by saying that China is still developing and should not be held strictly accountable, even though it's the world's second-largest economy.

Nor can they explain the big difference between the treatment of US companies in China and Chinese companies in the United States. When the Chinese-owned technology company Alibaba built a data center in Seattle, it was not forced to do this as a junior partner in a joint venture, nor was it forced to provide source code to the government for review, but US companies seeking to operate in China face those requirements.

The PRC routinely uses tactics such as nontariff barriers to trade, security regulations, procurement mandates, acquisitions (both licit and illicit) of foreign technology, and strategic investments in or acquisition of foreign firms to achieve its technological and economic goals. Meanwhile, companies from the US and other Western nations find themselves under pressure to make long-term concessions in technology transfer in exchange for market access.

It seems abundantly clear by now that Chinese policy is to extract technologies from Western companies; use subsidies and non-tariff barriers to competition to build competing national enterprises;

and then create a protected domestic market for these companies to give them an advantage as they compete globally. A Chinese official once remarked that if China had not blocked Google from the Chinese market, the huge Chinese technology company and search engine Baidu would not exist.

The root of Chinese predatory practices in commerce, intellectual property theft, and even the recovery of looted art is the same, and rooted in the story of King Goujian of the Yue State (described in Chapter 5) and how he got this revenge over Fuchai, the duke of Wu. Goujian attributed his victory to *wòxīn-chángdǎn* (臥薪嚐膽)—"sleeping on sticks and tasting gall"—metaphors for humiliation and perseverance. *Wòxīn-chángdǎn* is an idiom that roughly translated means "nurse vengeance."

Since the ascension of Mao in 1949, *wòxīn-chángdǎn* has become a rallying cry for the Chinese people—one that is meant to remove the stigma of defeat and humiliation from the late Qing period onward. This call to action has been used by every leader since Mao to convince the Chinese people that in order to avert a constant threat of dismemberment and disgrace, the country has to stay unified at all costs.

It has also become a strategy of how to deal with the West and the United States—countries and people that, given their tumultuous and recently shared history—the Chinese feel they can never trust. That strategy is the same as that used by King Goujian in the 5th century B.C.E.—to patiently build internal strength while secretly undermining your enemies. And, finally, to defeat them when they are weak and vulnerable.

This concept of "carefully disguised retribution" is also reflected in the Six Secret Teachings of the Chinese general and military and civic strategist Lü Shang (aka Jiang Ziya). Writing in the 11th century B.C.E., the second of Ziya's secret teachings reads:

Attracting the disaffected weakens the enemy and strengthens the state; employing subterfuge and psychological techniques allows manipulation of the enemy and hastens its demise. The ruler must visibly cultivate his Virtue (德) and embrace government policies that will allow the state to compete for the minds and hearts of the people; the state will thus gain victory without engaging in battle.[17]

Does this not sound familiar?

In 1999 two Chinese People's Liberation colonels—Qiao Liang and Wang Xiangsui—reiterated the strategy of weakening the enemy while strengthening the state in a treatise called "Unrestricted Warfare." The covert methods they propose for attacking the United States include trade warfare, financial warfare, ecological warfare, and drug warfare.[18]

In light of the recent museum break-ins maybe it's appropriate to include cultural warfare, too. Meanwhile, the tactic of drug warfare is clearly evident in the PRC's efforts to flood the US with fentanyl.

In 2017, life expectancy in the United States declined for the third consecutive year—something that hadn't happened since the 1940s. The Centers for Disease Control and Prevention (CDC) attributed the drop in part to fentanyl. In 2022, they declared the chemical, known as "China Girl" or "China White" on the street "a public health emergency."[19]

According to the final report of the House Select Committee on the Strategic Competition Between the United States and the Chinese Communist Party (CCP) issued on April 16, 2024:

> The substance is fentanyl, a deadly synthetic opioid that is up to 50 times stronger than heroin. Fentanyl kills on average over 200 Americans daily, the equivalent of a packed

Boeing 737 crashing every single day. Fentanyl is the leading cause of death for Americans aged 18–45 and a leading cause in the historic drop in American life expectancy. It has devastated families, with over 2.6 million children being raised by other relatives due to their parents' addiction.

The PRC, under the leadership of the CCP, is the ultimate geographic source of America's fentanyl crisis. Companies in China earlier produced 97 percent of illicit fentanyl that entered the United States. Today, these Chinese companies produce nearly all fentanyl precursors that are used to manufacture illicit fentanyl worldwide. The PRC's central role in the fentanyl crisis is uncontroversial, acknowledged by administrations of both parties and the bipartisan US Commission on Combating Synthetic Opioid Trafficking. The Drug Enforcement Administration (DEA), Department of Justice (DOJ) indictments, and independent experts have reached the same conclusion.[20]

Journalists, politicians, and commentators have been quick to point out the connection between the current fentanyl crisis in the United States and the opium epidemic of the 19th and 20th centuries in China.

According to journalist and scholar Markos Kounalakis, "China has a deep and visceral understanding of how an Opium War can convulse a nation and collapse an empire. After all, it happened to them in the 19th century. Chinese call it their 'Century of Humiliation.' Now the tables have turned. China has absorbed the Century of Humiliation's lessons of stealth attack and economic power and applied them globally."[21]

"I see this as a chemical attack on the United States, with the complicity of the Chinese government," said US businessman Jim Rauh,

whose son Thomas died from fentanyl. "They're pushing this material in what I consider the third Opium War, just this time by Chinese against us and Western countries, and fentanyl is the weapon of mass destruction."[22]

"Whereas China has gone to war with other drugs that have demand in China—such as methamphetamine—it has conspicuously failed to launch a similar crackdown on fentanyl, which had no demand in China," opined Congressman Chris Smith of New Jersey in 2018.[23]

The fentanyl scourge has hit particularly hard in Chicago. Cook County fentanyl deaths have risen dramatically from 560 in 2016, to 653 in 2017, to 847 in 2018. Said DEA agent Dennis Wichern in 2016, "With the addition of fentanyl from China, I'd say there's more death and destruction now than there was thirty years ago."[24]

"The Chicago epidemic is affecting forty-five-to-sixty-year-old men in the West Side," explained Amanda Brooks of the PCC Community Wellness Center. "Most of our patients are not intentionally taking fentanyl." Instead, they think they're taking a less powerful drug like heroin.[25]

"Just like the British East India Company two centuries ago, today the world's two biggest superpowers are producing opioids by the ton," wrote author Ben Westhoff. "The US generally does so legally as medicine, while China also does so illicitly, as drugs."[26]

Said *New York Times* columnist Nicholas Kristof, "If the Chinese government pursued drug companies the way it crushes dissident Christians, labor activists, lawyers or feminists, their drug exports would end."[27]

It was headline news in China in December 2018 when President Donald Trump met with President Xi Jinping in Buenos Aires. During the meeting, President Xi pledged to stop the export of fentanyl precursors. But he failed to follow through. In fact, most fentanyl precursors

remain perfectly legal in China and many of the chemical companies that produce them continue to receive incentives from the Chinese government.

Unfortunately, China's unrestricted warfare against the United States doesn't stop there. One of the officials who testified before the House Select Committee on the Strategic Competition Between the United States and the Chinese Communist Party (CCP) in April 2024 was former chief of operations of the DEA Raymond P. Donovan.

He said:

> One of the things we saw through our work with the Treasury Department is that the money the Chinese make is dropped into the biggest banks. One of them is the TD Bank, which Bloomberg News says is facing a $4.5 billion fine for narco money laundering. And a lot of the money the Chinese earn is going into real estate here in the US.
>
> The fact is that the US has never sanctioned a major Mexican or Chinese bank for money laundering or holding money for organized crime groups like the Cartel del Sol. And attempts to hold HSBC, Wachovia Bank, and Wells Fargo accountable back in the 2008–2010 period failed because they were deemed too big to fail and too big to go to jail.[28]

US Admiral Craig Fuller told Congress last year that Chinese money launderers are now the "number one underwriters" of drug trafficking in the Western Hemisphere.

Dr. David Asher is a former State Department official who continues to advise the US government on many issues including counterterrorism, money laundering, and China. According to Dr. Asher:

China is engaged in what they view as a sort of covert action program, which is a reverse of the Opium Wars—a way to use narcotic, the way the Brits used opium against the Chinese to undermine their state society and solidarity.

They're more or less underwriting the drug trafficking business for the cartels. It's the largest money laundering scheme in the world. And how it works is pretty simple. Chinese students across the country are called by Chinese brokers. I've seen it myself. A kid walking down the street with a big Samsonite suitcase filled with $100,000. He'll drop it off at a Chinese travel agency that is in some cases owned by the Chinese government. We are literally seeing four to five thousand students doing this a week. All right under our eyes.[29]

The CCP has also been actively involved with Venezuelans and Iranians with tampering with American elections.[30]

The effects of the Opium Wars in China live on, and not just in the museum break-ins. But now, the tables are turned. Concluded former CIA operations officer Gary Berntsen, "China is poisoning our people, our financial institutions, and our election system."[31]

## 18

# The Break-ins Continue

"The greatest victory is the one which requires no battle."

—Sun Tzu

At midnight, September 13th of last year, a security guard at Cologne's Museum for East Asian Arts heard loud noises, ran toward the sound, and caught a glimpse of two burglars leaving the museum. One was in his late twenties, had long hair, and was wearing a baseball cap. The other carried a gray rucksack like the ones used by food delivery services. The thieves made away with nine precious porcelain plates, vases, and pots from the Ming and Qing dynasties valued at more than one million dollars. Museum officials said that it seemed as though they had targeted specific objects.

"The staff members of the Museum for East Asian Arts are shocked and deeply consternated by the burglary," said museum director Shao-Lan Hertel. "More than financial and material damage, the museum mourns a loss of intangible nature."[1]

Hertel said most of the stolen objects were acquired by the museum founders Adolf and Frieda Fischer in China between 1906 and 1911,

documenting the acquisitions in detail in their purchase diary. Another item was a Ming-dynasty yellow-glazed dish, which was gifted to the museum in 2015.

He also revealed that burglars had tried to break into the museum months earlier, once in January 2023 and again in June. In the June incident a panel of glass on the south façade of the museum was smashed in, but no one attempted to enter the building and no objects were stolen.

Following the January attempt, security precautions at the museum were heightened, with more high-tech security systems and added personnel. Still, the thieves were able to break into the museum on the night of September 13 with what Hertel said was "great effort and violence."

The thieves entered through a wooden panel used to cover the glass that had been broken in the June attempt. The only witness was the security guard who saw them leaving.

German federal criminal police officers involved in the investigation admitted that the September break-in followed a familiar pattern—local criminals hired most probably by Chinese triads. A spokesperson for the German federal police said that the burglary at the Museum for East Asian Arts should serve as a wake-up call, not only in Cologne, but also countrywide and worldwide.

"The international dimension of the investigation corresponds to the cultural significance and financial value of the stolen property," Hertel said. "The objects are very well documented and therefore clearly identifiable, and so it is hoped that they will eventually find their way back into the museum collection."[2]

Six weeks later, on the night of October 29, thieves smashed through a glass panel on the first floor of the Roemer- und Pelizaeus-Museum in Hildesheim, Germany, 200 miles northwest of Cologne. At first

it appeared to be an unsuccessful break-in. Then three days later the thieves returned and stole three highly valuable objects from the collection of Ernst Ohlmer—two candlesticks and a shoulder pot. In a press release the museum stated that the burglary was probably carried out by professional criminals acting on someone else's behalf.

Ernst Ohlmer had worked as a private secretary to Robert Hart, the previously mentioned general inspector of the Chinese Maritime Customs Service from 1861 to 1911. In 1887, Ohlmer was appointed customs director in Canton. He was also a talented photographer. In 1873, just thirteen years after the sacking of the Old Summer Palace, Ohlmer photographed the ruins, leaving the earliest known visual record of the devastated site.

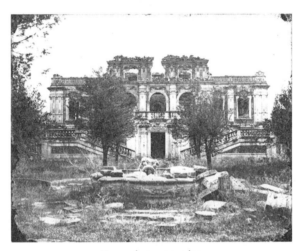

Yuanmingyuan ruins

Finally, on April 20, 2024, three thieves broke into the Royal Museum of Mariemont in Belgium's Hainaut province at around 4:00 A.M. and made off with a rare porcelain wine jar—a masterpiece from the Chinese imperial workshops dating back to the Ming dynasty.

Museum authorities activated all security protocols, including alarms and surveillance cameras, which captured images of the thieves. "They seemed well-prepared and knew exactly where to enter, where to exit, and which object was displayed in which room," said museum director Richard Veymiers.[3]

The wine jar, adorned with an aquatic motif, was originally acquired by Belgian freemason and industrialist Raoul Warocqué during a diplomatic mission to China in 1912.

This time the police got lucky and, based on evidence the thieves left behind, they were able to track them down. On May 28, 2024, the Belgian Federal Judicial Police of Charleroi, assisted by federal police special units, in close collaboration with the French Judicial Police of Lille and other police services, arrested two suspects on Belgian soil and two suspects on French soil.

One of the suspects confessed to the investigating judge that he had been hired by a member of a Chinese triad. An ensuing search recovered the wine jar intact.

Said Richard Veymiers: "I would like to salute the remarkable work of the Belgian and French police teams, and to thank them warmly for their involvement. It is a huge success, a real achievement. . . . For us, it's a huge relief."[4]

The wine jar was returned to its display at the Royal Museum of Mariemont in Belgium. But the controversy over ownership, repatriation, safety of art objects, and the use of criminal gangs didn't end there.

Taking no responsibility for the thefts, Chinese officials focused on complaints about the object's safety—even though the thieves who took the wine jar had been hired by a Chinese triad. "It triggers a trust issue in Western museums for us," said Chinese cultural expert Yao Yu. "Whenever the relic's repatriation topic is proposed, Western

museums often question the relic's original country whether or not they can better care for them. This incident that happened is like a joke, or a slap in the face."[5]

A slap in the face?

Or another unfortunate act in an ongoing cultural war ignited by a century of colonialism and humiliation?

The first step in healing any rift is usually better understanding on all sides. China is still angry about its colonial past and Century of Humiliation. However, playing up past grievances will only serve to impede future cooperation and a healthy relationship with the West.

The pattern of break-ins and thefts will continue until former Western colonial powers publicly acknowledge the crimes and other abuses they committed in China. Only then is the issue of the looted cultural objects likely to end in a way that allows people—not only in China and the West, but all over the world—to appreciate their sublime beauty and historical significance.

After all, the objects themselves were never meant to serve as symbols of power to be fought over, looted, and stolen back. The finest achievements of Chinese sculpture, ceramic-making, and painting were intended to lift the human spirits of all who viewed them. Isn't it time to honor the ancient artists' aspirations?

# Notes

**Chapter 1: Stockholm, 2010**
1. Interview with filmmaker Magnus (last name withheld), March 23, 2023.
2. "Drottningholm Palace, A Royal Home," SVT-1, Jan. 4, 2017.
3. Sveriges Radio, Aug. 6, 2010.
4. Marco Polo, "Observations of Khanbaliq [Beijing]," from *The Travels of Marco Polo*, written about 1298 C.E.
5. Interview with Diana Sundin, July 12, 2022.
6. Sveriges Radio, Aug. 6, 2010.
7. Ibid.
8. Interview with Magnus, March 23, 2023.
9. Lao-Tzu, *Tao Te Ching*, verse 78.

**Chapter 2: The Old Summer Palace, Beijing**
1. Victor Hugo, "Letter to Captain Butler," Nov. 25, 1861, www.yuanmingyuan.eu.
2. Quoted in "The Palace of Shame that Makes China Angry," Chris Bowlby, BBC News, Feb. 2, 2015.
3. Quoted in "Lessons of the Opium Wars," Andrew Moody, *China Daily*, Feb. 24, 2024.
4. Quoted in "Modern China and the Legacy of the Opium Wars," Monique Ross and Annabelle Quince, https://www.abc.net.au/news, Sept. 1, 2018.
5. Interview with Dr. Greg M. Thomas, Feb. 20, 2022.
6. Tablet erected by Zheng He in Changle, Fujian, in 1432. Cited in Levathes, Louise (1996). *When China Ruled the Seas: The Treasure Fleet of the Dragon Throne, 1405–1433*. Oxford University Press.
7. "How Spices Changed the Ancient World," www.mayilspices.com.
8. Richard Hughes, *Foreign Devil: Thirty Years Reporting in the Far East* (Random House, 1986).

9   Sir Alexander Hosie, *Five Reports by the Consul-General*, London: HMSO, 1983–1905.
10  Samuel Merwin, *Drugging a Nation: The Story of China and the Opium Curse* (CreateSpace Independent Publishing Platform, 2013), 55.
11  James Bruce Elgin, *Letters and Journals* (J. Murray), 190.
12  Austin Ramzy, "How Britain Went to War Over Opium," *New York Times*, July 3, 2018.
13  Simon Deschamps, "Merchant and Masonic Networks in Eighteenth Century Colonial India," *L'Empire*, vol. 74, 2017.
14  Jessica Harland-Jacobs, *Freemasons and British Imperialism* (University of North Carolina Press, 2007).
15  Interview with Simon Deschamps, April 21, 2023.
16  Emily Erikson, *Between Monopoly and Free Trade: The East India Trading Company* (Princeton University Press, 2014), 10.
17  Dave Roos, "How the East India Company Became the World's Most Powerful Monopoly," History.com, Oct. 23, 2020. https://www.history.com/news/east-india-company-england-trade.
18  Quoted in "Politics of the Poppy" by J. B. Brown, *Journal of Contemporary History*, vol. 8, no. 3, July 1973.
19  Merwin, *Drugging a Nation*, 45.
20  https://media.bloomsbury.com/rep/files/primary source 13.0 - lin.pdf.
21  Jocelyn, Viscount Robert (1841). *Six Months with the Chinese Expedition; or Leaves from a Soldier's Notebook* (John Murray, 1841), 59.
22  Ibid, 52.
23  "The Scots Who Hooked China on Opium," *The Scotsman*, July 2016.

**Chapter 3: The Opium Wars**
1   Speech of Sir George Staunton, House of Commons, April 4, 1843.
2   Joel Black, *National Bad Habits: Thomas De Quincey's Geography of Addiction* (Rutledge, 2007), 145.
3   Justin and Stephanie Pollard, "The Arrow Incident," *History Today*, vol. 69, issue 10, October 2019.
4   J. Y. Wong, "Harry Parkes and the 'Arrow War' in China," *Modern Asian Studies*, 9, 1975, 305.
5   Par Papers, "Naval Forces at Canton," 35.
6   Ronald Hyam, *Britain's Imperial Century, 1815–1914: A Study of Empire and Expansion* (Palgrave Macmillan, 2002), 126.
7   Merwin, *Drugging a Nation*, 46.
8   Paul Varin (actually Charles Dupin), *Expédition de Chine* (Michel Lévy Frères, 1862), 235–236.
9   Jean Denis Attiret (1702–1768). *A particular account of the Emperor of China's gardens near Pekin: in a letter from F. Attiret, a French missionary, now employ'd by that emperor to paint the apartments in those gardens, to his friend at Paris*, trans. Sir Harry Beaumont (printed for R. Dodsley; and sold by M. Cooper, 1752).
10  Viscount Wolseley, *Narrative of the War in China in 1860* (Longman, Green, 1862), 233.

11  Ibid.
12  Armand Lucy. *Lettres intimes . . .* (1861), 226–227.
13  Ibid.
14  James Bruce, *Journals*, 276.
15  Letter from Sir Harry Parkes to his wife, British Embassy, Peking, Oct. 27, 1860.
16  Wolseley, 282.

**Chapter 4: KODE Museum, Bergen, Norway**
1  www.chineseantiques.co.uk/chinese-antiques-stolen-from-bergen-museum/.
2  "Once Plundered by Colonialists, China Art is Being Stolen Back," WBUR Radio, Aug. 28, 2018.
3  "Thieves Hit Bergen Museum Again," *News in English, Norway*, Jan. 7, 2013.
4  Interview with Roald Eliassen, Dec. 1, 2023.
5  Irv Graham, "Chinese Antiquities Stolen from Bergen Museum," *Chinese Antiquities*, Jan. 7, 2013.
6  Bjornar Sverdrup-Thygeson, "The Norway-China Relationship: For Better, For Worse, For Richer, For Poorer." In Sverdrup-Thygeson, Lindgren, Wrenn; Lanteigne, Marc. (eds.) *China and Nordic Diplomacy* (Routledge, 2018), 77–100.
7  Garry Lu, "Chinese Billionaires Are Hiring Trained Thieves to Steal Back Art from European Museums," *Boss Hunting*, July 30, 2021.
8  Sarah Cascone, "Is China Going Rogue to Recover Looted Art?" *Artnet*, Aug. 17, 2018.
9  Sverdrup-Thygeson, "The Norway-China Relationship," 77.
10  Mark Wilding, "The Story Behind the Gang that Stole Millions of Dollars Worth of Rhino Horn," Vice News, April 5, 2016.
11  "Fitzwilliam Museum Chinese Art Theft: Hunting Lost Treasures," *BBC News*, Sept. 27, 2012.
12  Ibid.
13  Ibid.
14  Eamon Dillon, *Gypsy Empire: Uncovering the Hidden World of the Irish Travellers* (Transworld Ireland, 2013), 5.
15  "Rhino Horns Lure Museum Thieves," *New York Times*, Aug. 26, 2011.
16  "Men Jailed for Durham University Oriental Museum Raid," *BBC News*, Feb. 8, 2013.
17  Ibid.

**Chapter 5: The Century of Humiliation**
1  Paul A. Cohen, *Speaking of History* (University of California Press, 2009), xi.
2  Alison A. Kaufman, Testimony before the US-China Economic and Security Review Commission Hearing on "The Chinese View of Strategic Competition with the United States," https://www.uscc.gov.
3  Council of Foreign Relations, "China's Approach to Global Governance," https://www.cfr.org/china-global-governance/.
4  S. W. Baker, *Eight Years in Ceylon* (1855) xii.
5  Hyam, *Britain's Imperial Century*, 280.

6 Sima Qian, *Records of the Grand Historian: Confucius and Lao-tsu* (Daybreak Studios, 2023), 46.
7 Ibid.
8 Lao Tzu, *Tao Te Ching* (Amazon Reprints, 2024), 32.
9 T. Walrond (ed.), *Journals and Letter of James, the Eighth Earl of Elgin* (John Murray, 1872), 250.
10 Ibid, 199.
11 Robert Nield, *China's Foreign Places* (Hong Kong University Press, 2015), 36.
12 "Reading the Club as Colonial Island in E. M. Forster's *A Passage to India* and George Orwell's *Burmese Days*," *Island Studies Journal*, vol. 6, no. 1, 2011, 17.
13 Ibid.
14 George Orwell, "Shooting an Elephant," *New Writing*, 1936.
15 Michelle Qiao, "Shanghai's Masonic History," ShanghaiDaily.com, July 25, 2014.
16 Interview with Alexander Thomas Bruce, the 11th Earl of Elgin," *Freemasonry Today*, Winter 1998.
17 H. C. Whittlesey, "Sir Robert Hart," *The Atlantic*, Nov. 1900.
18 Ibid.
19 Ibid.
20 Jacques M. Downs's *The Golden Ghetto: The American Commercial Community at Canton and the Shaping of American China Policy, 1784–1844* (Hong Kong University Press, 2014), 150.
21 Amitav Ghosh, "The Blue Blood Families that Made Fortunes in the Opium Trade," *The Nation*, Jan. 23, 2024.
22 Downs, 226–227.
23 Jerome Fritel and Marc Roche, "Banksters: HSBC, the Untouchable Titan of Global Finance," YouTube.com.
24 Thomas Manuel, *Opium Inc.: How the Global Drug Trade Funded the British Empire* (HarperCollins India, 2021).
25 Alfredo Escolar, "Too Big to Jail: The Story of HSBC and the Mexican Drug Cartel," *Geads News*, June 13, 2020. https://geads.co.uk/2022/06/13/too-big-to-jail-the-story-of-hsbc-and-the-mexican-drug-cartel-business-news/.
26 Mencius, *Mencius*, Lau, D. C. (Dim Cheuk) (rev. ed.), (Penguin, 2004).
27 Michael Shuman, *Superpower Interrupted: The Chinese History of the World* (PublicAffairs, 2020), 272.
28 *Documents on Diplomacy, Dispatches from the Boxer Rebellion*, US Minister Edwin Conger, 1900, US.Archive.org.
29 Wilhelm II, *"Hun Speech" (1900) German History in Documents and Images (GHDI)*. germanhistorydocs.ghi-dc.org.

**Chapter 6: Château de Fontainebleau**
1 Steven Englund, *Napoleon: A Political Life* (Harvard University Press, 2005).
2 W. Travis Hanes and Frank Sanello, *The Opium Wars: The Addiction of One Empire and the Corruption of Another* (Barnes & Noble, 2005), 276.
3 Wang Shangchen's poem "Song of Yearning," cited in Zheng 2005: 133, c. 1850.

4  Interview with Jean-François Hebert, April 7, 2023.
5  "Chinese Art Stolen from France's Fontainebleau Palace," BBC News, March 2, 2015.
6  Interview with French inspector (name withheld), April 7, 2023.
7  Victor Hugo, "Letter to Captain Butler," Nov. 25, 1861, www.napoleon.org.
8  "Once Plundered by Colonialists, Chinese Art Is Being Stolen Back," Aug. 28, 2018, wbur.org.
9  "China Demands Return of Ancient Artifacts," China.org, Jan. 22, 2003.
10  "Interviews with Li Xueqin: The Life of a Chinese Historian: Part Two," *Early China*, 2013.
11  Interview with James Ratcliffe, June 9, 2022.
12  "China Protests Christie's Auction in Paris of Relics," *Christian Science Monitor*, Feb. 20, 2009.
13  Ibid.
14  *Cultural Property News*, April 10, 2018.
15  Hugh Eakin, "The Affair of the Chinese Bronze Zodiac Heads," *New York Review of Books*, May 14, 2009.
16  "China Protests Christie's Auction in Paris of Relics," *Christian Science Monitor*, Feb. 20, 2009.
17  "Two Bronze Animal Heads—China and Pierre Bergé," Arthemis, University of Geneva.
18  Ibid.
19  "Pinaults Return Looted Bronze Zodiac Heads to China," CBC News, June 23, 2013.
20  Ibid.
21  https://www.luxurydaily.com/wp-content/uploads/pdf_cache/2/8/3/4/2/8/283428.pdf.

**Chapter 7: Empress Cixi**
1  Edmund Backhouse, *Décadence Mandchoue* (Earnshaw, 2011), introduction.
2  Hugh Trevor-Roper, *The Hermit of Peking* (Alfred Knopf, 1976), 348–352.
3  Ibid.
4  *Oxford Dictionary of National Biography*. vol. 3, (Oxford University Press, 2004). 10.
5  Ibid.
6  Lo-Hui-min, "The Traditions and Proto-types of the China-Watcher," Thirty-seventh George Ernest Morrison Lecture in Ethnology, delivered at The Australian National University on October 27, 1976.
7  Ibid.
8  Ibid.
9  Katherine A. Carl. *With the Empress Dowager of China*. (The Century, 1905), 19.
10  J. Fairbank and S. Teng, *China's Response to the West: A Documentary Survey* (Harvard University Press, 1979), 53.
11  Josef Maria Casals, "Cixi, the Controversial Concubine Queen, Led China into the Modern Age," Nov.-Dec. 2016, *National Geographic Magazine*.

12　Ibid.
13　Richard S. Horowitz, "Politics, Power and the Chinese Maritime Customs: The Qing Restoration and the of Ascent Robert Hart," *Modern Asian Studies*, vol. 40, July 2006.
14　A conversation with Sarah Pike Conger from *Friendly China* by Bailey Willis (Stanford University Press, 1949).
15　Carl, *With the Empress Dowager of China*.
16　Iolanda Munck, "Masterpiece Story: The Portrait of Empress Dowager Cixi by Katherine Augusta Carl," *DailyArt Magazine*, Dec. 11, 2024.
17　Lihui Dong, *The Way to be Modern: Empress Dowager Cixi's Portraits of the Late Qing Dynasty*, PhD diss., University of Pittsburgh, 2017.
18　Interview with Professor Jung Chang, June 18, 2024.
19　Louisa Lim, "Who Murdered China's Emperor 100 Years Ago?" NPR, Nov. 14, 2008.
20　Edward Behr, *The Last Emperor* (Bantam, 1987).
21　RogerEbert.com, Dec. 9, 1987.

## Chapter 8: The Triads

1　"Chinese Artifacts Stolen from England's Museum of Asian Art," *Artforum*, April 19, 2018.
2　Ibid.
3　Taylor Dafoe, "Burglars Broke into a Dutch Museum and Made Off with 11 Rare Chinese Ceramics," *Artnet*, Feb. 14, 2023.
4　Ibid.
5　"Inside the Foiled Heist of a Chateau's Chinese Museum," *Le Monde*, Aug. 4, 2023.
6　Interview with Dick Ellis, Nov. 9, 2023.
7　Ibid.
8　Ibid.
9　"China's Stolen Treasures: A Question of Ownership," BBC Radio, Aug. 8, 2022.
10　"The 36 Oaths," Geocities Archive, www.oocities.org.
11　Sebastian Rotella and Kirsten Berg, "How a Chinese American Gangster Transformed Money Laundering for Drug Cartels," ProPublica, Oct. 11, 2022.
12　Peter Nepstad, The Illuminated Lantern Blog.
13　Interview with Omar Khan, May 5, 2023.
14　Ibid.
15　Ibid.
16　Ibid.
17　Interview with Jimmy Tsui, *Business Insider*, May 23, 2023.
18　James Griffiths, "US Sanctions Triad Boss 'Broken Tooth,'" CNN World, Dec. 10, 2020.
19　Ibid.
20　Ibid.
21　Ibid.

## Chapter 9: Sun Yat-sen

1. Orville Schell and John Delury, *Wealth and Power: China's Long March to the Twenty-first Century* (Random House, 2013), 131.
2. Ibid, 134.
3. Ibid.
4. Harold Z. Schiffrin, *Sun Yat-sen: Reluctant Revolutionary* (Little Brown, 1980).
5. "Sun's Letter to Li Hongzhang, 1894," *Asia Society*, asiasociety.org/china wealthpower/chapters/sun-yat-sen/.
6. https://en.wikipedia.org/wiki/Yellow_Turban_Rebellion.
7. Martin Purbrick, "Patriotic Chinese Triads and Secret Societies," *Asian Affairs*, vol. 50, 2019, 306.
8. Professor Xiaowei Zheng, *The Politics of Rights and the 1911 Revolution in China* (Stanford University Press, 2018).
9. *Wealth and Power*, 121.
10. Ying-shih Yu in *Sun Yat-sen's Doctrine in the Modern World*, Chu-yuan Cheng, ed. (Routledge, 2019), 80.
11. T. C. Woo, *The Kuomintang and the Future of the Chinese Revolution* (George Alan and Unwin, 1928), 246.
12. Jonathan D. Spence, *The Search for Modern China* (W. W. Norton, 1990), 419.
13. *Wealth and Power*, 181.
14. Dick Wilson, *When Tigers Fight: The Story of the Sino-Japanese War, 1937–1945* (Viking, 1982), 37.
15. Iris Chang, *The Rape of Nanking: The Forgotten Holocaust of World War II* (Basic Books, 1997), 40.
16. Ibid, 86–88.
17. *Wealth and Power*, 181.
18. Jay Winter, *America and the Armenian Genocide of 1915* (Cambridge University Press, 2003), 23.
19. Chang, 30.
20. Ministry of Foreign Affairs, Japan: Statement by Prime Minister Tomiichi Murayama "On the occasion of the 50th anniversary of the war's end," (Aug. 15, 1995).
21. *NewsHour with Jim Lehrer*, Dec. 1, 1998.
22. Takashi Yoshida, *The Making of "The Rape of Nanking," History and Memory in Japan, China, and the United States* (Oxford University Press, 2006), 5.
23. Fengqi Qian and Guoqiang Liu, "Remembrance of the Nanjing Massacre in the Globalised Era: The Memory of Victimization, Emotions and the Rise of China," *China Report* vol. 55, issue 2, 2019.

## Chapter 10: Repatriation

1. http://www.npc.gov.cn/englishnpc/Law/2007-12/13/content_1384015.htm.
2. Zhengxin Huo, "Legal Protection of Cultural Heritage in China, International Journal of Cultural Policy," March 2015.
3. Bruno Boesch and Massimo Sterpi, *The Art Collecting Legal Handbook* (Edward Elgar, 2023).

4 Hannah Beech, "Spirited Away," *Time*, Oct, 13, 2003.
5 Interview with He Shuzhong, May 23, 2024.
6 "China Revises Law to Strengthen Protection of Cultural Relics," People's Daily Online, Nov. 8, 2024.
7 "Draft Law Aims to Better Balance Cultural Relics Utilization, Protection," The National People's Congress of the People's Republic of China," June 28, 2024.
8 Wei Fen, "Chinese Short Video Reflects Call for Return of Artifacts," *Global Times*, Sept. 4, 2023.
9 Tori Campbell, "Nazi Plunder: A History of Missing and Recovered Art Treasures," *Artland Magazine*, 2024.
10 Alexander Herman, *Restitution: The Return of Cultural Artifacts* (Lund Humphries, 2021), 53.
11 Ibid, 47.
12 Ibid.
13 *Framework Principles for dealing with collections in colonial interests*, German Federal Government, March 13, 2019.
14 "Once Plundered by Colonialists, Chinese Art is Being Stolen Back," www.wbur.org/hereandnow, Aug. 28, 2018.

## Chapter 11: The Chinese Civil War

1 Paul A. Cohen, *History and Popular Memory: The Power of Story in Moments of Crisis* (Columbia University Press, 2014), 84.
2 *Wealth and Power*, 190.
3 Edgar Snow, *Journey to the Beginning: A Personal View of Contemporary History* (Random House, 1958), 137.
4 Zachary Keck, "The CCP Didn't Fight Imperial Japan; the KMT Did," *The Diplomat*, Sept. 4, 2014.
5 Gordon G. Chang, "Born of Struggle," *New York Times*, Sept. 6, 2013.
6 Michael Lynch, *The People's Republic of China 1949–76* (Hodder Education, 2008), 3.
7 Giuseppe Paparella, "Losing China? Truman's Nationalist Beliefs and the American Strategic Approach to China," *The International History Review*, vol. 44, 2022.
8 Jonathan Fenby, "Chiang Kai Shek: China's Generalissimo and the Nation He Lost," *Asian Europe Journal*, 2005.
9 Frank Dikotter, *The Tragedy of Liberation: A History of the Chinese Revolution 1945–1957* (Bloomsbury, 2013).

## Chapter 12: The Seventh Earl of Elgin

1 Arthur W. Lawrence and Richard A. Tomlinson, *Greek Architecture* (Yale University Press, 1996), 57.
2 William St Clair, "Bruce, Thomas, seventh earl of Elgin and eleventh earl of Kincardine (1766–1841)." *Oxford Dictionary of National Biography* (Oxford University Press, 2004), 6–9.
3 Letter from Lord Elgin to G. B. Lusieri, July 10, 1801.

4   Bruce Clark, "How the Much-Debated Elgin Marbles Ended up in England," *Smithsonian Magazine*, Jan. 11, 2022.
5   Report from the Select Committee of Parliament on the Earl of Elgin's Collection of Sculpted Marble, March 25, 1816, 66–67.
6   "The Parthenon Sculptures," The British Museum.
7   Tim Luckhurst, "Lord Elgin: Defender of Aristocratic Adventure and National Treasure," *The Independent*, Jan. 17, 2004.

## Chapter 13: Mao Zedong

1   Mao Zedong. *"The Chinese people have stood up"*. UCLA Center for East Asian Studies.
2   Mao Zedong, "Introducing a Cooperative," April 15, 1958.
3   Alexander V. Pantsov and Steven I. Levine, *Mao: The Real Story* (Simon & Schuster, 2013), 41.
4   Frederick C. Towes, "Mao and His Lieutenants," *The Australian Journal of Chinese Affairs*.
5   Mao Zedong, "On the People's Democratic Dictatorship: In Commemoration of the Twenty-eighth Anniversary of the Communist Party of China," June 30, 1949, Wilson Center Digital Archive, www.digitalarchive.wilsoncenter.org.
6   Lynch, *The People's Republic of China*, 10.
7   "The First Five-Year Plan," Alpha History, alphahistory.com.
8   Ibid.
9   David Bray, *Social Space and Governance in Urban China* (Stanford University Press, 2005), 5.
10  Spence, *The Search for Modern China*, 599.
11  *Time*, May 5, 1958.
12  Rebecca Kreston, "Paved with Good Intentions, Mao Tse-Tung's 'Four Pests' Disaster," *Discover*, Feb. 26, 2014.
13  Frank Dikotter, *Mao's Great Famine* (Walker, 2010), 320.
14  "On the People's Democratic Dictatorship," *Selected Works of Mao*, www.marxists.org.
15  Office of the Historian, US State Department, Foreign Relations of the United States, 1950, Korea, Volume VII.
16  Ibid.
17  Mao, "Reply To Comrade Kuo Mo-Jo," https://www.marxists.org/.
18  Allen Axelrod, *The Real History of the Cold War: A New Look at the Past* (Sterling, 2009), 213.
19  Chi-Kwan Mark, "Ideological Radicalization and the Sino-Soviet split," *China and the World Since 1945: An International History* (Routledge, 2012), 49.
20  Mao, "Reply to Comrade Kuo Mo-Jo."
21  Clifford Coonan, "A Red Reign of Terror," *The Irish Times*, Aug. 19, 2006.
22  John Gittings, "Bringing Up the Red Guards," *China File: The New York Review of Books*, Dec. 16, 1971.
23  Jens Muhling, "Tiananmen Square: A Foreign Journey to the Forbidden Heart of China," *Worldcrunch*, Oct. 12, 2024.

24 Geremie R. Barmé, "A Monkey King's Journey to the East," *China Heritage*, Jan. 1, 2017.

**Chapter 14: Antiquities Traffficking Unit**
1 www.renemagritte.org.
2 Leo Tolstoy, *What Is Art?* (Hackett, 1996), 3.
3 www.thesocratic-method.com/quote-meanings/pablopicassso.
4 Casey Haskins, "Kant and the Autonomy of Art," *Journal of Aesthetics and Art Criticism*, vol. 47, no. 1, Winter 1989.
5 H. W. Janson, *The History of Art* (Harry N. Abrams, 1991).
6 www.icom.museum/en/about-us/missions-and-objectives/.
7 Herman, *Restitution*, 45.
8 Alex W. Barker, "Looting, the Antiquities Trade, and Competing Valuations of the Past," *Annual Review of Anthropology*, vol. 45, 2018.
9 Manacorda S., "Criminal law protection of cultural heritage: an international perspective," from *Crime in the Art and Antiquities World: Illegal Trafficking in Cultural Property*, 17–50 (Springer, 2011).
10 Barker, "Looting, the Antiquities Trade, and Competing Valuations."
11 Henri Neuendorf, "Art Traffickers Beware," *Artnet*, Dec. 18, 2017.
12 Sam Tabachnik, "The Anatomy of an Art Heist," *Denver Post*, Dec. 1, 2022.
13 Ibid.
14 Jian Deleon, "The China-Themed Met Gala Wasn't Totally Offensive, But Still Problematic." Complex, May 17, 2016.
15 Aaron Katersky and Ayushi Agarwal, "New York Billionaire Surrenders Stolen Antiquities Worth $70M," *ABC News*, Dec. 6, 2021.
16 Tabachnik, "The Anatomy of an Art Heist."
17 "Meet the Man Causing Cracks in the Antiques Trade," *Economist*, May 23, 2024.
18 John Sanburn, "How the FBI Discovered a Real-Life Indiana Jones in, of All Places, Rural Indiana," *Vanity Fair*, Nov. 2021.
19 Domenica Bongiovanni, "US returns hundreds of artifacts to China," *IndyStar*, Feb. 28, 2019.
20 Ibid.
21 "More than 1000 artifacts in Metropolitan Museum of Art catalog linked to alleged looting and trafficking figures," March 20, 2023, ICIJ.org.
22 Ibid.
23 "In Response to Scandals and Stolen Art Seizures, the Met Plans to Scour Its Own Collections for Stolen Artifacts," International Consortium of Investigative Journalists, ICIJ.org, May 11, 2023.
24 Francesca Aton, "How the Met and Other Major US Museums are Approaching Provenance Research," *ArtNews*, Feb. 28, 2024.
25 Ibid.
26 Ibid.
27 "Practices of Provenancing 'Summer Palace' loot in British and French museums," 2019, Jane Milosch, Jane and Pearce, Nick (eds.) *Collecting Cultures-Cultures of Collecting: A History through Provenance*, ch. 25, 359.

## NOTES

28  Nick Pearce, "From the Summer Palace 1860: Provenance and Politics," in *Collecting and Displaying China's Summer Palace in the West*, ed. Louise Tythacott (Routledge, 2018), 46.
29  Interview with Joe-Hynn Yang, Dec. 4, 2023.
30  www.chateaudefontainebleau.fr/en/.

## Chapter 15: Deng Xiaoping

1  Rong Deng, "Deng Xiaoping and the Cultural Revolution," *Foreign Languages Press*, 46–47.
2  *Wealth and Power*, 270.
3  Seventh Plenum of the Third Communist Youth League, July 7, 1962.
4  *Wealth and Power*, 282.
5  "China to Open Wider to the World, Xi," *China Daily*, Oct. 10, 2014.
6  Patrick Tyler, "Deng Xiaoping: A Political Wizard Who Put China on the Capitalist Road," *New York Times*, Feb. 20, 1997.
7  "Heists, History and Heritage," China's Stolen Heritage, BBC Radio, March 15, 2020.
8  "For Investors, Glamorous Bounty Lies in Buying Looted Artwork," *China Daily*, Dec. 15, 2010.
9  Luo Ying, "Bare Bones That Were My Father," *Memories of the Cultural Revolution* (University of Oklahoma Press, 2015).
10  Ibid.
11  Ibid, 19.
12  "Marble Columns Back on Display at their Rightful Home," *China Daily*, Oct. 14, 2023.
13  Didi Kirsten Tatlow, "Chinese Deal for Iceland Property Founders Over Distrust," *New York Times*, Sept. 21, 2011.
14  "China's Huang Seeks Iceland Land for Eco-Resort," BBC News, Aug. 30, 2011.
15  Ibid.
16  "Chinese Deal for Iceland Property Founders Over Distrust."
17  Ibid.
18  "China's Soft Power Initiative," Council on Foreign Relations, cfr.org, May 19, 2006.
19  Interview with Chan Koonchung, *Los Angeles Review of Books*, April 5, 2019.
20  "China tycoon Huang Nubo angered by Iceland land move," BBC News, Nov. 28, 2011.
21  Ibid.
22  "Chinese Private Companies Frozen Out Abroad," *Global Times*, Dec. 11, 2011.

## Chapter 16: China Poly Group

1  "Start 2023 with Mysteries Worth Reading," *Seattle Times*, Jan. 10, 2023.
2  www.penguinrandomhouseretail.com/book/?isbn=9780593186060.
3  Sarah Salisbury, "Homecoming: Upcoming Novel Reimagines Chinese Art Heists," *US-China Today*, May 2, 2022.
4  Interview with Chinese Art Collector," Jan. 19, 2024.

5   www.poly.com.cn.
6   Huileng Tan, "Chinese state-owned giant is hoping to expand in the US—with culture," CNBC, Jan. 24, 2018.
7   Sam Cooper and Doug Quan, "How a Murky Company with Ties to the People's Liberation Army Set Up Shop in B.C.," *Vancouver Sun*, Aug. 26, 2017.
8   Naomi Garcia, "Open Secrets—China Poly Group," C4ADS, April 6, 2023, www.c4ads.org/commentary/open-secrets-prc-russia-wartime-trade/.
9   "Homecoming: Upcoming Novel Reimagines Chinese Art Heists."
10  Lia Zhu and Chang Jun, "Return of Lost Western Zhou Dynasty Relic Bridges Cultures," *China Daily*, Feb. 24, 2024.
11  Joyce ZK Lim, "Return of the Relics: China's Push to Reclaim Its Lost Treasures," *The Straits Times*, April 14, 2024.
12  Dr. Matthew Partridge, "Italy Joins China's Belt and Road Project," *MoneyWeek*, March 28, 2019. https://moneyweek.com/504069/italy-joins-chinas-belt-and-road-project.
13  Ibid.
14  Ido Vock, "Belt and Road: Italy Pulls Out of Flagship Chinese Project," *BBC News*, Dec. 7, 2023.
15  Paul Levine, "Never Forget National Humiliation," *American Diplomacy*, May 2013.
16  Mao Zedong, "The Chinese people have stood up," UCLA Center for East Asian Studies.
17  Jonathan Watts, "Violence Flares as the Chinese Rage at Japan," *The Guardian*, April 16, 2005.
18  Ministry of Education of China, "List of 'Three Hundreds' in Patriotic Education." Ministry of Education of China, 1994.
19  Zheng Wang, "National Humiliation, History Education and the Politics of Historical Memory," *International Studies Quarterly*, vol. 52, no. 4 (Dec. 2008), 804.
20  Ministry of Education, *Teaching Guideline for History Education* (People's Education Press).
21  William A. Callahan, "National Insecurities: Humiliation, Salvation and Chinese Nationalism," *Alternatives*, 29, 2004, 204.
22  Jeffrey Legro, "Never Forget National Humiliation," *The Focus: Postcolonial Dialogues*, 32, Spring 2012.
23  "National Humiliation, History Education, and the Politics of Historical Memory."
24  Gerrit Gong, ed., *Memory and History in East and Southeast Asia* (CSIS Press, 2002), 42.
25  Tom Plate, "Xi Jinping's China Needs a Foreign Policy Worthy of the 'Asian Century,'" *South China Morning Post*, May 19, 2020.

**Chapter 17: Unrestricted Warfare**
1   David Lotto and Bettina Muenster, "The Social Psychology of Humiliation and Revenge," *Oxford Scholarship Online*, March 2010.

## NOTES

2  Jonathan Sacks, "The Return of Anti-Semitism," *Wall Street Journal*. Jan. 30, 2015.
3  Ibid.
4  Ella Chochrek, "Coach, Givenchy Apologize Over T-Shirts Labeling Hong Kong, Taiwan as Separate Countries," *Footwear News*, Aug. 12, 2019.
5  Ibid.
6  Ibid.
7  "Coach, Givenchy join Versace in apologizing to Chinese consumers amid T-shirt outcry," CNN Style, Aug. 12, 2019.
8  Jordan Greer, "The Daryl Morey Controversy Explained," *Sporting News*, Oct. 23, 2019.
9  Ibid.
10 "National Humiliation, History Education, and the Politics of Historical Memory."
11 Michael Shuman, "China Wants to Control the World by Controlling the Rules," *The Atlantic*, Dec. 9, 2021.
12 Paul Gewirtz, "China, the United States and the Future of a Ruled-Based International Order," Brookings, July 22, 2024.
13 "China's Global Threat to Human Rights," Human Rights Watch, *World Report 2020*.
14 Ibid.
15 Ibid.
16 James Lewis, "Section 301 Investigation: China's Acts, Policies and Practices Related to Technology Transfer, Intellectual Property, and Innovation," *Center for Strategic and International Studies*, 2020, 2.
17 Ralph D. Sawyer, *The Seven Military Classics of Ancient China* (Basic Books, 2007), 38.
18 Qiao Liang and Wang Xiangsui, *Unrestricted Warfare* (Echo Point Books, 2015).
19 "Fighting Fentanyl: The Federal Response to a Growing Crisis," *CDC*, July 26, 2022.
20 "The CCP's Role in the Fentanyl Crisis," Select Committee on the CCP, April 16, 2024.
21 Markos Kounalakis, "China Using Fentanyl Against US," *Times Record News*, Nov. 5, 2017.
22 Sam Quinones, *The Least of Us: True Tales of America and Hope in the Time of the Fentanyl and Meth* (Bloomsbury, 2021), 101.
23 Ibid, 170.
24 Ben Westhoff, *Fentanyl, Inc. How Rogue Chemists Are Creating the Deadliest Wave of the Opioid Epidemic* (Atlantic Monthly Press, 2019), 236.
25 Ibid, 234.
26 Ibid, 218.
27 Nicholas Kristof, "Opioids, A Mass Killer We're Meeting with a Shrug," *New York Times*, June 22, 2017.
28 "Ray Donovan on the Fentanyl Crisis and Strategic Law Enforcement," The Hudson Institute, https://www.youtube.com/watch?v=NAO_kxgbMGU.

29  Interview with David Asher, Aug. 12, 2024.
30  For more information, I refer you to my recent book *Stolen Elections: The Plot to Destroy Global Democracy* (Skyhorse, 2024).
31  Interview with Gary Berntsen, Aug. 9, 2024.

**Chapter 18: The Break-ins Continue**
1  Adam Schrader, "A String of Burglaries Targeting Security Vulnerabilities Have Stripped a Cologne Museum of Objects Worth Millions," *Artnet*, Oct. 4, 2023.
2  Ibid.
3  "Imperial Chinese Wine Jar Stolen from Belgian Museum," *China Daily*, April 22, 2024.
4  "Rare Chinese Vase Stolen from Hainaut Museum Recovered by Police, Belgian and French Suspects Arrested," *The Bulletin*, May 26, 2024.
5  Oguz Kayra, "Ancient Chinese porcelain worth 1 million euros was stolen from the German museum, sparking anger," *Arkeonews*, Jan. 15, 2025.

# Acknowledgments

First, I would like to thank journalist Alex W. Palmer for his excellent August 2018 article in *GQ Magazine*, which was the inspiration for this book. Second, it was my good friend and former CIA case officer Doug Laux who brought Alex's article to my attention.

Initially, Doug and I were planning to write this book together. For a number of reasons, that didn't come to pass. I thank Doug for his friendship and contribution to the planning we did together.

Third, I want to thank editor Jessica Case for offering to publish this book. Her wise counsel, patience, and guidance helped me through. I'm extremely grateful. The excellent designers, copy editors, proofreaders, and the publicity team at Pegasus Crime all made significant contributions.

Finally, I want to thank my literary agent Mark Gottlieb of Trident Media Group. And, of course, my wife and family.

Thank you all!